P9-AEW-978

ART DIRECTOR'S CLUB OF LOS ANGELES
1258 North Highland Avenue Suite 209
Los Angeles, California 90038
213 / 465-8707
Executive Secretary Barbara Shore

Distributors to the trade in the United States:
Robert Silver Associates
307 East 37th Street New York, NY 10016

Distributors to the trade in Canada:
General Pubishing Co. Ltd., 30 Lesmill Road
Don Mills, Ontario, Canada M3B 2T6

Distributors outside the United States and Canada:
Hearst Publications International
1790 Broadway New York, NY 10019

Publisher:
Madison Square Press, Inc.
10 East 23rd Street New York, NY 10010

Printed in Japan.

ISBN 0-942604-21-0 ISSN 0887-4514

ADLA: 3 CREDITS

DESIGN	Elaine Johnson
BOOK COMMITTEE	Elaine Johnson
	Theresa Shibuya
	Becky Tee Ward
	Kurt DeVinney
	Tim Stedman
	Rich Loeffler
	Cindy Ratzlaff
	Loid Der
	Beth Hunter
	Tamara Keith
	Nelson Dodge
	Calvin Chin
	Rhondi Staley
	Libby Magnus
COVER DESIGN	Loid Der
	Edie Garrett
COVER ILLUSTRATION	Marty Gunsaullus
COVER PHOTOGRAPHY	Bill Van Scoy
ART DIRECTION	Toni Hollander
PROJECT COORDINATION	Toni Hollander
	Elaine Johnson
TYPOGRAPHY	Andresen Typographics
PHOTOGRAPHY	Roger Marshutz Studio
	Roger Marshutz
	Bruce Morr
	David Guilburt
CONTRIBUTORS	Hinsche & Associates
	The Design Works
	Andresen Typographics
	Royce Photographics
	F & C Reproductions
	Kirk Paper Company

ADLA·3

The
40th
Competition
Sponsored
by
the

Art
Directors
Club
of
Los
Angeles

TABLE OF CONTENTS

TONI HOLLANDER
President

ADLA has continued its tradition of innovations and achievements again this year.

We presented excellent programs and events.

A landmark seminar on the Apple Macintosh gave an SRO crowd an introduction to the computer revolution and how it can help in our profession. Our Halloween Gala was a success so exciting that it attracted network coverage.

This year's Competition (the results of which you are seeing in this book) expanded on last year's new Entertainment section; it also inaugurated a special section on Editorial advertising and design. We expect both of these sections to be major showcases for our industry.

The Library of Congress has continued to make selections from the ADLA Competition for its Permanent Collection. Ours is one of only two shows in the country to be cited by the Library of Congress for its selection.

The book committee working on ADLA:3 has redefined the words dedication and professionalism. They built so well on the foundation laid last year that I can only say, "This is the way it should be done"; I know of no higher praise.

We have made our list of contributors as comprehensive as we are able; we will be dismayed if we have overlooked anyone.

Heading the list of contributors this year is George Rice and Sons Lithographers. Their annual award is a milestone for recognition of achievement and scholarship development. We describe this outstanding contribution more fully on page 16.

ADLA and I are indebted to the many talented professionals who gave so selflessly over the year. The book committee, judges, competition volunteers and the banquet committee all pulled together in a terrific team effort that was a joy to behold and an honor with which to be associated.

Thank you.

GARY HINSCHE
Vice President

It seems to me that any competition simply isolates a time and place and represents but a moment, a glance at advertising and design. Nothing more.

But competitions are valuable. They document what is good, and in so doing provide reference for the student, the professional and the client. Competitions become the benchmark by which we must judge our own work. They define excellence.

Competitions also advance advertising and graphic design to our collective market place, the clients.

Perhaps the most important aspect of competitions is that they honor and reward deserving graphic design and art direction.

With that I present you the Los Angeles Art Directors' Club 40th Competition recognizing but a moment in Advertising and Design.

Events mark the passing of time like hands on a clock. The time itself is unimportant . . . the event becomes a memory. Annual events are far more memorable because they are met with anticipation and become traditions.

The 1986 Awards Banquet is such a memory, one well on its way to becoming an ADLA tradition.

The banquet was a tremendous success. It was completely sold out and everyone enjoyed themselves. It was a time to meet new friends and reacquaint ourselves with old friends too, but moreover it was the community taking the time to honor those exceptional performances of 1985-86.

Congratulations to all the winners.

Leah Hoffmitz
*Judging
Chairperson*

VOLUNTEERS

Vicki Adjami	Adriane Jack
Gregorio Amaro	Elaine Johnson
Julie Anderson	Tamara Keith
Ruthie Berman	Bill Kent
Jerry Bonar	B.J. Krivanek
Gene Bramson	Sachi Kuwahara
Doug Brotherton	Sara Ledgard
Eugene Cheltenham	Dan Lennon
Yee-Ping Cho	Joey Montoya
Andi Choo	Bruce Moore
Jeannie Collini	Rhonda Page
Marcia De Angelis	Greg Pickman
Jim DeLuise	Cindy Ratzlaff
Brian Deputy	Tom Rogers
Loid Der	June Rubin
Kurt DeVinney	Dino Santilli
Nelson Dodge	Ricardo Scozzari
Sue Eck	Sunny Sherder
Mike Ellison	Theresa Shibuya
Nan Faessler	Laurel Shoemaker
Maurene Erbe	Brien Spanier
Jan Gartenberg	Anita Sperling
Chris Gaw	Ross Thompson
Mark Gilmour	Gary Valenti
Sharon Goldberg	Rosalind Vaughn
Laura Gruenther	Pam Verbanatz
Concetta Halstead	Neal Ward
Holly Hampton	Hedi Yamada
Sally Hartman	
Leah Hoffmitz	
Beth Hunter	
Adriane Jach	

The 40th Annual ADLA Awards weekend kicked off Friday, August 15 at the Los Angeles Athletic Club. Energy ran high as team captains directed enthusiastic volunteers, organizing 4,000 entries submitted from all over the country.

Categories for this year's competition included Advertising, Design, Entertainment, and a new category for Editorial which was quite successful.

Jim Cross, one of the competition's 14 nationally acclaimed judges, shared an organizational method learned from his recent AIGA judging experience. This time-saving system, combined with efforts from highly-motivated volunteers, created a well-orchestrated means for dealing with a massive amount of work.

A high point of the weekend was Saturday night's formal dinner at the Athletic Club, followed by dancing at The Rex. The entertainment provided an excellent opportunity for everyone to become better acquainted, and dancing was a great release for the weekend's energy build-up. Somehow we all recovered for the concluding day's intense work.

Show judgings aim at two goals: recognizing the most innovative work being produced, and letting industry members commingle and have fun. We believe both objectives were accomplished, and we look forward to next year's event.

Elaine Johnson
Design

BOOK COMMITTEE
Elaine Johnson
Theresa Shibuya
Becky Tee Ward
Kurt DeVinney
Tim Stedman
Rich Loeffler
Cindy Ratzlaff
Loid Der
Beth Hunter
Tamara Keith
Nelson Dodge
Calvin Chin
Rhondi Staley

This year's book, ADLA:3, is the second full-color, hard bound volume of the Art Directors annual competition. The first such edition, ADLA:2, had provided the learning process for producing such a publication. As a result, this year's annual was completed in about half the time as ADLA:2.

A core group which grew out of last year's book committee was joined by a new group of dedicated volunteers. Each person gave of his and her time, energy and creativity, providing a perfect example of what is meant by the words "team effort."

The ADLA wishes to thank everyone who participated in the making of ADLA:3, from the art directors and designers who entered the competition, to the judges who selected the work and especially to those people listed here.

GEORGE RICE & SONS

This year the ADLA introduces the George Rice and Sons Annual Award.

Recipients of the award will be determined by an impressive selection committee who will honor an outstanding creative talent for his or her achievement and contribution to our profession. The first award will be presented at the 1987 ADLA Awards banquet.

In honor of this award, George Rice & Sons Lithographers has created a permanent endowment that will fund, on an annual basis, a special ADLA scholarship which will be presented each year to an outstanding student art director or designer. This scholarship award will also be presented for the first time at the 1987 ADLA Awards banquet.

Special recognition goes to Gary Hinsche, ADLA Vice President, and Max Goodrich, President of George Rice & Sons, for making these two outstanding additions to ADLA possible.

The selection committee will consist of:
Jack Roberts
Jim Cross
Saul Bass
Jay Chiat
Lou Danziger
Toni Hollander
Gary Hinsche
Max Goodrich

CARLA BARR
Editorial

ROBERT BARRIE
Advertising

ROBERT BEST
Editorial

Carla Barr was educated at both the University of California, Los Angeles and the Art Center College of Design, Pasadena. She graduated with a BFA in Graphic Design.

Throughout her career, Ms. Barr has worked for many highly respected companies. Before beginning work for *Connoisseur* magazine, she was the Associate Art Director for *Life, Rolling Stone* and *Esquire* magazines. She also worked at Push Pin Studio, CBS-Columbia Records, *New York Magazine* and the *New York Times.*

Ms. Barr has been honored with many distinguished awards and her work has been represented in design competitions by the New York Art Directors' Club, the Society of Publication Designers, the American Institute of Graphic Arts, the PhotoGraphis Annual and the Graphis Annual.

Carla Barr is presently the Art Director for *Connoisseur* magazine, where she has worked since 1983.

Robert Barrie joined Fallon McElligott as Art Director in 1983. Mr. Barrie works on accounts such as Control Data Business Advisors, Interline, Lexitel, Continental Illinois Bank, The Minnesota Zoo, MedCenters Health Plan and Prince Spaghetti Sauces.

He has won many prestigious awards from The Clios (The Clio Competition of 1985 brought him five Clios), Communication Arts, The One Show, The Art Directors' Club of New York, the Athena Awards and the Ad Club of New York. Also, in 1985 he was named "Television Art Director of the Midwest" by *Adweek* magazine.

Before Robert Barrie joined Fallon McElligott, he was with Bozell & Jacobs in Minneapolis. At Bozell & Jacobs his accounts included First Bank System, Onan Corporation, Henkel Chemical and Northwestern Bell.

Robert Best is Design Director of *New York Magazine.* He joined *New York Magazine* in 1978 and became an art director in 1981 and Design Director in 1983.

New York Magazine has received numerous awards for magazine design under Mr. Best's direction. The American Society of Magazine Editors, the Magazine Publishers' Association and the Columbia University Graduate School of Journalism honored this magazine with a National Magazine Award for Design. The magazine has received honors from the Society of Publication Designers, the Society of Typographic Designers, the American Institute of Graphic Artists and the International Editorial Design Competition.

Mr. Best teaches editorial design at the School of Visual Arts. He participates annually in the Folio Face-to-Face seminars and has been a judge at the Advertising Art Directors' Club of New York, the Society of Publication Designers and the National Magazine Awards. Before he began his work at *New York Magazine,* Robert Best was with the art staff of *Newsweek.*

Mr. Best is a graduate of the School of Visual Arts at Syracuse University.

MICHAEL BIERUT
Design

BRENT BOUCHEZ
Advertising

JAMES CROSS
Design

Michael Bierut was born in Cleveland, Ohio, and graduated summa cum laude from the University of Cincinnati's College of Design, Architecture, Art and Planning. He joined Vignelli Associated in 1980 and is the Vice President of Graphic Design.

His experience includes work in corporate identity, packaging, advertising and poster design. Mr. Bierut's clients include Artemide, The Architectural League, Federated Department Stores, Kroin Incorporated, Formica Corporation, Ritz-Carlton Hotels, The International Design Center and Santa Cruz Fashions. Magazine and publication design credits include projects for *Skyline, Nation's Business, Equitable Real Estate* and *Time.* Among his real estate development clients are Rudin Management, Madison Equities, Park Tower Realty, The Macklowe Organization and the Edward S. Gordon Company.

Mr. Bierut has taught at the State University of New York at Purchase, and currently serves as Vice President of the New York Chapter of the American Institute of Graphic Arts. His work has been widely published and has received awards from AIGA and the Art Directors' Club. Mr. Bierut's work is also represented in a permanent collection of New York's Museum of Modern Art.

Brent Bouchez is Senior Vice President, Creative Director and Copywriter of Ogilvy & Mather Advertising. Mr. Bouchez worked for Chiat/Day, Inc. and Phillips-Ramsey before he began at Ogilvy & Mather. Some of his clients throughout his career include Pizza Hut, Yamaha Motor Corporation-USA, Porsche Cars-North America, Nike, Pioneer Electronics of America, Mitsubishi Motors, Air California and San Diego Trust & Savings.

Mr. Bouchez studied at Pierce College and the Art Center College of Design. He said he went into advertising because "medical school took too long." He got his first copywriting job at twenty. Now, just nine years later, he's operating as Senior Vice President, Creative Director at Ogilvy & Mather. How'd he do it? "Unlike doctors, I work Wednesdays."

James Cross began his career as a corporate art director for the Rand Corporation and Northrop Corporation after graduating from UCLA's School of Fine Arts in 1956. Mr. Cross taught at UCLA during 1957 to 1963. In 1960 he was elected to the Board of Directors of the International Design Conference in Aspen, Colorado until 1966. He began to design for Saul Bass and Associates in 1963 and opened his own firm, Cross & Associates, that same year. He now has offices in Los Angeles and San Francisco.

Mr. Cross taught graphic design at the Art Center College of Design from 1970 to 1972. He became a member of the Alliance Graphic Internationale and was appointed to the International Executive Committee in 1984. He has served on the Advisory Board of the Art Center College of Design since 1978 and was Director of the AIGA from 1976 to 1979. In 1985 he was chairman of the AIGA Communication Graphics Show. He lectures frequently at universities and professional organizations and has received numerous design awards. These awards came from the New York Art Directors' Club, AIGA, the Society of Typographic Arts, Communication Arts and the Art Directors' Club of Los Angeles. His work has been published in articles for *Graphis, Print, Communication Arts* and *High Q.*

ROD DYER
Entertainment

RICHARD FRANKEL
Entertainment

APRIL GREIMAN
Design

Rod Dyer was born in Pretoria, South Africa. He graduated from Johannesburg Technical College, School of Art and Photography. He immigrated to the United States in the late 1950's to join the New York firm, Gore/Smith/Greenland as an art director. A move to Los Angeles took him to Carson/Roberts Advertising. He stepped from Carson/Roberts to Jerome Gould & Associates as head of graphics to work on numerous supermarket packaging projects and corporate graphics programs. He later headed the graphics department at Charles Eames Office.

As a successful and versatile designer, Mr. Dyer formed Rod Dyer, Inc. in 1967. The company was renamed Dyer/Kahn in 1981. He has many interests including interior design, industrial design and toy design. As a film director he conceptualizes and directs film trailers, television commercials and has finished five MTV rock videos to date.

During his career, Mr. Dyer has been honored by many top awards in advertising and design. Awards for his work have come from the Art Directors' Clubs of New York and Los Angeles, the American Institute of Graphic Arts, The Beldings and *Communication Arts.* In 1982 the Hamano Institute of Tokyo, Japan invited him to exhibit his work in retrospect at Axis Gallery.

Richard Frankel is the Creative Director for A&M Records. He designs all packaging for A&M's record products as well as its advertising design and video production.

Before Mr. Frankel joined A&M Records he was a creative director for MTV Networks in New York. He created graphics and promotions for MTV, the Movie Channel and Nickelodeon cable networks. He was also an art director for CBS Records in New York.

He studied graphic design and serigraphy under Arthur Hoener at Hamshire College in Amherst, Massachusetts. After his graduation Mr. Frankel was a design instructor at Hamshire College and owned his own studio in Massachusetts.

April Greiman is the principal of April Greiman Incorporated located in Los Angeles, California. Ms. Greiman's work has been seen in a wide variety of publications. They include *ArtForum, Time, Wet, Progressive Architecture, Domus, Vogue, A History of Graphic Design* by Phillip Meggs and *An Introduction to Design* by Robin Landa.

She has lectured throughout the country and is represented in the collections of the Cooper-Hewitt Museum, the Library of Congress, the Museum of Modern Art, the Swiss National Print Center and the Gemeentemuseum of the Hague, among others. She was represented as a "One Woman Show" in 1986 at the Reinhold/Brown Gallery. In 1984 Ms. Greiman was awarded the Vesta Award for women who have made a significant contribution to the arts and related industries in Southern California.

Ms. Greiman's professional affiliations are as far-reaching as her accomplishments in the design world. They include the Society of Typographic Arts, the American Institute of Graphic Arts in New York and Los Angeles, the Alliance Graphique Internationale, the Art Directors' Club of Los Angeles and Type Directors' Club in New York.

She received a BFA degree from Kansas City Art Institute in 1970. She did graduate work in 1970-71 at Allgemeine Kuntgewerbeschule, Basel under Armin Hoffman and Wolfgang Weingart.

CLIFF HAUSER
Entertainment

KOSH
Entertainment

SEYMON OSTILLY
Advertising

After graduating from Trinity College in Hartford, Connecticut, Cliff Hauser began his career with Ted Bates Advertising, where he worked for eleven years. While at Ted Bates Advertising, Mr. Hauser worked on various accounts for 20th Century Fox, Paramount, Warner Brothers and Orion Pictures.

Presently, Mr. Hauser is the Vice President of Marketing for the Samuel Goldwyn Company. He has served as the Vice President of Advertising and Publicity for four of Paramount Pictures' network television divisions, and also as Creative Director for 20th Century Fox.

Throughout his career, Mr. Hauser has worked on several significant projects including *Heaven Can Wait, Shogun, Flamingo Kid, Dance with a Stranger, Raiders of the Lost Ark, Grease,* the original *Care Bears* and *Sid and Nancy.*

Kosh became prominent as a designer in the mid-sixties when he designed campaigns for the Royal Ballet and the Royal Opera. By the end of the sixties Kosh was the Creative Director for Apple Corps., a multi-faceted company formed by The Beatles. He designed the infamous "Abbey Road" album cover and many other significant Beatles album covers. This work enabled him to expand to include the cream of British bands and London avant garde of that time.

He was elected to the British Designers & Art Directors Association Jury in 1974 before he moved to Los Angeles. In 1976 Kosh & Co. was formed and he extended his clientele to service major entertainment corporations. He has had many long-time affiliations with people such as Linda Ronstadt, The Eagles, Rod Stewart, James Taylor and Bob Dylan.

Kosh has received numerous awards from the New York and London Art Directors' Clubs. Between 1977 and 1985 he has been nominated for six Grammy Awards and received his third Grammy Award for album cover design in 1985. He is an active member of the Board of Governors of the Academy of Recording Arts & Sciences.

Seymon Ostilly was born and raised in Durban, South Africa and graduated from Advertising & Industrial Design in Durban. Mr. Ostilly has worked with agencies in Durban, Johannesburg and London. He is now based in New York as Vice President, Senior Art Director with Lord, Geller, Federico, Einstein Incorporated.

As Senior Art Director, Mr. Ostilly has worked on accounts for IBM, Burroughs, Oscar de la Renta, Wamsutta, Elizabeth Arden, Contel, Stirling Drug, Hoffman LaRoche, Lenox China/ Jewelry and Wrangler.

His outstanding work has been recognized with numerous awards. Within the last five years he has received the 1981 Silver, 1984 and 1985 Gold award from the New York Art Directors' Club. The One Club (copy club) of New York honored him with their Silver award in 1984.

Seymon Ostilly has lived and worked in New York for the past ten years.

WOODY PIRTLE
Design

JESSICA WEBER
Editorial

Woody Pirtle is President and Creative Director of Pirtle Design, a multi-faceted design firm in Dallas, Texas. Pirtle Design offers graphic consultation and creative services to major corporations, public relations firms and advertising agencies.

Mr. Pirtle has been honored by his peers in local, regional, national and international design competitions. He was named Individual Communicator of the Year by the Art Directors' Club of Houston in 1979, 1981 and received both Individual and Corporate Communicator of the Year in 1982 and 1983. Woody Pirtle was one of fourteen selected nationally for *Adweek*'s 1983 All American Creative Team. He has been consistently represented in annual design competitions by *Communication Arts, Graphis,* the New York Art Directors' Club, the American Institute of Graphic Arts, the Dallas Society of Visual Communications and the Houston Art Directors' Club.

Mr. Pirtle was elected to the Board of Directors of the American Institute of Graphic Arts in 1982 and is one of fifty-two American members of the Alliance Graphique International.

A graduate of Parsons School of Design and New York University, Jessica Weber is currently Executive Art Director of Book-of-the-Month-Club. She directs the design of the company's five monthly magazines and newsletters, record covers and collateral material for its record division plus catalogues for its merchandise division.

Ms. Weber was previously the founding art director of the *International Review of Food & Wine* magazine. She redesigned the magazine when it was acquired by the American Express Publishing Company and re-named it *Food & Wine.*

Awards for her work have come from the New York Art Directors' Club, the Society of Illustrators, the Society of Publication Designers and *Art Direction* magazine.

Ms. Weber has been a member of the faculty of the Parsons School of Design since 1980. She lectures frequently and has served on numerous juries for visual art competitions. She is the President of the Visual Communicators Education Fund of the Art Directors' Club of New York and is a member of the organization's Executive Board. She serves on the Advisory Board of the Department of Illustration at the Fashion Institute of Technology in New York City and is a member of the Board of Directors of the Mercantile Library in New York.

BERNARD REILLY
Library of Congress

This is the second year that the Library of Congress has made selections for its Permanent Collection from the ADLA Competition.

The Art Director's Club of Los Angeles provides one of the two sources in the country utilized by the Library for this purpose.

The Collection's Curator, Mr. Bernard Reilly, returned to Los Angeles to evaluate the entries based on typography and the book arts, including illustration, layout and other visual aspects of printing. He considered not only excellence in design but documentary significance, i.e. how a particular piece (or series) reflects societal values, interests and trends.

As last year, Mr. Reilly noted that building the national collections along these lines enables the Library to provide students, publishers, scholars, filmmakers and the general researchers of every stripe a breadth of resources which is unmatched anywhere else.

You can identify the Library's selections by the ▲ symbols throughout the book.

Year after year, ADLA
is supported by the
generosity of many bus-
inesses. They contribute
money, time, talent,
creativity and moral
support. Once again
we thank all of them
for their superb commit-
ment to our organization
and our profession.

D L A

ART DIRECTOR
Michael Manwaring
DESIGN DIRECTOR
Michael Manwaring
DESIGNER
Michael Manwaring
PHOTOGRAPHER/
ILLUSTRATOR
Michael Manwaring
Paul Chock
AGENCY
The Office of
Michael Manwaring
CLIENT
Heffalump

ART DIRECTOR
Jerry Leibowitz
DESIGN DIRECTOR
Jerry Leibowitz
DESIGNER
Jerry Leibowitz
PHOTOGRAPHER/
ILLUSTRATOR
Jerry Leibowitz
AGENCY
Metroart
CLIENT
Desert Popsicle
Company

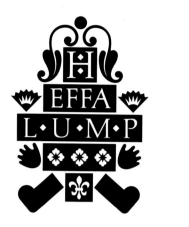

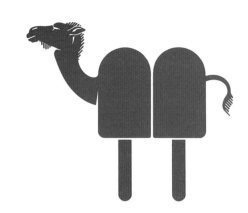

ART DIRECTOR
Tamotsu Yagi
DESIGNER
Tamotsu Yagi
AGENCY
Esprit Graphic Design
Studio
CLIENT
Esprit De Corp.

DESIGN DIRECTOR
Michael Patrick Cronan

DESIGNER
Michael Patrick Cronan
Michael Shea

AGENCY
Cronan Design, Inc.

CLIENT
University of
California,
San Francisco

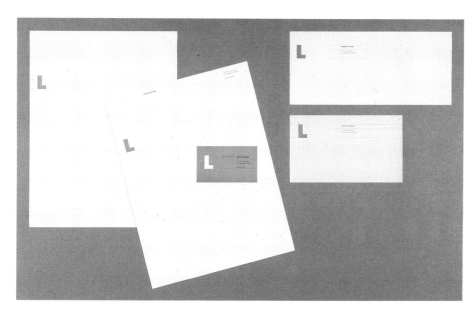

ART DIRECTOR
Leah Toby Hoffmitz

DESIGN DIRECTOR
Leah Toby Hoffmitz

DESIGNER
Leah Toby Hoffmitz

AGENCY
Letterform Design

CLIENT
Letterform Design

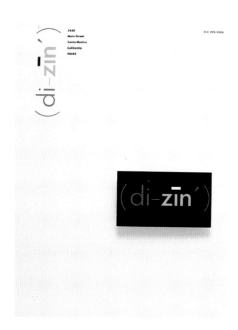

ART DIRECTOR
April Greiman

DESIGN DIRECTOR
April Greiman

DESIGNER
April Greiman

AGENCY
April Greiman Studio

CLIENT
Akbar Alijamshid

ART DIRECTOR
Tom Geismar
DESIGNER
Tom Geismar
*PHOTOGRAPHER/
ILLUSTRATOR*
Alan Shortall
AGENCY
Chermayeff & Geismar
Associates
CLIENT
The Shoshin Society

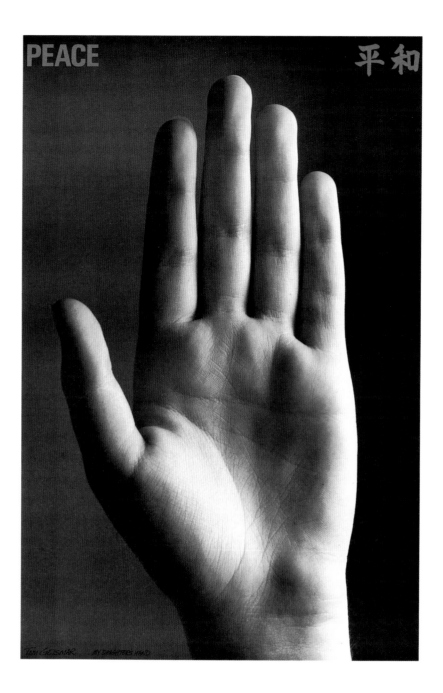

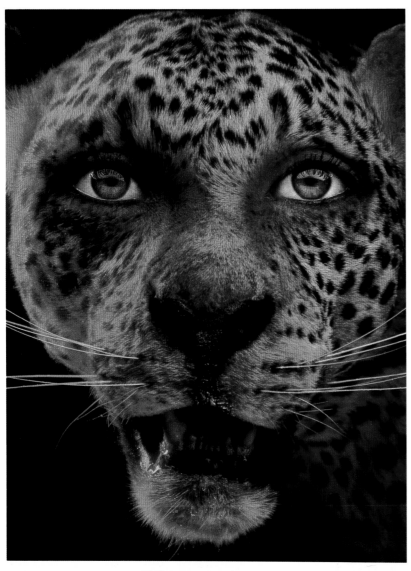

RAVELS

A WILDLY CIVILIZED NIGHTCLUB

For Dancing. For Mingling. Or For Our Happy Hour Buffet. In The Registry Hotel.

ART DIRECTOR
Alan Lidji
DESIGN DIRECTOR
Alan Lidji
DESIGNER
Alan Lidji
WRITER
Mike Kirby
PHOTOGRAPHER/
ILLUSTRATOR
Robert Latorre
AGENCY
Rosenberg & Company
CLIENT
The Registry Hotel

ART DIRECTOR
Stephen Frykholm
Sara Giovanitti

DESIGN DIRECTOR
Stephen Frykholm

DESIGNER
Sara Giovanitti

WRITER
Nancy Green

PHOTOGRAPHER
Bill Lindhout
Kerry Rasikas
Andy Sacks
Brad Trent

AGENCY
Sara Giovanitti Design

CLIENT
Herman Miller Inc.

ART DIRECTOR
Kit Hinrichs

DESIGN DIRECTOR
Kit Hinrichs

DESIGNER
Lenore Bartz
D.J. Hyde

WRITER
Delphine Hirasuna
Kiane Hirasuna

*PHOTOGRAPHER/
ILLUSTRATOR*
Tom Tracy
Phillipe Weisbecke
Sarah Waldron
Regan Dunnick
John Hyatt
Tim Lewis
John Mattos
Will Nelson
Tadashi Ohashi
Hank Osuna
Daniel Pelavin
Colleen Quinn
Susie Reed
Alan Sanders
Ward Schumaker
Duqald Stermer
David Stevenson
Bud Thon
Carolyn Vibbert

AGENCY
Pentagram Design, Ltd.

CLIENT
Chronicle Books

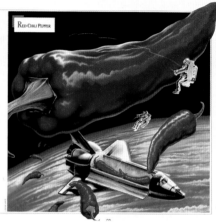

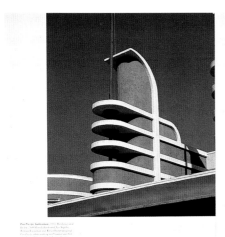

ART DIRECTOR
Robert Petrick
DESIGN DIRECTOR
Robert Petrick
DESIGNER
Robert Petrick
WRITER
Robert Petrick
PHOTOGRAPHER/ ILLUSTRATOR
Tom Vack
Corinne Pfister
AGENCY
Petrick Design
CLIENT
City

the '30s

The Streamline Moderne style of the 1930s in Los Angeles was a contrasting dress rehearsal for the democratic technological future of the 1950s. Even the Great Depression could not completely dampen the élan.

Throughout the depression, the hope of a brighter tomorrow was a popular theme. Advancing technology seemed to offer the most promising road. The evidence of mass production, household appliances, and air travel supported the promise; as a symbol of this new technology, the Streamline Moderne became widely popular.

The smooth Streamline forms carried the eye easily around corners, reducing resistance for efficient movement, a visual metaphor of the reduced wind resistance of streamlined locomotives and airplanes. The teardrop form, its continuous planes submerging individual elements under a single organic shape, became a symbol of the movement, despite the fact it was not, scientifically speaking, the ideal wind-resistant form. It certainly looked like it was, for symbolic purposes of design announcing a new age, that was enough.

Designers were not looking for the scientific fact, they were imagining what invisible forces of speed and energy would look like. In the public mind, streaming lines came to be associated with modern technology. High art critics labeled the Streamline merely cosmetic, but in the public eye its curves relieved some of the austere lines of boxlike Bauhaus modernism.

The Pacific Federation, 1935. Rendering and design. Published/furnished for Angeles Pelham Richardson and Peter Hartnessyce. Produced by administrating art Pomme and the air-designed, Inspiration Schematic 20-15.

Nothing in the East compares with the best things of this sort in Los Angeles.

—Henry-Russell Hitchcock, 1940

THE '30S 19

GOOGIE 18

ART DIRECTOR
Jim Heimann
DESIGN DIRECTOR
David Barich
DESIGNER
Mike Fink
PHOTOGRAPHER/ ILLUSTRATOR
Mike Fink
AGENCY
Jim Heimann Design
CLIENT
Chronicle Books

predicting a hurricane is one thing. Predicting an earthquake is quite another. But since seismologist Charles Richter developed the science of measuring the scale of any earthquake on the planet, a method of prediction has become a scientific probability.

ART DIRECTOR
Kit Hinrichs
DESIGN DIRECTOR
Kit Hinrichs
DESIGNER
Franca Bator
WRITER
Maxwell Arnold
PHOTOGRAPHER
Henrik Kam
Michele Clemen
Terry Heffernan
John Blaustein
ILLUSTRATOR
David Stevenson
Carole Onasch
Antonio Lopez
Gary Overacre
Ward Schumaker
Tanya Stringham
Daniel Pelavin
John Craig
Will Nelson
John Mattos
Douglas Smith
AGENCY
Pentagram Design, Ltd.
CLIENT
Simpson Paper Co.

ART DIRECTOR
Robert J. Post
DESIGN DIRECTOR
Robert J. Post
DESIGNER
Robert J. Post
*PHOTOGRAPHER/
ILLUSTRATOR*
Stephen Shames
AGENCY
Chicago Magazine
CLIENT
Chicago Magazine

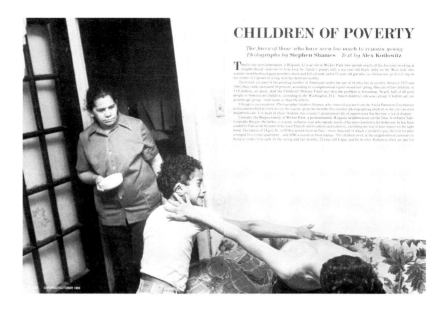

CHILDREN OF POVERTY

*The faces of those who have seen too much to remain young
Photographs by Stephen Shames. Text by Alex Kotlowitz*

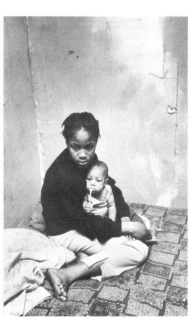

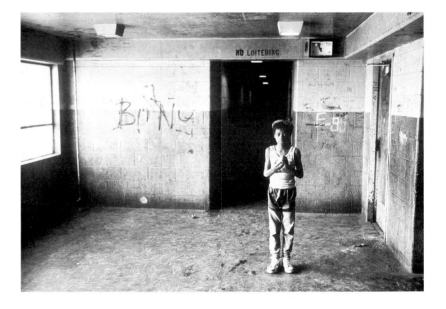

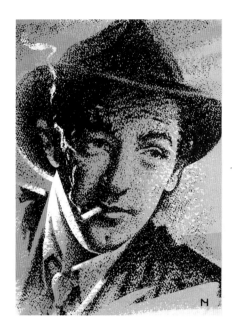

Philip Marlowe, P.I. by Mick Haggerty

FROM THE SIMPLE ART OF MURDER

THE HERO

DOWN THESE MEAN STREETS a man must go who is not himself mean, who is neither tarnished nor afraid. The detective in this kind of story must be such a man. He is the hero, he is everything. He must be a complete man and a common man and yet an unusual man. He must be, to use a rather weathered phrase, a man of honour, by instinct, by inevitability, without thought of it, and certainly without saying it. He must be the best man in his world and a good enough man for any world. I do not care much about his private life; he is neither a eunuch nor a satyr; I think he might seduce a duchess and I am quite sure he would not spoil a virgin; if he is a man of honour in one thing, he is that in all things. ✥ He is a relatively poor man, or he would not be a detective at all. He is a common man or he could not go among common people. He has a sense of character, or he would not know his job. He will take no man's money dishonestly and no man's insolence without a due and dispassionate revenge. He is a lonely man and his pride is that you will treat him as a proud man or be very sorry you ever saw him. He talks as the man of his age talks, that is, with rude wit, a lively sense of the grotesque, a disgust for sham, and a contempt for pettiness. ✥ The story is this man's adventure in search of a hidden truth, and it would be no adventure if it did not happen to a man fit for adventure. He has a range of awareness that startles you, but it belongs to him by right, because it belongs to the world he lives in. If there were enough like him, I think the world would be a very safe place to live in, and yet not too dull to be worth living in. —Raymond Chandler

21

ART DIRECTOR
Rip Georges
DESIGN DIRECTOR
Rip Georges
DESIGNER
Rip Georges
PHOTOGRAPHER/ ILLUSTRATOR
Various
EDITOR
Joie Davidow
AGENCY
LA Style Magazine
CLIENT
LA Style, Inc.

THE FORTIES

The year 1940 brought forth one powerful burst of nightclub activity that would sustain the motion picture colony through its gradual demise in the period following the war. Hollywood, the sleepy suburb of a mere twenty-five years before, was now a town of mythic proportions. The hamlet of silent picture stars had spread out all over the Los Angeles area by the 1940s, and what was referred to as "Hollywood" was really meant to encompass anything having to do with the motion picture industry. Stars had settled down in Bel Air, Brentwood, and the Valley. Studios were established in all directions, from Culver City to Burbank. Spending millions was commonplace.

Two entertainment ventures debuted in January. The first was Casa Mañana, which revamped Frank Sebastian's Cotton Club into a modern dance ballroom. With the demise of the Palomar, Casa Mañana took up the lead, and top bands added it to their agenda as one of the West Coast "musts." Skinnay Ennis opened the place to a hall full of big band devotees, who were still plentiful in the movie colony.

On the Strip, entrepreneur Billy Wilkerson was at it again—this time, planning another legendary showplace of magnificent proportions on the site of the old Club Seville. Ciro's opened at the end of January, 1940, and, as was the case with his other enterprise, it was an instant hit. The stars, abandoning the recent trend of staying home, flocked to Hollywood's

newest in-spot. What greeted them was a sophisticated exterior facade by George Vernon Russell and inside a Baroque confection by interior designer Tom Douglas. Under the supervision of Wilkerson, Mr. Douglas created the latest in Hollywood glamour, with walls draped in heavy ribbed silk, dyed pale rosada green, and a ceiling painted American Beauty red. The stars sunk themselves into walls also of silk, dyed to match the ceiling. Bronze columns and urns served as lighting fixtures that flanked the bandstand. Everywhere, the endless attention of a Wilkerson business was evident. Ads preceding the opening were a daily occurrence in the *Hollywood Reporter*, wherein mailers were reminded that "Everybody that's anybody will be at Ciro's." And pretty much everybody in Hollywood turned up for the two openings on subsequent nights. Emil Coleman's orchestra initiated the bandstand, and it was reported that as a lark a bartender received five shares of Grand National stock. For weeks after the opening, the only place to be was Ciro's. Post-premiere parties, benefits, and birthdays were all celebrated there. Certainly one of the oddest occasions in its early days was a fashion show by a local farmer who paraded models in his expensive pelts accompanied by a live animal with the same fur she wore. Beavers, leopards, and minks got a firsthand view of Hollywood nightlife in the hallowed halls of Ciro's.

The latest hotspot naturally was under surveillance by the leading columnists,

183

ART DIRECTOR
Jim Heimann
DESIGN DIRECTOR
Henry Vizcarra
DESIGNER
Valerie Sutphin
WRITER
Jim Heimann
AGENCY
Ninety Degrees, Inc.
CLIENT
Abbeville

ART DIRECTOR
Rick Boyko
Gary Johns
Andy Dijak
Yvonne Smith
WRITER
Bill Hamilton
Jeff Gorman
Mark Monteiro
PHOTOGRAPHER/
ILLUSTRATOR
Mark Coppos
AGENCY
Chiat/Day
Advertising
CLIENT
Nike, Inc.

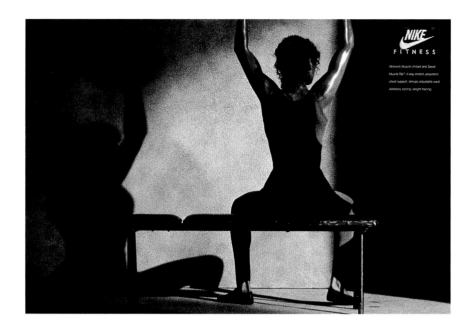

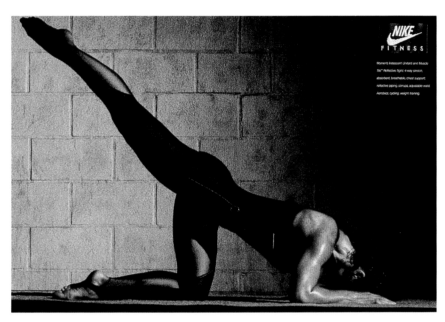

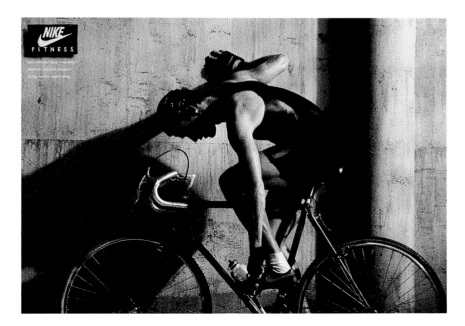

ART DIRECTOR
Jean Robaire
Tom Cordner

WRITER
John Stein
Brent Bouchez

*PHOTOGRAPHER/
ILLUSTRATOR*
Bill Werts
Bob Stevens

AGENCY
Chiat/Day
Advertising

CLIENT
Yamaha Motor Corp.,
U.S.A.

The day touring riders come in out of the rain, so will we.

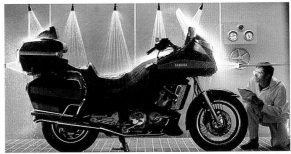

They said the mud in Louisiana could stop an ox. That's all we needed to hear.

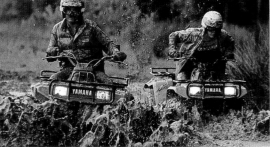

Without an oil-bathed ignition, we couldn't run this three-wheeler. Or this ad.

ART DIRECTOR
Rick Boyko
Marc Chiat
WRITER
Martin Scorsese
John Huston
Ridley Scott
Bill Hamilton
PHOTOGRAPHER/
ILLUSTRATOR
Norman Seeff
AGENCY
Chiat/Day
Advertising
CLIENT
Mitsubishi Electric
Sales America, Inc.

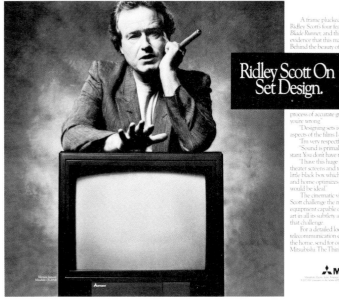

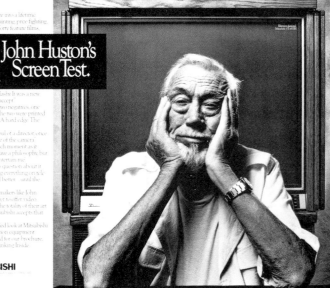

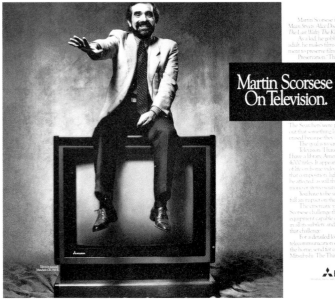

"Tiger Teasie."

 Hamilton Island When an Australian goes on vacation he likes nothing better than to take it easy. If you include Hamilton Island and The Great Barrier Reef on your holiday itinerary, you'll discover how much fun it is to "tiger teasie" Aussie style.

Set amidst the great natural beauty of the Whitsunday Islands, Hamilton Island offers a variety of modern accommodations. Including the Coral Cat, The Great Barrier Reef's first luxury floating hotel.

For information on Hamilton Island and all the other wonders of Australia, order the free 120-page travel guide called Destination Australia. It's yours when you call 1-800-445-3000 and ask for Dept. SG91.

Then come and say g'day. We'll show you how easy it is to have fun.

Australia The Wonder Down Under.

"Orphus Rocker."

When an Australian says someone is "orphus rocker," he means crazy. A pretty fair description of anyone who'd miss the chance to see a land where kangaroos can be road hazards and the opals come as big as your fist.

So what's your excuse for missing the Wonder Down Under?

Attend a performance at the world famous Sydney Opera House. Or be enchanted by an impromptu cockatoo concert from a ghost gum tree. See the terraced Victorian homes of Adelaide. And visit a beach where the dress code is decidedly un-Victorian.

The wonders of Australia are gloriously revealed in the 120-page Destination Australia travel guide. Yours for the taking when you call 1-800-445-3000 and ask for Dept. NYO3.

Then come and say g'day. We're crazy about visitors.

Australia The Wonder Down Under.

"Yeggowan?"

On an Australian Pacific Tour, be ready to answer a few questions. Like "you going" to the Reef, mate? Or "you going" to the Outback?

We're not nosy. It's just that on an Australian Pacific Tour, a lot of the people are Aussies, and they want to make sure you see the real Down Under.

That's why you should travel Australian Pacific Tours. We're the largest coach operator in the country. All our guides and hostesses are Aussies. And fully inclusive tours are available from four days to four weeks, anywhere in the country.

So call for your free Australian Pacific Tours brochure and the free 120-page travel guide called Destination Australia. Just dial 1-800-445-3000 and ask for Dept. F184.

Then come and say g'day. And tell an Aussie where yeggowan.

Australia The Wonder Down Under.

ART DIRECTOR
Ivan Horvath

WRITER
Scott Olson
Mike Kerley

AGENCY
N W Ayer, Inc.

CLIENT
Australian Tourist
Commission

ART DIRECTOR
Yvonne Smith
Jeff Roll

WRITER
Mark Monteiro

*PHOTOGRAPHER/
ILLUSTRATOR*
Lamb & Hall

AGENCY
Chiat/Day
Advertising

CLIENT
Porsche Cars
North America

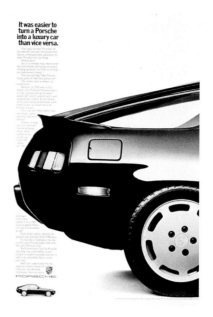

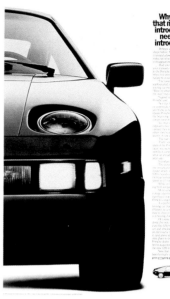

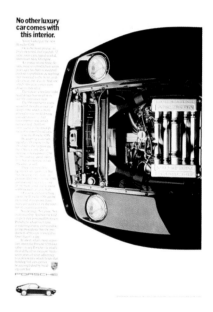

IMAGINE HOW YOU'LL FEEL IF YOU MISS THE MAYA EXHIBITION.

MAYA Treasures of an Ancient Civilization Sept. 7-Nov. 10
Natural History Museum of Los Angeles County, Exposition Park.
For information call (213) 744-MAYA.

A DELAY IN RESERVING TICKETS FOR THE MAYA EXHIBITION COULD LAND YOU IN VERY HOT WATER.

MAYA Treasures of an Ancient Civilization Sept. 7-Nov. 10
Natural History Museum of Los Angeles County, Exposition Park.
For information call (213) 744-MAYA.

APPROXIMATELY 900 YEARS AGO THE MAYA VANISHED. AND THEY'RE ABOUT TO DO IT AGAIN.

MAYA Treasures of an Ancient Civilization Sept. 7-Nov. 10
Natural History Museum of Los Angeles County, Exposition Park.
For information call (213) 744-MAYA.

ART DIRECTOR
Lisa Doan
WRITER
Mike Kerley
AGENCY
N W Ayer, Inc.
CLIENT
Natural History
Museum of LA County
(Public Service)

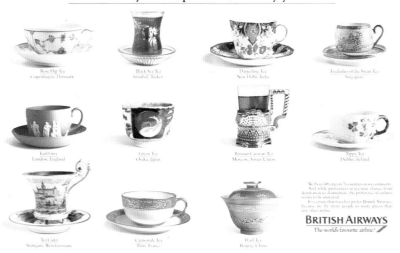

It goes like a bat out of Zuffenhausen.

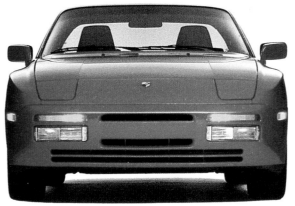

Over the years, our factory in Zuffenhausen has turned out some pretty remarkable engines.

But early in the development of the Porsche 944 Turbo, our engineers set themselves a rather ambitious goal. A 50% increase in horsepower from a 4-cylinder engine that was already one of the biggest, most powerful fours in production anywhere.

The result? A 50% increase in horsepower, of course. From 143 to 217.

Acceleration: 0 to 60 in 6.1 seconds. Top speed: 152 mph. Handling: still what Car and Driver once described as "scalpel sharp."

If you hurry, you can see the 944 Turbo at your authorized Porsche dealer, doing just what we've been talking about. Going fast.

PORSCHE

The Porsche experience begins with your authorized Porsche dealer.
(Dealer Name)

©1986 Porsche Cars North America, Inc.

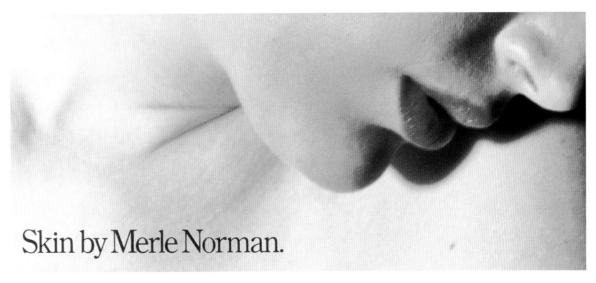

Skin by Merle Norman.

ART DIRECTOR
Jerry Gentile
WRITER
Steve Diamant
PRODUCTION MANAGER
Paul Newman
AGENCY
Doyle Dane Bernbach/
L.A.
CLIENT
Merle Norman

THE DRIVER DOESN'T CARRY CASH. WE DO.

Santa Monica Bank
MEMBER FDIC

ART DIRECTOR
Ivan Horvath
WRITER
Ivan Horvath
AGENCY
N W Ayer, Inc.
CLIENT
Santa Monica Bank

 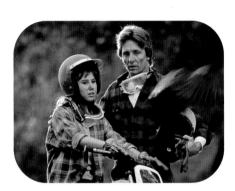

ART DIRECTOR
Tom Cordner
WRITER
Brent Bouchez
AGENCY
Chiat/Day
Advertising
CLIENT
Yamaha Motor Corp.,
U.S.A.

"CHASE"

MUSIC: FAST PACED.

ANNCR: The Yamaha Big Wheels come with extra-wide, extra-stable tires...

...and a low profile that makes them simple to ride. So it's fun and easy to get to places you might not go otherwise.

MOM: So what took you guys so long?

FATHER: (AS HE LOOKS AT DAUGHTER KNOWINGLY) Nothing.

ANNCR: The Yamaha Big Wheels. Perhaps they're the adventure you've been looking for.

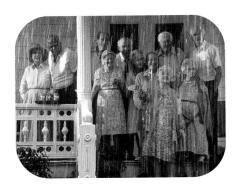 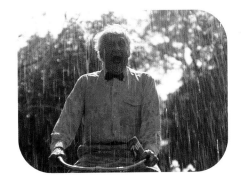 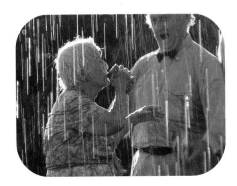

"SUNNY LANE HOME"

COMMERCIAL TAKES PLACE ON THE GROUNDS OF THE SUNNY LANE RETIRE-MENT HOME.

STAFF MEMBER BRINGS OUT A TRAY OF SEVEN-UP FOR RESIDENTS ON A HOT SUNNY DAY.

MUSIC: (UNDER THROUGHOUT.)

WOMAN: Refreshments anyone?

MAN: What do you have in mind?

WOMAN: (SMILES.)

MAN: (OPENS CAN OF SEVEN-UP AS IT STARTS TO RAIN.)

RESIDENTS HAVE A WONDERFUL TIME PLAYING IN THE RAIN AS WE HEAR THE SEVEN-UP JINGLE.

JINGLE: Feels so good comin' down
Feels so good comin' down
Seven-Up splashin' on the fun
Pouring cool and clear on everyone
Seven-Up
Feels so good good good
Seven-Up

ART DIRECTOR
Phil Raskin
Walt Maes
Gary Conroy

DIRECTOR
Leslie Dektor

WRITER
Phil Raskin
Walt Maes

PHOTOGRAPHER/ ILLUSTRATOR
Leslie Dektor

AGENCY
Petermann Dektor Films

CLIENT
Seven-Up

ART DIRECTOR
Tom Cordner
WRITER
Brent Bouchez
AGENCY
Chiat/Day
Advertising
CLIENT
Pizza Hut, Inc.

"COOKING SCHOOL"

MUSIC: "LA BOHEME" ADAPTATION UNDER THROUGHOUT.

SFX: DOG BARKS.

INSTRUCTOR: Parti li funghi Marco—vieni. (Cut the mushrooms Marco—come.)

Ma Vincenzo-che hal fatto qui? (But Vincenzo, what did you do here?)

Ah, buon jiourno, Maestro. Lavore! (Ah! Good morning "Maestro." Work!)

Fatto—Lavora. (Done—Work.)

Pui meglio. Pui meglio. (Even better. Even better.)

No! Che fai? (No! What are you doing?)

Beh! Mettilo, mettilo, mettilo. (Well, put it in, put it in, put it in.)

ANNCR: In Italy there are many...

...ways to make the classic Italian pie.

From blends of fine...

...meats to the best cheeses, even poultry.

Each recipe a closely guarded secret.

INSTRUCTOR: Ah! Piano, piano, piano, piano, bravo. (Ah! Slowly, slowly, slowly, slowly, good job.)

ANNCR: In America...

INSTRUCTOR: Lavora. Lavora. (Work. Work.)

ANNCR: ...there is a special Italian pie.

We call it Priazzo.™

You'll find it...

...baked fresh each day only at Pizza Hut.

INSTRUCTOR: Bravo.

And that's all we intend to tell you.

 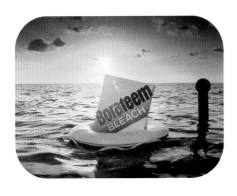

"STOWAWAY"

SFX: (LOW END SYNTHESIZER SOUNDS. WAVES LAPPING. WIND. FOOTSTEPS ON DOCK. HEARTBEATS.)

SFX: (SYNTHESIZER TONE DROPS. BOAT BUMPERS SQUEAKING. FOOTSTEPS STOP. FLASHLIGHT BEAM FLARES LENS. WIND GUSTS. MAN STEPS INTO BOAT.)

SFX: (SYNTHESIZER UNDER. FOOTSTEPS IN BOAT. BATTERY BEING SET DOWN ON STERN COMPARTMENT.)

SFX: (SYNTHESIZER DROPS IN TONE. EXAGGERATED SOUND OF BATTERY DROPPING INTO COMPARTMENT.)

SFX: (SYNTHESIZER RISES IN INTENSITY. EXAGGERATED SOUND OF CABLE MEET- ING TERMINAL.)

SFX: (SYNTHESIZER CACOPHONY INCREASES. EXAGGERATED SOUND OF WING NUT BEING TIGHTENED.)

SFX: (SYNTHESIZER CACOPHONY INCREASES. EXAGGERATED SOUND OF KEY ENTERING IGNITION.)

SFX: (SYNTHESIZER CACOPHONY INCREASES. STRING OF ELECTRONIC SOUNDS SYNCHED TO SONAR.)

SFX: (SYNTHESIZER CACOPHONY NOW VERY LOUD. SOUND OF ENGINE CRANK- ING AND STARTING.)

SFX: (SYNTHESIZER CACOPHONY REACHES PEAK AND SUBSIDES. HIGH PITCHED SOUND SYNCHED TO SPOTLIGHT.)

SFX: (LOW END SYNTHESIZER UNDER. SOUND OF ENGINE IDLING. WIND GUSTS.)

ANNCR: Stowaway. The marine battery.

SFX: (SYNTHESIZER BUILDS TO BELL- LIKE CHORD. ENGINE (IN GEAR) REVS UP AND FADES UNDER SYNTHESIZER CHORD.)

ART DIRECTOR
Peter Coutroulis

DESIGN DIRECTOR
Fred Petermann

WRITER
Howie Krakow

PRODUCTION COMPANY
Petermann / Dekor

AGENCY
DJMC—18th Floor

CLIENT
U.S. Borax

ART DIRECTOR
Jean Robaire
WRITER
John Stein
AGENCY
Chiat / Day
Advertising
CLIENT
Pizza Hut, Inc.

"PACKING"

MOMMA: (IN ITALIAN) I have raised him. I have clothed him. I have fed him. I gave him everything, everything.

SON: Look at Momma, she's beside herself. She found out I had Calizza™ for lunch at Pizza Hut. That wasn't so bad. Then she found out I loved it. That was bad.

They make one with Italian sausage and green peppers and another with five delicious cheeses, just like Momma does.

And it's served in five minutes guaranteed.

ANNCR: Calizza™ Italian turnover. At Pizza Hut.

SON: I can't believe Momma's going.

MOMMA: Momma is not.

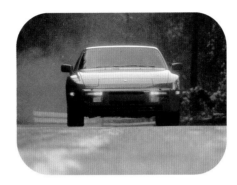

"944 TURBO"

MUSIC: THROUGHOUT.

ANNCR: Imagine you were a car.

SFX: A GENERIC CAR ACCELERATING.

SFX: CONTINUE

ANNCR: What would you be?

SFX: PORSCHE 944 ACCELERATING, WITH-OUT TURBOCHARGER.

ANNCR: You'd be a sports car.

SFX: ENGINE REVS

ANNCR: You'd be quick...

SFX: CONTINUE.

ANNCR: ...Agile.

SFX: CONTINUE.

ANNCR: You'd be...
turbo-charged.

SFX: ENGINE SOUND INCREASES, AMPLI-FIED BY TUNNEL, AS TURBOCHARGER KICKS IN.

ANNCR: And, of course...

ANNCR: ...You'd be a Porsche.

ART DIRECTOR
Jeff Roll
Andy Dijak
WRITER
Dave Butler
AGENCY
Chiat/Day
Advertising
CLIENT
Porsche Cars
North America

ART DIRECTOR
Ken Berris

DESIGN DIRECTOR
Ken Berris (Creative
Director)

WRITER
Ken Berris

PHOTOGRAPHER/
ILLUSTRATOR
River Run

AGENCY
D'Arcy Masius
Benton & Bowles

CLIENT
Van de Kamp's

"VIGNETTES"

ANNCR: Sometimes you want great
Mexican food without all the atmosphere.

WAITRESS: Sangria? Sangria?

WAITER: (OBVIOUSLY NOT MEXICAN)
So, like I'm your waiter Jose.

MARIACHIS: Blaring.

SINGERS: La Cucharacha. La Cucharacha.

WAITRESS: Sangria? Sangria?

WAITER: HOT PLATE! HOT PLATE!

ANNCR: That's why there's Van de Kamp's
Mexican Classics.
Real Jack Cheese.
Shredded beef.
Rich Ranchero sauce.
Van de Kamp's. Great Mexican food...

WAITRESS: Sangria? Sangria?

ANNCR: ...without the atmosphere.

WAITRESS: Or what?

 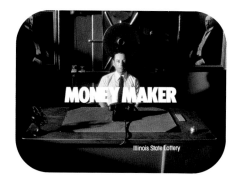

"COWBOY"

What would I do with a million dollars? Me...I'd go West...I'd become a cowboy...I'd get a 10 gallon hat and a big black stallion. I'd ride off into the sunset each night like Hopalong Cassidy. And at the end of the day I'd sit around the campfire with the boys and eat beans and listen to the coyotes play and sing Home On The Range...*(SINGS HOME ON THE RANGE)*

VO: With a million dollars, you can do practically anything you want. So Play Money Maker Instant Lottery.

ART DIRECTOR
Denis Hogen
CREATIVE DIRECTOR
Richard Coad
AGENCY
Bozell, Jacobs,
Kenyon & Eckhardt
CLIENT
Illinois State Lottery

ART DIRECTOR
Jean Robaire
WRITER
John Stein
AGENCY
Chiat/Day
Advertising
CLIENT
Pizza Hut, Inc.

"PIZZA FUN—B REV. #1"

OPEN ON FAMILY SITTING AT TABLE ENJOYING THEIR PIZZA AT PIZZA HUT RESTAURANT.

MOM: Honey wouldn't…a new rug in the den… be just perfect?

CUT TO OUR BOY WHO TAKES A BITE OF PIZZA.

HE CONTINUES TO EAT.

DAD NODS. A WALL IN THE BACK-GROUND OPENS. BOY IS TRANSPORTED IN A FANTASY-LIKE WAY ONTO STAGE IN BACKGROUND.

MUSIC: (UPBEAT PIZZA HUT MUSIC UNDER THROUGHOUT.)

CUT TO KIDS WALKING SINGLE-FILE DRESSED IN HAND COSTUMES.

SINGERS: Pi, Pi, Pizza Hut.

CUT TO KIDS DRESSED AS PIZZA SLICES—THEY JUMP.

SINGERS: Uh oh!

CUT TO BOY CLIMBING LADDER TO DIVING BOARD.

SINGERS: Pi, Pi, Pi, Pi, Pi, Pi, Pizza Hut.

CUT TO BOY STANDING ON BOARD.

CUT TO BOY CLIMBING DOWN LADDER.

SINGERS: Pi, Pi, Pizza Hut.

CUT TO BOY WITH SUITCASE PREPARING TO THROW PIZZA DISCUS.

CUT TO PIZZA SLIDING INTO PAN ON TABLE TOP.

SINGERS: Pizza Hut.

CUT TO BOY SMILING AS HE EATS A SLICE OF PIZZA.

CUT TO GIRL SINGING.

GIRL: Piz-za Hut!

CUT TO KIDS AT TABLE IDENTICALLY DRESSED WHO JUMP UP AND DOWN.

CUT TO BOY TWIRLING AROUND.

CUT TO KIDS AT TABLE DANCING.

SINGERS: Pizza Hut.

CUT TO BOY CONTINUING TO TWIRL.

CUT TO FAMILY SITTING AT TABLE AT PIZZA HUT RESTAURANT. BOY TWIRLS INTO FRAME.

MOM: Let's go back to that…

CUT TO STAGE CURTAIN CLOSING.

SUPER: PIZZA HUT® LOGO.

OUR BOY COMES OUT TWIRLING. THEN BITES SLICE OF PIZZA.

FADE OUT.

"UNIVERSE"

(MUSIC THROUGHOUT)

This is a slice of Pan Pizza. You can tell it's Pan Pizza because I can hold it by the crust and look, gravity is having no effect on it. And yet, I take a bite, it goes right down. It's an incredible universe we live in.

ART DIRECTOR
Doug Patterson

WRITER
Ed Cole

AGENCY
Chiat/Day
Advertising

CLIENT
Pizza Hut, Inc.

ART DIRECTOR
Doug Patterson
WRITER
Steve Kessler
AGENCY
Chiat / Day
Advertising
CLIENT
Pizza Hut, Inc.

"SALAD BAR"

*VIDEO: OPEN ON ROSEANNE BARR
EATING A SLICE OF PIZZA.*

MUSIC: (UNDER THROUGHOUT)

BARR: So my husband says to me, "Roseanne
you've been workin' real hard. How 'bout if we
take the kids out for pan pizza and you can eat
at the salad bar?" So I said, "Well what a great
idea, honey. While you and the kids are eatin'
a hot, steamy, cheesy pizza, I can be off in the
corner grazing on a delightful array of sprouts
and garbanzo beans.

*DISSOLVE TO SUPER:
ROSEANNE BARR*

Get real."

*DISSOLVE TO SUPER:
PAN PIZZA…HOT…STEAMY…CHEESY.*

DISSOLVE TO PIZZA HUT® LOGO.

 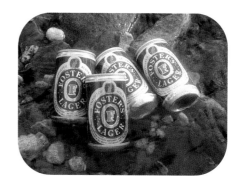

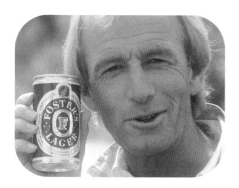

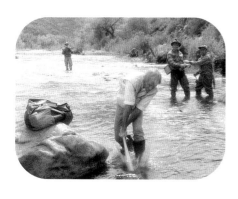 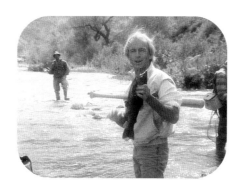

"FISHING"

HOGAN: G'day. Ya know, trout fishing here in the U.S. is a real art form.

The finesse of fly tying. The skill of laying out a perfect cast.

And the chance for a Foster's or two at the end of the day.

SFX: (DROPPING FOSTER'S INTO STREAM)

HOGAN: The golden throat charmer.

Think I'll try the Wombat Haired Waterbug.

Aussie bait. . .and American tackle.

SFX: (BAT HITTING WATER)

SFX: (LAUGHTER IN BACKGROUND)

HOGAN: Good combination, eh?

Foster's. It's Australian for beer, mate.

PRODUCER
Norman Zuppicich
Barry Orell

DIRECTOR
Stu Haggman

PRODUCTION CO.
H.I.S.K. Productions

WRITER
Fishing & Beach:
Jeff Seebeck
Shark Wrestling:
Mike Veach

AGENCY
Diener/Hauser/Bates
Advertising

CLIENT
Carlton United
Breweries - Foster's
Lager

PRODUCER
Norman Zuppicich
Barry Orell

DIRECTOR
Stu Haggman

PRODUCTION CO.
H.I.S.K. Productions

WRITER
Fishing & Beach:
Jeff Seebeck
Shark Wrestling:
Mike Veach

AGENCY
Diener/Hauser/Bates
Advertising

CLIENT
Carlton United
Breweries - Foster's
Lager

"BEACH"

HOGAN: G'day. Typical American beach. Surf, sun...and the kind of scenery that reminds me of home.

Especially when you can top it off with a genuine Foster's.

Tastes like an angel crying on your tongue.
(GIRL GIGGLES.)

HOGAN: As Australian as a bikini on Bondi Beach.
(CROWD CHEERING AND CLAPPING)

HOGAN: The only difference is...we don't chuck our plates around after lunch.
(GIRL GIGGLES)

HOGAN (V.O.): Foster's. It's Australian for beer, mate.

 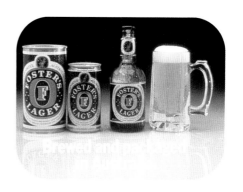

"SHARK WRESTLING"

HOGAN: G'day. America sure is a sporting nation. This one's my favorite over here:

Rap dancing.

SFX: (FOOTBALL GAME IN BACKGROUND)

HOGAN: Course, back home our favorite sport is shark wrestling.

MAN AT BAR: Shark wrestling?

HOGAN: Nothing better than sitting down to a few rounds of man versus hungry white pointer. With a drop of the amber nectar, Foster's.

MAN AT BAR: White pointer?

HOGAN: Yeah. Course, the hard part is getting the sharks into those tight little wrestling shorts.

SFX: (LAUGHTER)

HOGAN (V.O.): Foster's. It's Australian for beer, mate.

PRODUCER
Norman Zuppicich
Barry Orell

DIRECTOR
Stu Haggman

PRODUCTION CO.
H.I.S.K. Productions

WRITER
Fishing & Beach:
Jeff Seebeck
Shark Wrestling:
Mike Veach

AGENCY
Diener/Hauser/Bates
Advertising

CLIENT
Carlton United
Breweries - Foster's
Lager

fifty seven

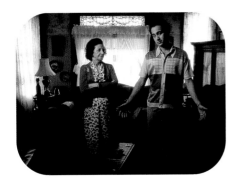 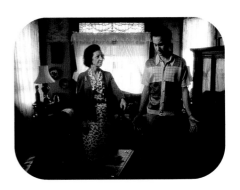

ART DIRECTOR
Jean Robaire
WRITER
John Stein
AGENCY
Chiat/Day
Advertising
CLIENT
Pizza Hut, Inc.

"PACKING"

OPEN ON A LIVING ROOM AS AN APPROXI-MATELY 30-YEAR-OLD MAN TALKS TO THE CAMERA. ON THE COUCH BEHIND HIM HIS MOTHER IS PACKING A SUITCASE, AS SHE MUMBLES IN ITALIAN.

MOMMA: (IN ITALIAN) I have raised him. I have clothed him. I have fed him. I gave him everything, everything.

SON: Look at Momma, she's beside herself. She found out I had Calizza™ for lunch at Pizza Hut. That wasn't so bad. Then she found out I loved it. That was bad.

CUT TO CALIZZA™ BEING PREPARED.

They make one with Italian sausage and green peppers and another with five delicious cheeses, just like Momma does.

CUT BACK TO SON.

And it's served in five minutes guaranteed.

SUPER: GUARANTEE APPLIES 11:30AM TO 1:30PM ON ORDERS OF 5 OR LESS.

CUT TO LOGO.

SUPER: CALIZZA™ FOR LUNCH.

ANNCR: Calizza™ Italian turnover. At Pizza Hut.

SUPER: AVAILABLE AT PARTICIPATING PIZZA HUT® RESTAURANTS.

CUT BACK TO SON. MOTHER HAS CLOSED THE SUITCASE AND IS STANDING BESIDE SON WITH IT. SHE DROPS IT TO THE FLOOR AT SON'S FEET.

SON: I can't believe Momma's going.

MOMMA: Momma is not.

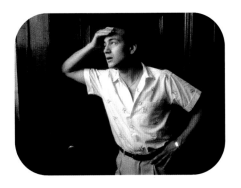

"BEDROOM"

OPEN ON A LIVING ROOM AS AN APPROXIMATELY 30-YEAR-OLD MAN TALKS TO THE CAMERA. HE OCCASIONALLY POINTS TO THE BEDROOM.

SON: As you know, Momma's very upset. She locked herself in the bedroom. Her special Italian turnover…Pizza Hut's now got one for lunch too, Calizza they call it.

MOMMA YELLS IN ITALIAN.

MOMMA: Vivia. (Go away.)

SON: No Momma, I didn't give them the recipe.

CUT TO A CALIZZA BEING PREPARED.

It's got five delicious cheeses, a tomato sauce, even a light crust, just like Momma's.

SUPER: GUARANTEE APPLIES 11:30AM-1:00PM ON ORDERS OF FIVE OR LESS.

And it's served in five minutes, guaranteed.

MOMMA YELLS IN ITALIAN. THROWS SOMETHING AT THE DOOR THAT SHATTERS.

MOMMA: Vivia. (Go away.)

SON: I swear, Momma, I didn't.

CUT TO LOGO.

SUPER: CALIZZA™ FOR LUNCH. PIZZA HUT® LOGO.

ANNCR: Calizza™ Italian turnover. At Pizza Hut.

SUPER: AVAILABLE AT PARTICIPATING PIZZA HUT RESTAURANTS.

CUT BACK TO SON.

SON: She's never comin' out.

HE SMILES.

Hmmm.

ART DIRECTOR
Jean Robaire
WRITER
John Stein
AGENCY
Chiat/Day
Advertising
CLIENT
Pizza Hut, Inc.

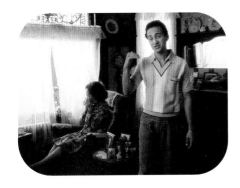
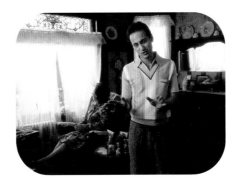

ART DIRECTOR
Jean Robaire
WRITER
John Stein
AGENCY
Chiat/Day
Advertising
CLIENT
Pizza Hut, Inc.

"YOU STILL GOTTA ME"

OPEN ON A LIVING ROOM AS AN APPROXIMATELY 30-YEAR-OLD MAN TALKS TO THE CAMERA. HIS MOTHER SITS IN A CHAIR NEXT TO THE WINDOW CRYING AS SHE STARES OUTSIDE.

SON: My momma's so upset. She found out that her special Italian turnover…Pizza Hut's now got one for lunch, too. Calizza they call it. How they got the recipe, I don't know.

HIS MOTHER TURNS OVER THE PICTURE OF ANGELO.

SON: Maybe my cousin Angelo gave it to 'em.

CUT TO A CALIZZA BEING PREPARED.

SON: It's got sausage and green peppers, a delicious tomato sauce—even a light crust just like Momma's.

CUT TO SON TALKING TO CAMERA. MOMMA IS SNIFFLING IN BACKGROUND.

SON: And they serve it in five minutes—Guaranteed.

SUPER: GUARANTEE APPLIES 11:30AM-1:00PM ON ORDERS OF FIVE OR LESS.

CUT TO SUPER: CALIZZA™ FOR LUNCH. AVAILABLE AT PARTICIPATING PIZZA HUT RESTAURANTS. PIZZA HUT® LOGO.

ANNCR: Calizza Italian turnover. At Pizza Hut.

CUT BACK TO SON.

SON: Momma, they might have a Calizza but you still gotta me.

MOMMA: (CRIES)

"BLIND CHILDREN'S CENTER"

SINGER: I can see clearly now, the rain is gone. I can see all obstacles in my way. Gone are the dark clouds that had me blind. . .Gonna be a bright, bright sunshiney day. Gonna be a bright, bright sunshiney day. Look all around, there's nothing but blue skies. . .look straight ahead nothing but blue skies. . .

ANNCR: With the extra love, care and support of the Blind Children's Center, you'd be amazed at how much a blind child can see.

SINGER: Gonna be a bright, bright sunshiney day.

ART DIRECTOR
Jeff Roll
WRITER
Dave Butler
AGENCY
Chiat/Day
Advertising
CLIENT
Blind Children's Center

ADVERTISING

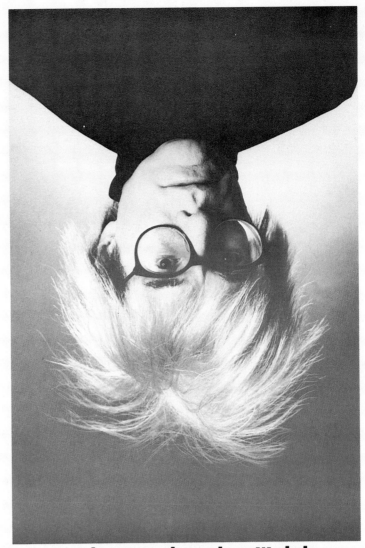

L.A. has a new place to hang Warhol.

The new Los Angeles Museum of Contemporary Art will open in December, 1986.
We, the Partners of California Plaza, feel privileged to donate this building to the people of Los Angeles.
We hope that everyone will have the chance to enjoy its spectacular works of art.

Metropolitan Structures. Cadillac Fairview. Metropolitan Life Insurance Company. Shapell Industries. Goldrich, Kest and Associates. CALIFORNIA PLAZA

Faster than schnell.

The German word for "fast" is "schnell." And the German word for "schnell" has always been "Porsche." Most recently, the Porsche 944. Well, this year, we've given new meaning to the word "schnell." With the Porsche 944 Turbo. If the performance of its normally aspirated cousin can be described as extraordinary, the performance of this machine almost defies description.

Horsepower is up 50%. Top speed is 152. Zero to 60 time is 6.1 seconds. Handling is still what Car and Driver magazine once described as "scalpel sharp."
And if you hurry, you can see the 944 Turbo at your authorized Porsche dealer, doing just what we've been talking about.
Going fast.

PORSCHE

The Porsche experience begins with your authorized Porsche dealer.

© 1986 Porsche Cars North America, Inc.

It goes like a bat out of Zuffenhausen.

Over the years, our factory in Zuffenhausen has turned out some pretty remarkable engines.
But early in the development of the Porsche 944 Turbo, our engineers set themselves a rather ambitious goal. A 50% increase in horsepower from a 4-cylinder engine that was already one of the biggest, most powerful fours in production anywhere.
The result? A 50% increase in

horsepower, of course. From 143 to 217.
Acceleration: 0 to 60 in 6.1 seconds. Top speed: 152 mph. Handling: still what Car and Driver once described as "scalpel sharp."
If you hurry, you can see the 944 Turbo at your authorized Porsche dealer, doing just what we've been talking about. Going fast.

PORSCHE

The Porsche experience begins with your authorized Porsche dealer.
(Dealer Name)

© 1986 Porsche Cars North America, Inc

Something's not kosher in the ham business.

It has recently come to our attention that there has been some flim flam surrounding the sale of our ham. Specifically, when you ask for Boar's Head you may not always be getting it. You may be getting lower priced,

What you see isn't always what you get.

lesser-quality ham instead [the latest twist on the old switcheroo].

At Boar's Head, this makes us extremely unhappy. First, we didn't work for 80 years to gain the reputation as one of the world's great hams, only to have someone pawn off a run-of-the-mill substitute as us. Second, if you are going to pay a little more to get the best, you shouldn't end up with anything less than the best.

Mind you, we don't suspect this bit of delicatessen petty larceny is of epidemic proportions. Most deli owners are decent, hardworking folks like the rest of us. But we have taken some precautions to protect you from those who aren't.

Next time you go in to buy Boar's Head ham, ask the deli man to show you the brand on the ham itself. [Even after the wrapper is off the ham, the Boar's Head brand remains.] Then make sure that the ham he has showed you is the ham that ends up on the slicer.

If the man says it is Boar's Head but won't show you the Boar's Head brand, walk.

A man who cheats you on quality on one thing will certainly do it on others. Then call us at 1-718-456-3600 and let us know who the culprit is. He will soon be an ex-Boar's Head dealer.

Simple as that.

In the ham business, nothing is worse than a few bad eggs.

555-0626

8

In an emergency, which number would be easier for your child to call?

With Contel's Speed Calling your child can make a call by dialing a single digit.

So if he has to reach someone in a hurry, he won't have to waste valuable time dialing a seven digit number. A number he may have trouble remembering.

Speed calling is just one of the custom calling services now offered by Contel.

There's also Call Waiting, Call Forwarding. And Three-Way Calling.

To order Speed Calling, [or any of the other custom calling features] contact your local Contel office. And enjoy the service that makes using a phone child's play.

CONTEL
Continental Telephone System

ART DIRECTOR
Robert Reitzfeld
DESIGN DIRECTOR
Robert Reitzfeld
WRITER
David Altschiller
PHOTOGRAPHER/ ILLUSTRATOR
Robert Ammirati
AGENCY
Altschiller Reitzfeld, Inc.
CLIENT
Boar's Head Provision

NEWSPAPER
ART DIRECTOR
Brian Kelly
WRITER
Jim Schmidt
AGENCY
Bozell, Jacobs, Kenyon & Eckhardt
CLIENT
Contel Telephone

STOP YOUR BELLY ACHING.

Your stomach hurts. Really hurts.

And all the complaining in the world is not going to make it any better.

But we will.

Our pain specialists have had great success helping patients who couldn't find help anywhere else.

If your stomach pain is due to a physical problem, we'll find it and treat it.

If it's related to pressure at work or at home, we'll show you safe, effective ways to cope with stress.

You can put a stop to that pain in your stomach once and for all.

Just use your head.

Call us for a free consultation.

Glendale Adventist Medical Center
Persistent Pain Program
818-242-5959
1509 Wilson Terrace, Glendale, CA 91206

ART DIRECTOR
Bill Snitzer
WRITER
Rick Colby
Mitchell Wein
AGENCY
LarsenColbyKoralek
CLIENT
Glendale Adventist Medical Center

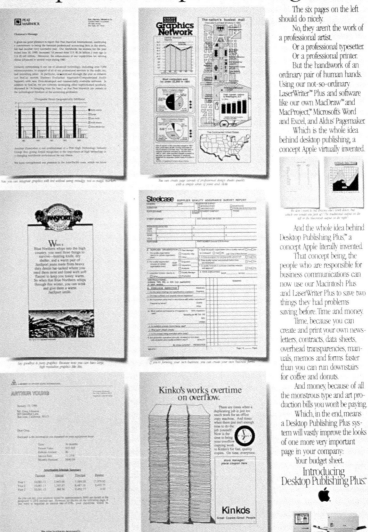

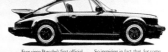

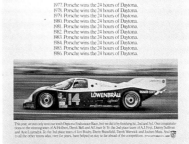

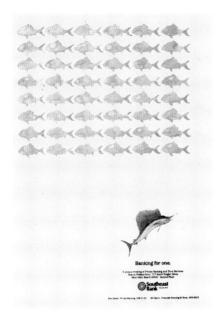

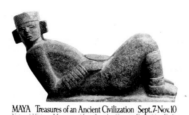

Another way of saying you've arrived.

NEWSPAPER

ART DIRECTOR
Chuck Thomas

DESIGN DIRECTOR
David Rushlow

WRITER
S. Dwork

ILLUSTRATOR
Bill James

AGENCY
Group 3hree
Advertising

CLIENT
SouthEast Bank

ART DIRECTOR
Chuck Thomas

DESIGN DIRECTOR
David Rushlow

WRITER
S. Dwork

ILLUSTRATOR
Bill James

AGENCY
Group 3hree
Advertising

CLIENT
SouthEast Bank

IMAGINE HOW YOU'LL FEEL IF YOU MISS THE MAYA EXHIBITION.

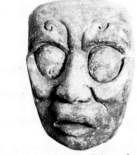

MAYA Treasures of an Ancient Civilization Sept. 7-Nov. 10
Natural History Museum of Los Angeles County, Exposition Park.
For information call (213) 744-MAYA.

APPROXIMATELY 900 YEARS AGO THE MAYA VANISHED. AND THEY'RE ABOUT TO DO IT AGAIN.

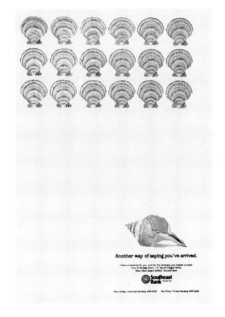

MAYA Treasures of an Ancient Civilization Sept. 7-Nov. 10
Natural History Museum of Los Angeles County, Exposition Park.
For information call (213) 744-MAYA.

ART DIRECTOR
Lisa Doan

WRITER
Mike Kerley

AGENCY
N W Ayer, Inc.

CLIENT
Natural History
Museum of LA County
(Public Service)

A DELAY IN RESERVING TICKETS FOR THE MAYA EXHIBITION COULD LAND YOU IN VERY HOT WATER.

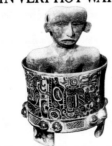

MAYA Treasures of an Ancient Civilization Sept. 7-Nov. 10
Natural History Museum of Los Angeles County, Exposition Park.
For information call (213) 744-MAYA.

ADVERTISING

NEWSPAPER

ART DIRECTOR
Yvonne Smith
Jeff Roll

WRITER
Mark Monteiro

PHOTOGRAPHER/
ILLUSTRATOR
Lamb & Hall

AGENCY
Chiat/Day
Advertising

CLIENT
Porsche Cars
North America

ART DIRECTOR
Steve Beaumont

WRITER
David Lubars

PHOTOGRAPHER/
ILLUSTRATOR
Dan Wolfe
Bo Hylen
Cynthia Shern

AGENCY
Chiat/Day
Advertising

CLIENT
Apple Computer, Inc.

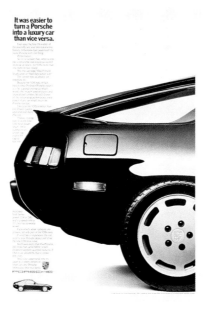

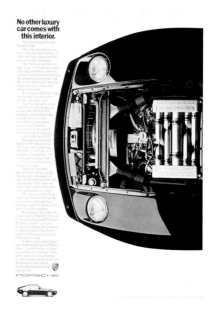

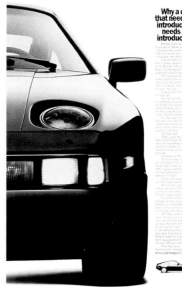

All great revolutions have been started by a single piece of paper.

NOW YOU CAN PUT A TYPEWRITER, WORD PROCESSOR & PRINTER ALL IN THIS SPACE.

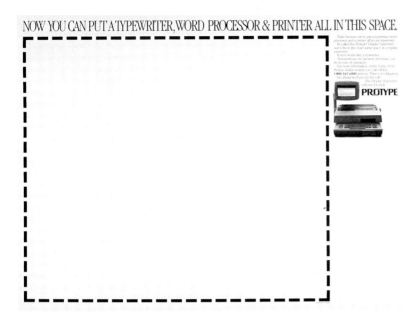

Success hasn't changed this world champion one bit.

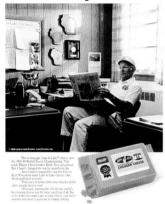

A 40-pound world champion is born in Kiel, Wisconsin every day.

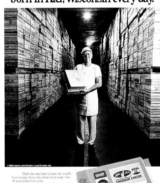

When Lake to Lake won the World Cheese Championship, the factory celebrated like never before.

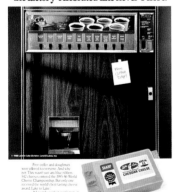

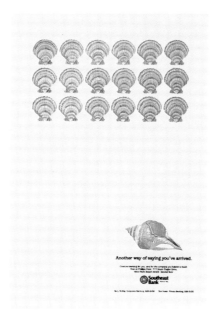

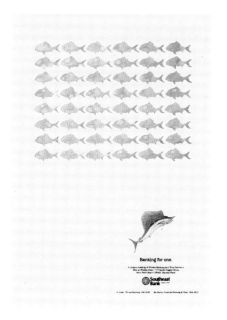

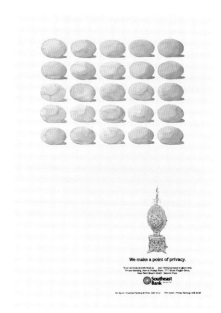

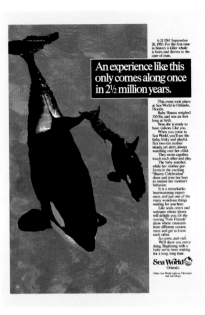

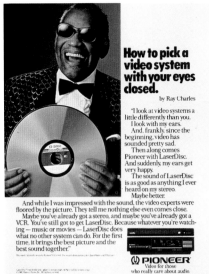

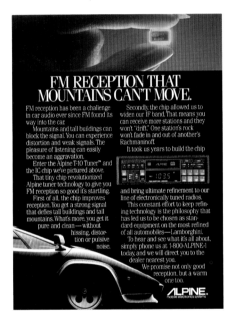

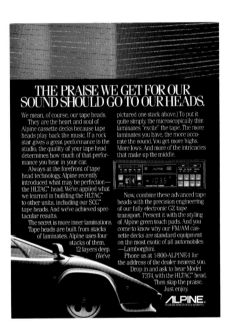

MAGAZINE

ART DIRECTOR
Brent Bouchez
Amy Miyano

WRITER
Brent Bouchez

AGENCY
Chiat/Day
Advertising

CLIENT
Yamaha Motor Corp.,
U.S.A.

ART DIRECTOR
Doug Patterson

WRITER
Ed Cole

AGENCY
Chiat/Day
Advertising

CLIENT
Yamaha Motor Corp.,
U.S.A.

You can start calling it Yamaha Beach, Florida again.

For thirteen years, the winner's circle at Daytona looked more like a Yamaha showroom.

The name appeared on banners, flags, hats and most importantly, the leathers of the guy who stood at the top of the winner's podium.

Thirteen years in a row. Thirteen victories in a row.

And then they changed the rules.

Daytona became a Superbike race instead of a Formula One event.

We had two choices. Complain...or build a great Superbike.

Just one year later, Eddie Lawson and the Yamaha FZ750 made the winner's circle at Daytona Motor Speedway look like home again.

Which proves one thing. If you can't beat 'em, join 'em. And then beat 'em.

YAMAHA
We make the difference.

We ran this ad to brag about our 10th place finish at Daytona.

Heavyweight Superbike Expert Division			
1	Yamaha FZ750	6	Yamaha FZ750
2	Yamaha FZ750	7	Yamaha FZ750
3	Yamaha FZ750	8	Yamaha FZ750
4	Yamaha FZ750	9	Yamaha FZ750
5	Yamaha FZ750	10	Yamaha FZ750

On October 20 at the AMA Sprint Race Championship in Daytona, Yamaha FZ750-mounted Steven Kluge finished 10th in the Heavyweight Superbike Expert Division.

We were ecstatic.

And for good reason. Because the nine riders who crossed the finish line before Steven were also all on Yamahas. Including Tom Mason, who won on his FZ750.

Later that very same day, Tom and his FZ finished second in the Unlimited Superbike Expert Division. We were deliriously happy. Because Danny Walker won that one aboard his FZ750. And right behind Danny and Tom were four more Yamaha riders.

In fact, that was pretty much the way the entire weekend went.

The Middleweight Superbike Expert Division was captured by Kevin Schwantz aboard a Yamaha FJ600. Second, third and fourth also fell to Yamaha riders.

On Saturday, Mark Mastrangelo won the Lightweight Superbike Expert Division. Can you guess what kind of motorcycle he was riding?

Here's a clue. Eight out of the top ten finishers were riding it, too.

If you said Yamaha, we're glad you did. Because if we said it, it would sound too much like bragging.

YAMAHA
We make the difference.

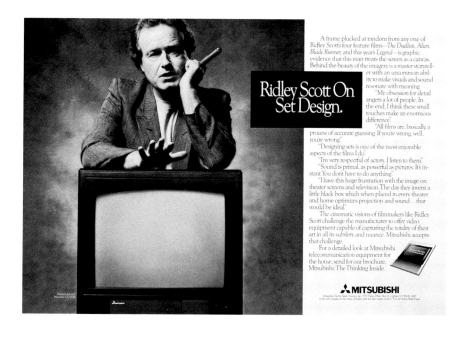

Ridley Scott On Set Design.

A frame plucked at random from any one of Ridley Scott's four feature films—*The Duellists, Alien, Blade Runner,* and this year's *Legend*—is graphic evidence that this man treats the screen as a canvas. Behind the beauty of the imagery is a master storyteller with an uncommon ability to make visuals and sound resonate with meaning.

"My obsession for detail angers a lot of people. In the end, I think these small touches make an enormous difference."

"All films are, basically, a process of accurate guessing. If you're wrong, well, you're wrong."

"Designing sets is one of the most enjoyable aspects of the films I do."

"I'm very respectful of actors. I listen to them."

"Sound is primal, as powerful as pictures. It's instant. You don't have to do anything."

"I have this huge frustration with the image on theater screens and television. The day they invent a little black box which when placed in every theater and home optimizes projection and sound...that would be ideal."

The cinematic visions of filmmakers like Ridley Scott challenge the manufacturer to offer video equipment capable of capturing the totality of their art in all its subtlety and nuance. Mitsubishi accepts that challenge.

For a detailed look at Mitsubishi telecommunication equipment for the home, send for our brochure, Mitsubishi: The Thinking Inside.

MITSUBISHI

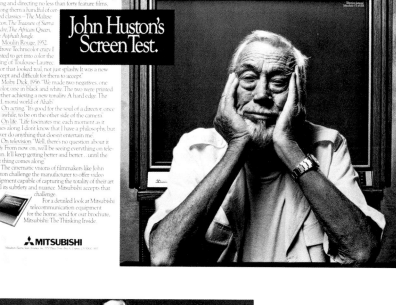

John Huston's Screen Test.

John Huston has packed more into a lifetime than a half dozen men. Writing, painting, prize fighting, acting and directing no less than forty feature films, among them a handful of certified classics—*The Maltese Falcon, The Treasure of Sierra Madre, The African Queen, The Asphalt Jungle.*

Moulin Rouge, 1952. "...drove Technicolor crazy. I wanted to get into color, the feeling of Toulouse-Lautrec. Color that looked real, not just splashy. It was a new concept and difficult for them to accept."

Moby Dick, 1956. "We made two negatives, one in color, one in black and white. The two were printed together achieving a new tonality. A hard edge. The hard, moral world of Ahab."

On acting: "It's good for the soul of a director, once and awhile, to be on the other side of the camera."

On life: "Life fascinates me, each moment as it comes along. I don't know that I have a philosophy, but I never do anything that doesn't entertain me."

On television: "Well, there's no question about it really. From now on, we'll be seeing everything on television. It'll keep getting better and better...until the next thing comes along."

The cinematic visions of filmmakers like John Huston challenge the manufacturer to offer video equipment capable of capturing the totality of their art in all its subtlety and nuance. Mitsubishi accepts that challenge.

For a detailed look at Mitsubishi telecommunication equipment for the home, send for our brochure, Mitsubishi: The Thinking Inside.

MITSUBISHI

Martin Scorsese On Television.

Martin Scorsese is challenging. Like his pictures. *Main Street, Alice Doesn't Live Here Anymore, Raging Bull, The Last Waltz, The King of Comedy.*

As a kid, he gobbled up films like popcorn. As an adult, he makes films, collects films, and leads the movement to preserve films.

Preservation: "The idea is to raise the consciousness of the studios, to make them realize that with the advent of cable, they had to start preserving their stuff. Even the stuff they think is no good. You can't make a value judgement. The old pictures that you think are no good, very often are 10 years later the most influential. Classics like Psycho and The Searchers were panned in their own time. I found out that something like 20 years of Johnny Carson were erased because they needed the space.

The goal is to save everything.

Television: "I have TV on all the time, in every room. I have a library, American directors, obscure films, maybe 4,000 titles. It appears that my own films may have more of a life on home video than in the theater. This means that composition, lighting, size of people in the frame will be affected, as will the choice of black and white or color, mono or stereo sound.

You have to be sure what you want to say will have as full an impact on the small screen as on the big screen."

The cinematic visions of filmmakers like Martin Scorsese challenge the manufacturer to offer video equipment capable of capturing the totality of their art in all its subtlety and nuance. Mitsubishi accepts that challenge.

For a detailed look at Mitsubishi telecommunication equipment for the home, send for our brochure, Mitsubishi: The Thinking Inside.

MITSUBISHI

MAGAZINE

ART DIRECTOR
Rick Boyko
Marc Chiat

WRITER
Bill Hamilton
Ridley Scott

PHOTOGRAPHER/
ILLUSTRATOR
Norman Seeff

AGENCY
Chiat/Day
Advertising

CLIENT
Mitsubishi Electric
Sales America, Inc.

ART DIRECTOR
Rick Boyko
Marc Chiat

WRITER
Bill Hamilton
John Huston

PHOTOGRAPHER/
ILLUSTRATOR
Norman Seeff

AGENCY
Chiat/Day
Advertising

CLIENT
Mitsubishi Electric
Sales America, Inc.

ART DIRECTOR
Rick Boyko
Marc Chiat

WRITER
Bill Hamilton
Martin Scorsese

PHOTOGRAPHER/
ILLUSTRATOR
Norman Seeff

AGENCY
Chiat/Day
Advertising

CLIENT
Mitsubishi Electric
Sales America, Inc.

ADVERTISING

MAGAZINE

ART DIRECTOR
Todd McVey

WRITER
Cameron Day

*PHOTOGRAPHER/
ILLUSTRATOR*
Barry Jackson

AGENCY
Hamilton Advertising

CLIENT
Politix

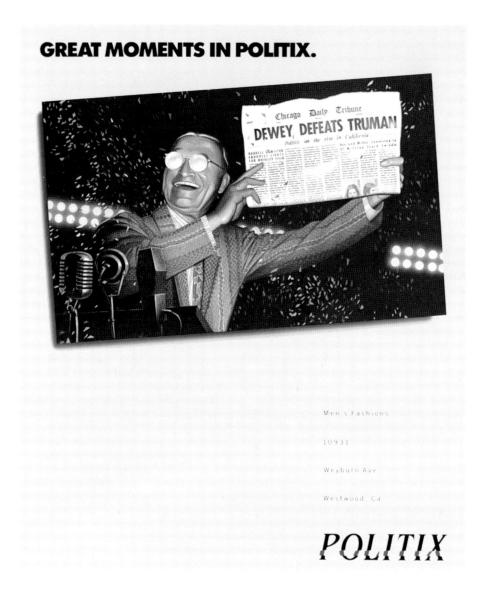

ART DIRECTOR
Michael Arola

WRITER
Michael Arola

PHOTOGRAPHER
Bob Grigg

AGENCY
Cochrane Chase,
Livingston

CLIENT
Pirelli Tire Corp.

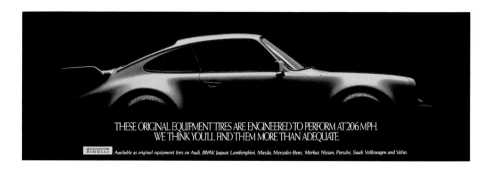

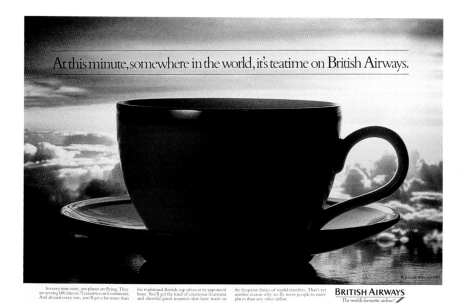

At this minute, somewhere in the world, it's teatime on British Airways.

In every time zone, our planes are flying. They are serving 148 cities in 71 countries on 6 continents. And aboard every one, you'll get a lot more than the traditional British cup of tea at its appointed hour. You'll get the kind of courteous treatment and cheerful good manners that have made us the frequent choice of world travelers. That's yet another reason why we fly more people to more places than any other airline.

BRITISH AIRWAYS
The world's favourite airline.

MAGAZINE

ART DIRECTOR
Charlie Abrams

DESIGN DIRECTOR
David Herzbrun
Charlie Abrams

WRITER
David Herzbrun

PHOTOGRAPHER/
ILLUSTRATOR
Onofrio Paccione

AGENCY
Saatchi & Saatchi
Compton Inc.

CLIENT
British Airways

Without an oil-bathed ignition, we couldn't run this three-wheeler. Or this ad.

We realize that the chances of finding anyone riding a three-wheeler 30 feet below the surface of the Pacific Ocean are slim.

But the fact that this Yamaha could operate in this environment says that we do things just a little differently.

We don't test our machines in the warmth and comfort of a test lab because, chances are, you won't ride our machines in a test lab.

So we get off the beaten track. To places you wouldn't go, like the bottom of the Pacific Ocean. And to places you would go, like the Deep South.

Not to a hotel or a campground, but into the bayou. Where you'll find some of the thickest mud in the world. The most tortuous sand in the world. And, most of all, swamps. Miles and miles of swamps. So much water that you can't ride more than a minute or two without being up to your axles (or worse) in brown H2O. Not to mention snakes or gators.

Not the kind of place you want to break down. So it didn't take long for our engineers to invent a way to keep our three-wheelers from falling prey to the most common killer of machines ridden in the wet. Water in the ignition system.

The cure: Oil-bathed ignition. A theory based on the fact that oil and water don't mix. So it follows that if you put a barrier of oil between the ignition and the water, the water will stay out and the ignition will stay dry.

So much so that Three-Wheeling magazine recently heralded Yamaha's three-wheelers as the most waterproof the industry has to offer.

Out of our rather unorthodox testing facilities have come a whole family of machines. Each one improved year after year. This year's Tri-Z250, for example, now has a six-speed transmission for faster acceleration and even more top speed than last year's model.

And to handle that extra speed, we've also added lower profile tires that slide easier in the corners.

On the other hand, our YTM225DR and our kids three-wheeler, the Tri-Zinger 60, have only minor changes. The 225 does have a new paint scheme that matches the machine's reputation as the "Cadillac" of three-wheelers. But for the most part we've left these two proven machines well enough alone.

That's another thing the swamps can teach you. If it works, don't fix it.

Tri-Z250
YTM225DR

Tri-Zinger

YAMAHA
We make the difference.

ART DIRECTOR
Tom Cordner

WRITER
Brent Bouchez

PHOTOGRAPHER/
ILLUSTRATOR
Bob Stevens

AGENCY
Chiat/Day
Advertising

CLIENT
Yamaha Motor Corp.,
U.S.A.

NIKE
FITNESS

Women's Muscle Unitard and Sweat

Muscle Tex™, 4 way stretch, absorbent, sheer support, stirrups, adjustable waist

Aerobics, cycling, weight training

ART DIRECTOR
Rick Boyko
Gary Johns
Andy Dijak
Yvonne Smith

WRITER
Bill Hamilton
Jeff Gorman
Mark Monteiro

AGENCY
Chiat/Day
Advertising

CLIENT
Nike, Inc.

MAGAZINE

ART DIRECTOR
Tracy Wong

DESIGN DIRECTOR
Ross Sutherland

DESIGNER
Tracy Wong

WRITER
Mike LaMonica

PHOTOGRAPHER/
ILLUSTRATOR
Chuck LaMonica

AGENCY
Ogilvy & Mather/NY

CLIENT
Owens-Corning
Fiberglas

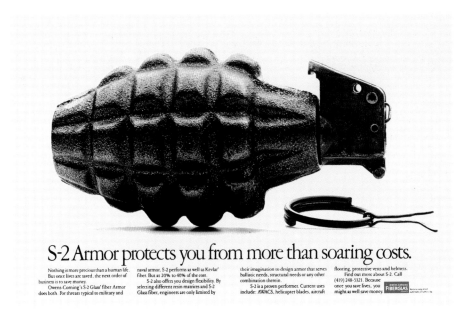

S-2 Armor protects you from more than soaring costs.

Nothing is more precious than a human life. But once lives are saved, the next order of business is to save money.

Owens-Corning's S-2 Glass' fiber Armor does both. For threats typical to military and naval armor, S-2 performs as well as Kevlar' fiber. But at 20% to 40% of the cost.

S-2 also offers you design flexibility. By selecting different resin matrices and S-2 Glass fiber, engineers are only limited by

their imagination to design armor that serves ballistic needs, structural needs or any other combination therein.

S-2 is a proven performer. Current uses include: AWACS, helicopter blades, aircraft

flooring, protective vests and helmets.
Find out more about S-2. Call (419) 248-5321. Because once you save lives, you might as well save money. **OWENS CORNING FIBERGLAS**

ART DIRECTOR
Susan Casey

DESIGNER
Nancy Manfredi

WRITER
Dave Goldenberg

PHOTOGRAPHER/
ILLUSTRATOR
Peter Lavery

AGENCY
Anderson & Lembke

CLIENT
Masonite

Brideshead Redecorated.

ART DIRECTOR
Rick Boyko
Gary Johns
Andy Dijak
Yvonne Smith

WRITER
Bill Hamilton
Jeff Gorman
Mark Monteiro

PHOTOGRAPHER/
ILLUSTRATOR
Mark Coppos

AGENCY
Chiat/Day
Advertising

CLIENT
Nike, Inc.

They said the mud in Louisiana could stop an ox. That's all we needed to hear.

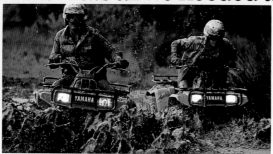

There's an area in Southern Louisiana known as Cameron Parish. Fifteen or so miles from Lake Charles, just down the road from Hackberry.

The area isn't known for much. Water moccasins perhaps, mosquitoes definitely, and mud. The thickest, slickest, slimiest, tackiest mud you'll find anywhere. "Gumbo mud" they call it.

It was here, in 1982, our engineers came with their four-wheelers to do a little experimenting. After all, if our machines could handle Cameron Parish, they could handle just about anything.

They did. And our engineers learned a lot in the process. How, for example, to build machines with real horsepower. Honest to goodness, eyeball-jerking horse-power. The kind that give Yamaha the best power-to-weight ratios in the industry.

We learned the importance of building our machines with shaft drive. Not just our top of the line YFM225 and YFM200DX, but our YF60 and YFM80 as well.

We learned the need for using labyrinth seals to keep our wheel bearings working perfectly—even in the incredibly fine, Louisiana sand.

And we learned how to build the most waterproof four-wheelers in the industry. Something we accomplished by pioneering oil-bathed ignitions. And something everyone else has since picked up on.

But perhaps the most important thing we learned was the importance of learning. Not just how to build one or even two four-wheelers, but how to build a family of four-wheelers.

Machines which would be constantly improved as Yamaha—and Cameron Parish—sees fit.

This year's YFM200DX, for example, is sportier than ever. Thanks to something extra we're now putting between the 200DX and its wheels.

Springs. Or more accurately, a full suspension using a swing axle with 70mm of travel up front and a race-proven Monoshock with 110mm of travel at the rear.

All in all, it's one of the two finest dual-purpose four-wheelers made. The other being our YFM225. A vehicle equipped with the only ten-speed dual-range transmission in its class. As well as an 8-1/2 foot turning radius. Again, the best in its class.

There's one final thing to consider, one more point we'd like to make. What you see here is the finest line of four-wheelers in the world.

But only 'til next year, when we go back to Cameron Parish. And take another lesson from the water moccasins, the mosquitoes, and of course, the mud.

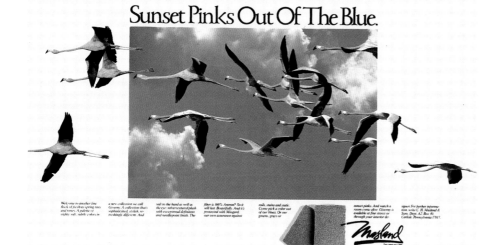

Our YFM200DX has a full suspension incorporating a swing axle and rear Monoshock.

This year's YF80 comes with front and rear lights. And a wide choice of colors.

Our YF60 features an adjustable throttle limiter and a rear-mounted kitchen switch.

YAMAHA
We make the difference.

Sunset Pinks Out Of The Blue.

Welcome to another line flock of pin-has-spring rises and tones. A palette of eighty soft, subtle colors in a new collection we call Giverny. A collection that's sophisticated, stylish, teasingly different. And soft to the hand as well as the eye: velvet textured plush with exceptional definition and needlepoint finish. The fiber is 100% Anstron® So it will last. Beautifully. And it's protected with Masgard, our own assurance against soils, stains and static. Come pick a color out of our blues. Or our greens, grays or sunset pinks. And watch a room come alive. Giverny is available at fine stores or through your interior de-signer. For further information, write C. H. Masland & Sons, Dept. A2, Box 40, Carlisle, Pennsylvania 17013.

Masland
Fine carpets since 1866

MAGAZINE

ART DIRECTOR
Jean Robaire
Tom Cordner

WRITER
John Stein
Brent Bouchez

PHOTOGRAPHER/
ILLUSTRATOR
Bill Werts

AGENCY
Chiat/Day
Advertising

CLIENT
Yamaha Motor Corp.,
U.S.A.

ART DIRECTOR
Dick Henderson

DESIGNER
Dick Henderson

WRITER
Jim Cole

PHOTOGRAPHER/
ILLUSTRATOR
Eric Henderson

AGENCY
Cole Henderson Drake,
Inc.

CLIENT
Masland Carpets

MAGAZINE

ART DIRECTOR
Rick Boyko
Gary Johns
Andy Dijak

WRITER
Bill Hamilton
Jeff Gorman
Mark Monteiro

*PHOTOGRAPHER/
ILLUSTRATOR*
Mark Coppos

AGENCY
Chiat/Day
Advertising

CLIENT
Nike, Inc.

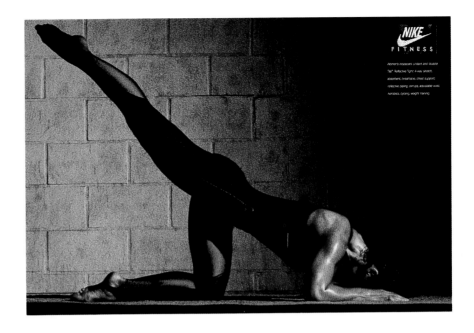

ART DIRECTOR
Doug Levin

WRITER
David Herzbrun

PHOTOGRAPHER
Onofrio Paccione

AGENCY
Saatchi & Saatchi
Compton Inc.

CLIENT
British Airways

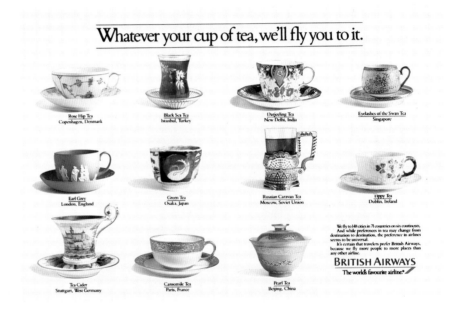

ART DIRECTOR
Jean Robaire
Tom Cordner

WRITER
John Stein
Brent Bouchez

*PHOTOGRAPHER/
ILLUSTRATOR*
Bill Werts

AGENCY
Chiat/Day
Advertising

CLIENT
Yamaha Motor Corp.,
U.S.A.

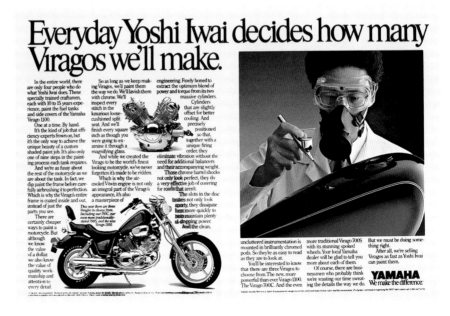

MAGAZINE

ART DIRECTOR
John Porter

WRITER
Jim Offerman

PHOTOGRAPHER/
ILLUSTRATOR
Tom Bach/Marvy!

AGENCY
DBK&O, Inc.

CLIENT
GNB Incorporated

The acid test.

Only one battery can pass it. Stowaway.™ It won't spill, leak, or corrode. And it will never need maintenance. What's more, Stowaway is the most potent combination of deep-cycle and cranking power you can buy. For the dealer nearest you, call 1-800-447-1700.

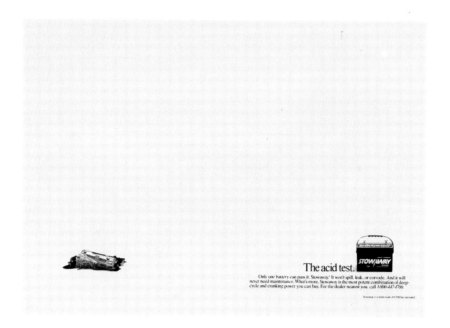

Porsches change. What makes them Porsches doesn't.

What is it about a decades-old Porsche that makes it so very desirable—even with the $15,000-plus price tag such a car is more likely to command these days? Horsepower? Handling? Top speed? None of the above.

Its true value lies in the total commitment of two uncompromising men to build cars that would be more than simply a means of getting from one place to another. Cars that would be a joy to drive. Cars like no one else had ever built. Or ever would.

This commitment has been passed on successfully—some might say miraculously—to the uncompromising people who build Porsches today.

The workers on the Zuffenhausen assembly line who, in their off-hours, have been known to grab their friends, point at a passing Porsche and say with genuine pride, "That's one of mine."

The quality control technicians—one for every ten production workers—whose goal is to take the ideal of "zero defects" and make it a daily reality.

And, of course, the engineers at our R&D facility at Weissach.

For them, the pursuit of excellence will never fit comfortably between the hours of 8 and 5. Or within the theoretical vacuum of an air-conditioned office.

For them, theories have value only on the inside of a Porsche, at speed, on the Weissach test track—preferably with one of them behind the wheel.

The results of their labors, and the extent of their success, is reflected in the procession of cars you see below.

From the first recorded Porsche win on July 11, 1948 at Innsbruck to the most recent victory at Le Mans, these cars have dominated the racing circuits of a world that loves fast cars.

As they have dominated the highways, turnpikes, interstates, autobahns, city streets and winding back roads of a world that loves to drive them.

ART DIRECTOR
Jeff Roll

WRITER
Dave Butler

PHOTOGRAPHER/
ILLUSTRATOR
Lamb & Hall
Richard Leech

AGENCY
Chiat/Day
Advertising

CLIENT
Porsche Cars
North America

MAGAZINE

ART DIRECTOR
Charlie Abrams

DESIGN DIRECTOR
David Herzbrun
Charlie Abrams

WRITER
David Herzbrun

*PHOTOGRAPHER/
ILLUSTRATOR*
Onofrio Paccione

AGENCY
Saatchi & Saatchi
Compton Inc.

CLIENT
British Airways

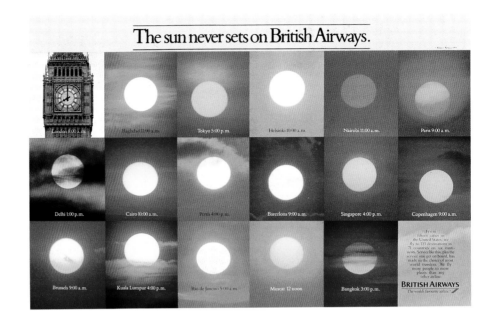

ART DIRECTOR
Doug Patterson

WRITER
Ed Cole

*PHOTOGRAPHER/
ILLUSTRATOR*
Dave LeBon

AGENCY
Chiat/Day
Advertising

CLIENT
Yamaha Motor Corp.,
U.S.A.

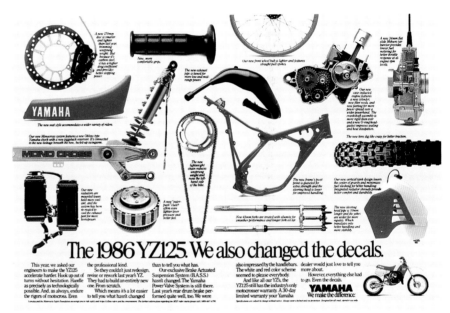

Special delivery. An empty mailbox at the end of the drive. On a day like this, the mail could wait. For there was food in the pantry and heat in the house.

As long as winters keep coming, so will Philgas.

Clearing a path. That was your job when the thick blanket came. You had a part to play in every snow. As sure as the hay in the barn and heat in the house.

As long as winters keep coming, so will Philgas.

MAGAZINE
CAMPAIGN

CREATIVE DIRECTOR
Frank Rizzo

CREATIVE DIRECTOR
WRITER
Neil Scanlan

AGENCY
Tracy-Locke

CLIENT
Phillips

"Tiger Teasie."

"Orphus Rocker."

Hamilton Island When an Australian goes on vacation he likes nothing better than to take it easy. If you include Hamilton Island and The Great Barrier Reef on your holiday itinerary, you'll discover how much fun it is to "tiger teasie" Aussie style.

Set amidst the great natural beauty of the Whitsunday Islands, Hamilton Island offers a variety of modern accommodations. Including the Coral Cat, The Great Barrier Reef's first luxury floating hotel.

For information on Hamilton Island and all the other wonders of Australia, order the free 120-page travel guide called Destination Australia. It's yours when you call 1-800-445-3000 and ask for Dept. SG91.

Then come and say g'day. We'll show you how easy it is to have fun.

Australia The Wonder Down Under.

When an Australian says someone is "orphus rocker," he means crazy. A pretty fair description of anyone who'd miss the chance to see a land where kangaroos can be road hazards and the opals come as big as your fist.

So what's your excuse for missing the Wonder Down Under?

Attend a performance at the world famous Sydney Opera House. Or be enchanted by an impromptu cockatoo concert from a ghost gum tree. See the terraced Victorian homes of Adelaide. And visit a beach where the dress code is decidedly un-Victorian.

The wonders of Australia are gloriously revealed in the 120-page Destination Australia travel guide. Yours for the taking when you call 1-800-445-3000 and ask for Dept. NYO3.

Then come and say g'day. We're crazy about visitors.

Australia The Wonder Down Under.

ART DIRECTOR
Ivan Horvath

WRITER
Scott Olson
Mike Kerley

AGENCY
N W Ayer, Inc.

CLIENT
Australian Tourist
Commission

"Yeggowan?"

On an Australian Pacific Tour, be ready to answer a few questions. Like "you going" to the Reef, mate? Or "you going" to the Outback?

We're not nosy. It's just that on an Australian Pacific Tour, a lot of the people are Aussies, and they want to make sure you see the real Down Under.

That's why you should travel Australian Pacific Tours. We're the largest coach operator in the country. All our guides and hostesses are Aussies. And fully inclusive tours are available from four days to four weeks, anywhere in the country.

So call for your free Australian Pacific Tours brochure and the free 120-page travel guide called Destination Australia. Just dial 1-800-445-3000 and ask for Dept. F184.

Then come and say g'day. And tell an Aussie where yeggowan.

Australia The Wonder Down Under.

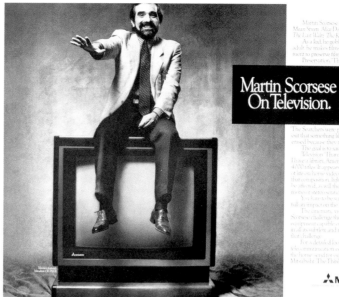

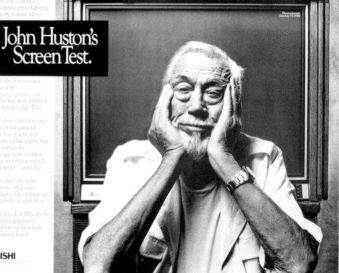

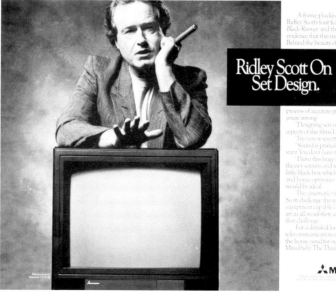

TOYO. WHEN THE ROAD THROWS YOU FOR A LOOP.

If you don't want hairpins to whip you in circles, try Toyo 600 series high performance radials. An SCCA winning streak proves they're race-hot. The 130 mph treads show you why. Their High Filler bead responds with predictable precision. And Toyo's Turbine Blade Slits give you wet road control. See Yellow Pages for your nearest Toyo dealer.

TOYO TIRES
DRIVEN TO PERFORM

TOYO. WHEN THE ROAD THROWS YOU A CURVE.

If you don't want esses to wind you down to a crawl, try Toyo 600 series high performance radials. Their 130 mph treads can take you to the limit. The High Filler bead gets you back with predictable control. Rain just gives 'em something to sink their Turbine Blade Slits into. And an SCCA winning streak proves Toyo is king of the road. See Yellow Pages for your nearest Toyo dealer.

TOYO TIRES
DRIVEN TO PERFORM

TOYO. WHEN THE ROAD TAKES A TURN FOR THE WORST.

If you don't want corners to hook you into a fishtail, try Toyo 600 series high performance radials. Their 130 mph treads give you road-gripping power. Toyo's High Filler bead provides sure-footed control. The Turbine Blade Slits devour wet pavement. And an SCCA winning streak proves Toyo can take on any road. See Yellow Pages for your nearest Toyo dealer.

TOYO TIRES
DRIVEN TO PERFORM

MAGAZINE CAMPAIGN

ART DIRECTOR
Doug Newbry

DESIGN DIRECTOR
Doug Newbry

DESIGNER
Doug Newbry

WRITER
Brenda Asheim

AGENCY
Lenac, Warford, Stone, Inc.

CLIENT
Toyo Tire USA Corp.

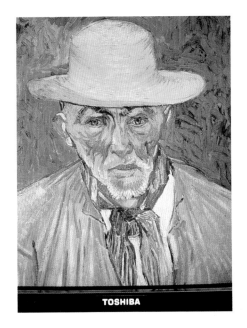

Van Gogh By Toshiba.

The beauty of a picture that is this faithful to the original is the beauty of Toshiba digital technology.

Toshiba's new generation of color TVs and VCRs uses microprocessors to digitally enhance the broadcast signal. Optimizing clarity, contrast and color. Minimizing ghosting and video noise. Ensuring crisp, clear images.

Digital technology enhances every product we create. From medical equipment to home electronics, office automation to heavy electric equipment.

Over 100 years of technological innovation has made Toshiba the ninth largest electric and electronics manufacturer in the world.

At Toshiba, we're choosing a better tomorrow, creating the products that improve the quality of our lives.

The proof is right in front of your eyes. Making a "Portrait of a Peasant" look like a million bucks.

In Touch with Tomorrow
TOSHIBA

Naisbitt By Toshiba.

High Tech meets High Touch in a perfectly reproduced color copy. And that is the beauty of Toshiba digital technology.

Digital technology allows the microprocessor in Toshiba's full color copier to continuously monitor the printed image. So nothing can be lost in transmission. Yet the copier controls are so simple, you get top-quality copies the very first time you use it.

Digital technology enhances every product we create. From medical equipment to home electronics, office automation to heavy electric equipment.

Over 100 years of technological innovation has made Toshiba the ninth largest electric and electronics manufacturer in the world. Creating products that improve the quality of our lives.

That is the challenge of tomorrow. A Megatrend.

In Touch with Tomorrow
TOSHIBA

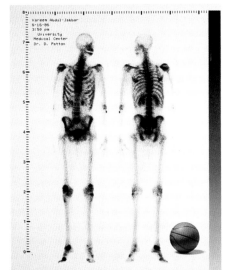

Kareem By Toshiba.

The beauty of putting a whole body skeleton on a single transparency the size of this page is the beauty of Toshiba digital technology.

At 30 frames per second, Toshiba's new medical scanners quickly and clearly record every bone in the body in a single pass. The digital information is stored in a microprocessor. Then is perfectly reproduced on a CRT screen or a single sheet of transparent film.

Digital technology enhances every product we create. From medical equipment to home electronics, office automation to heavy electric equipment.

Over 100 years of technological innovation has made Toshiba the ninth largest electric and electronics manufacturer in the world.

At Toshiba, we're choosing a better tomorrow, creating quality products that improve the quality of our lives.

And you don't do that with magic.

In Touch with Tomorrow
TOSHIBA

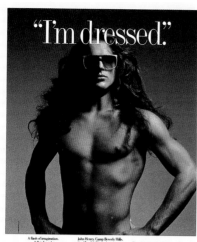

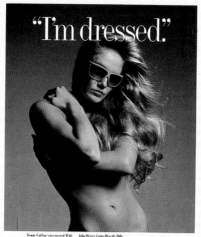

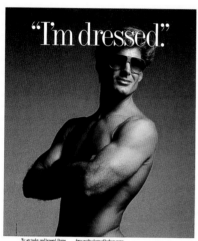

MAGAZINE CAMPAIGN

ART DIRECTOR
Joel Gilman
DESIGN DIRECTOR
Joel Gilman
DESIGNER
Joel Gilman
WRITER
Adrienne Powell
Vicki Garmel
PHOTOGRAPHER/ ILLUSTRATOR
Charles Bush
AGENCY
Eisaman, Johns & Laws
CLIENT
Tropic-Cal

ADVERTISING

*MAGAZINE
CAMPAIGN*

ART DIRECTOR
Michael Arola

WRITER
Michael Arola

PHOTOGRAPHER
Bob Grigg

RETOUCHER
Joe Kennedy

AGENCY
Cochrane Chase,
Livingston

CLIENT
Pirelli Tire Corp.

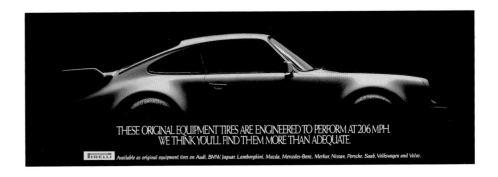

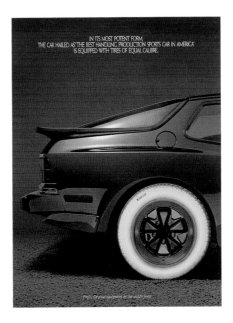

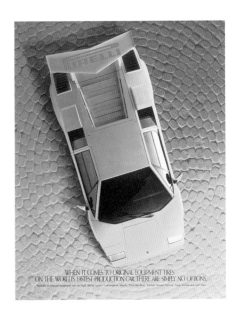

CODORNÍU WITH SPRING BOUQUET AND MELON SLICE

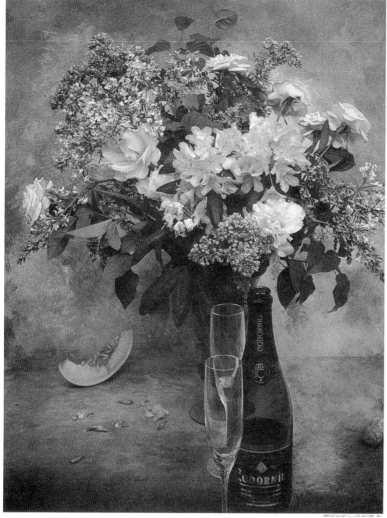

ℒODORNÍU

EUROPE'S TRUE CLASSICS ARE WITHIN EVERYONE'S REACH

CODORNÍU WITH ARTICHOKE AND BROKEN WALNUT SHELL

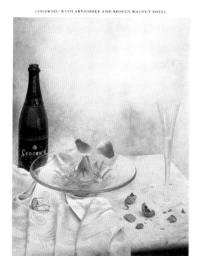

ℒODORNÍU

EUROPE'S TRUE CLASSICS ARE WITHIN EVERYONE'S REACH

CODORNÍU WITH WILD STRAWBERRY PASTRY AND PLUMS

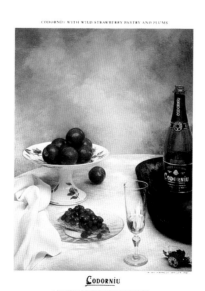

ℒODORNÍU

EUROPE'S TRUE CLASSICS ARE WITHIN EVERYONE'S REACH

MAGAZINE CAMPAIGN

ART DIRECTOR
Janet Trompeter

WRITER
Lynn Dangel

PHOTOGRAPHER/ ILLUSTRATOR
Francois Gillet

AGENCY
Ogilvy & Mather Partners

CLIENT
Codorniu

ADVERTISING

*MAGAZINE
CAMPAIGN*

ART DIRECTOR
Nick Kelly

*V.P. CREATIVE
DIRECTOR*
Eric Loeb

AGENCY
Bozell, Jacobs,
Kenyon & Eckhardt

CLIENT
James B. Beam
Distilling

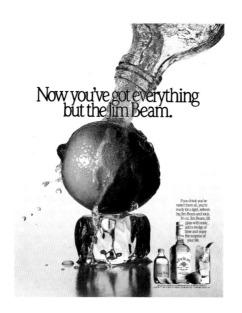

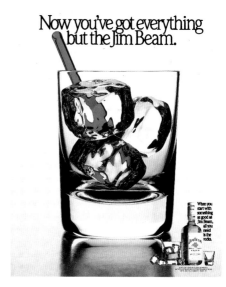

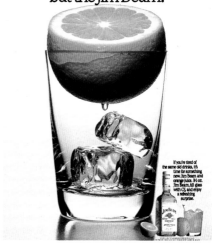

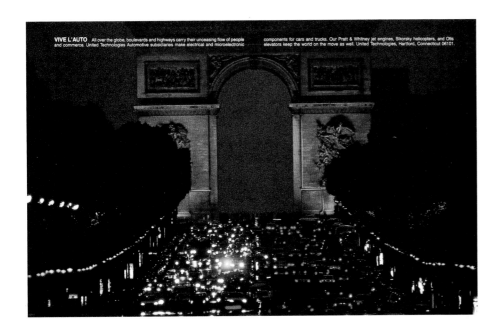

VIVE L'AUTO All over the globe, boulevards and highways carry their unceasing flow of people and commerce. United Technologies Automotive subsidiaries make electrical and microelectronic components for cars and trucks. Our Pratt & Whitney jet engines, Sikorsky helicopters, and Otis elevators keep the world on the move as well. United Technologies, Hartford, Connecticut 06101.

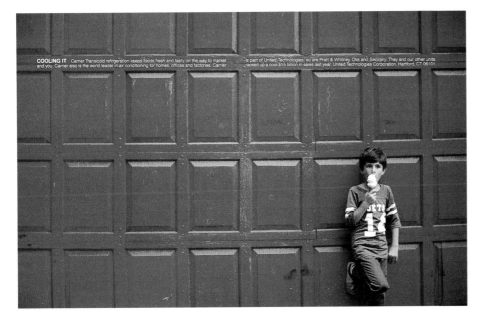

COOLING IT Carrier Transicold refrigeration keeps foods fresh and tasty on the way to market and you. Carrier also is the world leader in air conditioning for homes, offices and factories. Carrier is part of United Technologies; so are Pratt & Whitney, Otis and Sikorsky. They and our other units cracked up a cool $15 billion in sales last year. United Technologies Corporation, Hartford, CT 06101.

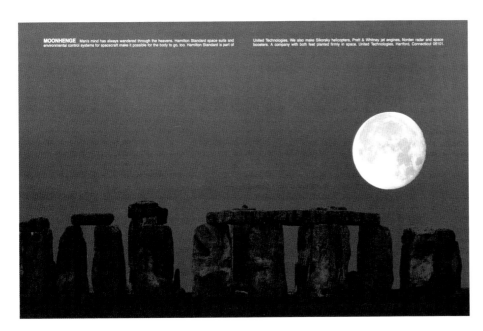

MOONHENGE Man's mind has always wandered through the heavens. Hamilton Standard space suits and environmental control systems for spacecraft make it possible for the body to go, too. Hamilton Standard is part of United Technologies. We also make Sikorsky helicopters, Pratt & Whitney jet engines, Norden radar and space boosters. A company with both feet planted firmly in space. United Technologies, Hartford, Connecticut 06101.

MAGAZINE CAMPAIGN

ART DIRECTOR
Gordon Bowman

DESIGN DIRECTOR
William Wondriska

DESIGNER
William Wondriska

WRITER
Gerald Nason

PHOTOGRAPHER/ ILLUSTRATOR
Jay Maisel

AGENCY
Wondriska Associates, Inc.

CLIENT
United Technologies Corp.

MAGAZINE
CAMPAIGN

ART DIRECTOR
John Morrison

WRITER
Penny Kapousouz

PHOTOGRAPHER/
ILLUSTRATOR
Dennis Manarchy
Cynthia Shern

AGENCY
Chiat/Day
Advertising

CLIENT
Apple Computer, Inc.

"I may still run out of time. But at least now I know 30 days in advance."

When Informatics General was awarded a multi-million dollar, 60-man-year software development project for NASA, Project Director David Kaiser decided the colored yarn and push-pins had to go.

They had been one of many methods of constantly revising the PERT (scheduling) charts his projects so heavily depend on.

"I'd tried everything," David remembers. "I even pinned 3 x 5 index cards to a bulletin board and connected interdependent tasks with rubber bands. When anything changed, I'd move the cards by hand. The colored yarn indicated our critical path."

Then David discovered a computer called Macintosh.™ And a powerful software program called MacProject.™

And according to David, project management hasn't been the same since.

"When I was scheduling on paper, I was limited to roughly 300 separately scheduled tasks. With Macintosh, we can work with 1600 separately scheduled tasks."

And scheduling at a greater level of detail is just one of the many differences Macintosh makes in David's work.

Unlike other scheduling programs, MacProject makes updating as easy as a point and click of Macintosh's mouse.

So David and his task managers are actually willing to do it. MacProject does the rest. Recalculates dates. Reformulates the critical path. And monitors all project resources.

So anyone on any project, from high-rise construction to film production, can refer to the most current information on people, money and time.

At a glance.

"We still wind up working a few weekends," David admits. "Only now we can calculate in advance exactly how many weekends we'll need to work to stay on schedule."

Another testimony to the fact that Macintosh not only helps work stay on schedule, but weekend ski trips, too.

"It's saved us money we didn't even know we had."

When Gary Lieber received his budget allotment this year, he found himself faced with the same old problem: too much to buy, and too little to spend.

He also found himself faced with a brand new solution: a Macintosh™ personal computer, and powerful software programs like Excel from Microsoft.

Gary is a Senior Operations Administrator for a subsidiary of Hughes Aircraft.

And in his business of competitive contract bidding, where any rise in overhead means a fall in profit, Gary's convinced that Macintosh is the best tool yet devised for reading between the numbers.

"Using MacTerminal™ and Switcher,™ I can cut raw data out of the corporate mainframe database and paste it directly into my spreadsheets," Gary explains.

"Financial models that used to take days with my IBM, now take a few minutes."

But the time Macintosh saves Gary is secondary to the unique perspective it affords him.

He cites a recent $100,000 purchase as a classic example.

"I had quotes from some 15 vendors. Using my Macintosh and Excel, I could not only forecast precise bulk costs for each, but cross-foot them against projected costs and pick the vendor that was most economical *long term.*"

And Macintosh not only makes it easier to assess financial expenditures, but easier to communicate and control them.

"With the LaserWriter™ printer, for the first time I can do graphs for my analyses and print them up as overheads on the fly."

"Bottom line," Gary explains, "was that I ended up several thousand dollars *under* budget. For my money, Macintosh paid for itself right there."

Which may account for the fact that more and more businesses are employing it.

"If you can't make your point with a Macintosh, you may not have a point to make."

On August 10, 1984, in a federal building in Philadelphia, an attorney named Jim Burger and a computer named Macintosh™ won their very first arbitration.

Hands down.

We like to refer to the case as: *Jim & Macintosh vs. The Surprised Lawyer & His Art Department.*

It involved an airline/labor dispute. And enough paperwork to cover the entire floor of Jim's office in the weeks before the hearing.

There were binders full of industry comparatives on profit and loss. Copies of wage agreements. Wage disagreements. Testimony. Research notes scrawled on legal pads.

It was too complicated a job to recruit help from legal assistants. Too urgent to wait for the usual secretarial face-lift.

There was only one source Jim could turn to for help: his Macintosh.

In a succession of 16-hour days, using powerful, easy to use software like Microsoft's Multiplan, Chart and Word, MacDraw™ and Think-Tank 512, Jim turned an undeniable mess into an indisputable case.

In part, by presenting the arbitrator with a 50-page document containing exhibits like the one exhibited here.

"It gave me a tremendous amount of confidence having that document under my arm," Jim remembers.

Of course, the opposing lawyer had brought a few exhibits of his own. Unfortunately, all his charts succeeded in demonstrating was that his art department had been in a hurry to do them.

To make a long arbitration short, when all had been said and done and objected to and overruled, the arbitrator decided in favor of Jim's client.

Jim's client decided in favor of buying some Macintosh computers of his very own.

And we decided it all made another great case for Macintosh.

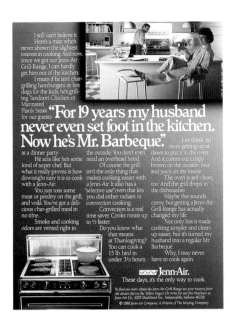

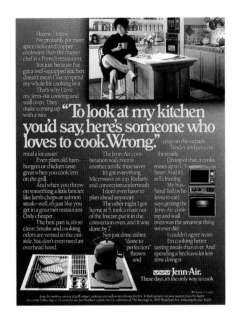

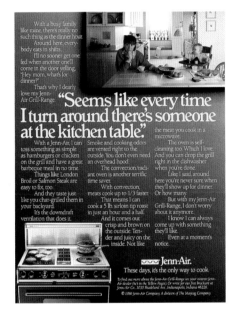

MAGAZINE
CAMPAIGN

ART DIRECTOR
Jill Bohannan

WRITER
Ray Theim

AGENCY
Young & Rubicam
Chicago

CLIENT
Jenn-Air Company

ADVERTISING

MAGAZINE
CAMPAIGN

ART DIRECTOR
Robert Reitzfeld

DESIGN DIRECTOR
Robert Reitzfeld

WRITER
David Altschiller

PHOTOGRAPHER/
ILLUSTRATOR
Hashi

AGENCY
Altschiller
Reitzfeld, Inc.

CLIENT
Compari USA

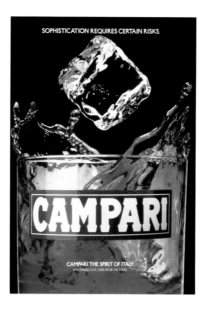

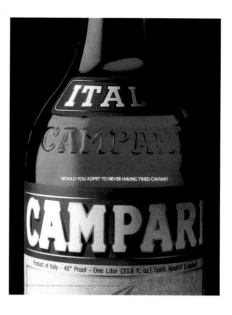

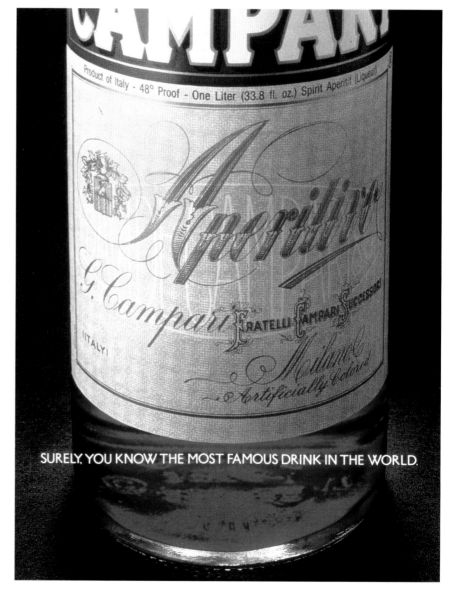

MAGAZINE
CAMPAIGN

ART DIRECTOR
Marten Tonnis

WRITER
Steve Rabosky

PHOTOGRAPHER /
ILLUSTRATOR
Bo Hylen

AGENCY
Chiat / Day
Advertising

CLIENT
Apple Computer, Inc.

We have more good family programs than ABC, NBC and CBS combined.

You've taped every episode of the Bill Cosby Show. Twice.

You've flipped through the channels so often that its worn the decals off your remote control.

And your eight-year-old just came downstairs wearing 12 of your best gold necklaces and asked you to give him a Mohawk haircut. *fool!*

If those are recurring plot themes around your house, maybe it's time you looked into an Apple® IIc Personal Computer.

It can run over 10,000 different programs, the world's largest library of personal computer software. So no matter what anyone in the family wants to do, an Apple IIc can help them do it.

You can manage your personal finances with programs like Dollars and Sense and Tax Preparer.

Pop a program like AppleWorks™ into its disk drive, and you've got an integrated spreadsheet, word processor and data base to help you catch up with your work at home.

Or you can select from thousands of specialized programs for doctors, lawyers, contractors, farmers, brokers, screenwriters or just about any other legitimate business.

And the Apple IIc is a compact version of the computer that's used in schools more than all other computers combined—the Apple IIe.

So, unlike TV, it can teach kids more valuable lessons than how to drive a car through the side of a building without getting a scratch.

Of course, the Apple IIc isn't all work and no play. In fact, it can provide greater fun, adventure and excitement than the networks during the new season premieres.

There are programs that let you travel space, solve mysteries, explore jungles, become an instant million-aire, get elected president and save the world.

And an Apple IIc is easier to set up than the average VCR. Just take it out of the box, plug in two cords and you're ready to compute.

Plus you can just as easily add things like our new Image-Writer™ II printer, ColorMonitor II, Apple Personal Modem, mouse and external disk drive.

To see everything an Apple IIc can do live and in person, visit any authorized Apple dealer.

While they may not have all 10,000 software packages on hand, you'll find plenty of programs the whole family will want to run.

And rerun.

Why every kid should have an Apple after school.

Today, there are more Apple® computers in schools than any other computer.

Unfortunately, there are still more kids in schools than Apple computers.

So innocent youngsters (like your own) may have to fend off packs of bully nerds to get some time on a computer.

Which is why it makes good sense to buy them an Apple IIc Personal Computer of their very own.

Send them home to a good school system.

The IIc is just like the leading computer in education, the Apple IIe. Only smaller. About the size of a three-ring notebook, to be exact.

Of course, since the IIc is the legitimate off-spring of the IIe, it can access the world's largest library of educational software. Everything from Stickybear

Shapes™ for preschoolers to SAT test preparation programs for college hopefuls.

In fact, the IIc can run over 10,000 programs in all. More than a few of which you might be interested in yourself.

For example, the best-selling, AppleWorks™ 3-in-1 integrated soft-ware package. Personal finance and tax pro-grams. Diet and fit-ness programs.

Not to mention

fun programs for the whole family. Like "Genetic Mapping" and "Enzyme Kinetics."

One Apple that won't leave them hungry.

The Apple IIc is easy to set up and learn. And it comes com-plete with most everything you need to start computing in one box.

Including a free, easy-to-use 4-diskette course to teach you all about the IIc—when your kids get tired of your questions.

As well as a long list of built-in features that would add about $800 to the cost of a smaller-minded computer.

The features include: 128K of internal memory—as powerful as the average office computer.

The ImageWriter II prints high quality color graphics.

A built-in disk drive that could drive up the price of a less-senior machine considerably.

And built-in adaptors for

adding accessories, like our new ColorMonitor IIc, Image-Writer™ II printer and the Apple Personal Modem 300/1200.

A feast for their eyes.

The big 14-inch ColorMonitor IIc displays crisp, color graph-

The most popular peripherals plug right into the back of the Apple IIc.

ics or a high resolution 80-column monochrome text for word processing.

You can print sharp color graphics, too, with our new ImageWriter II. It also prints

And speaking of high quality color introducing ColorMonitor IIc.

near-letter-quality text in black and white, quickly and quietly. And, with its new SheetFeeder, you can switch to single sheets without

removing the sprocket paper.*

If local color isn't enough, you can talk to the rest of the world through our new wall-mounted Apple Personal Modem 300/1200. With it, you can do your banking at home, check your stocks, gain access to all kinds of information libraries and much more.

Which would all add up to a very impressive list of expand-able accessories if it weren't for all the others. Like an Apple-Mouse. And an extra disk drive when the time comes.

Avoid growing pains.

So while your children's shoe sizes and appetites continue to grow at an alarming rate, there's one thing you know can keep up with them. Their Apple IIc.

To learn more about it, visit any authorized Apple dealer. Or talk to your own computer experts.

As soon as they get home from school.

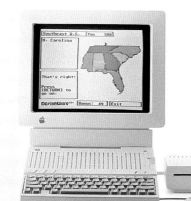

This is the first parent-teacher meeting ever held in a magazine.

Sorry, we can't offer you any punch and cookies.

Nor will we be presenting the third grade class rendition of *West Side Story*.

But we can give you some expert advice about how to help your kids get ahead at school:

Buy them an Apple® IIc per-sonal computer to use at home.

An Apple IIc can be a lot better incentive for learning than giving your kids a dollar every time they get an A on their report card.

It's a compact version of the computer that's used by schools more than all other personal

computers combined — the Apple IIe.

The Apple IIc works just like our IIe. And it runs the same educational software. So it can teach kids all the subjects they're currently learning on Apple computers at school. Everything from the alphabet to zoology.

And most kids find that it's a heck of a lot of fun to do their homework on an Apple.

Which means they may finally be as interested in learning about King George as they are Boy George.

All you former liberal arts majors out there will be happy to know that setting up and using the Apple IIc doesn't require a crash course in computer science.

The Apple IIc comes com-plete with a built-in disk drive that would cost about $300 if it weren't. And a hefty 128K of internal memory.

Since you only have to plug in two cords, anyone can easily hook it together. And just as easily add goodies like an Image-Writer™ II printer, Apple Personal Modem, ColorMonitor IIc, mouse and second disk drive.

Plus, every Apple IIc includes something your kids

probably won't need: a free, four-disk tutorial.

But you may find that it comes in pretty handy. Especially when you consider all the things an Apple IIc can teach you.

Like how to do a better job of managing your finances. Or planning your taxes. How to get more work done at home. Sell real estate. Manage swine. Speak Spanish. Fight dragons. And destroy planets.

Or do just about anything else you can think of that's legal.

Because the Apple IIc runs over 10,000 different programs. The world's largest library of personal computer software.

For a closer look at some of them, just visit an authorized Apple dealer.

Once you learn more about what an Apple IIc can do for you and your kids, we have a feeling our next meeting will take place in a more conven-ient location.

Your home.

MAGAZINE
CAMPAIGN

ART DIRECTOR
Rick Boyko
Gary Johns
Andy Dijak
Yvonne Smith

WRITER
Bill Hamilton
Jeff Gorman
Mark Monteiro

PHOTOGRAPHER/
ILLUSTRATOR
Mark Coppos

AGENCY
Chiat/Day
Advertising

CLIENT
Nike, Inc.

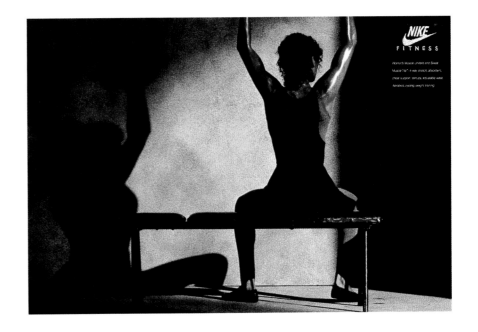

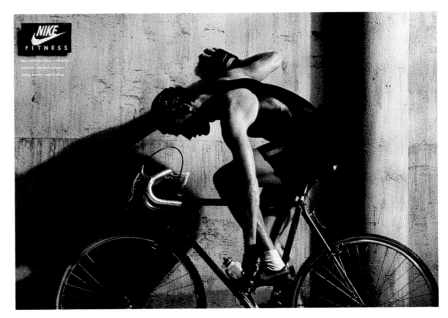

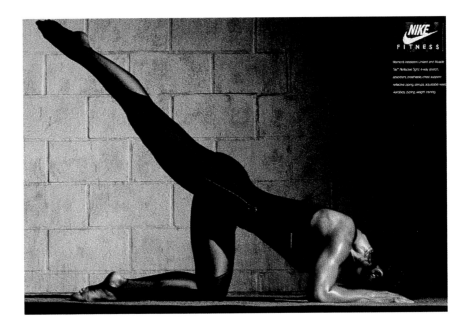

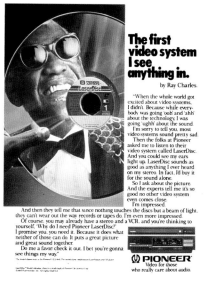

The first video system I see anything in.
by Ray Charles.

"When the whole world got excited about video systems, I didn't. Because while everybody was going 'ooh' and 'ahh' about the technology, I was going 'ughh' about the sound.

I'm sorry to tell you, most video systems sound pretty sad.

Then the folks at Pioneer asked me to listen to their video system called LaserDisc. And you could see my ears light up. LaserDisc sounds as good as anything I ever heard on my stereo. In fact, I'd buy it for the sound alone.

So I ask about the picture. And the experts tell me it's so good no other video system even comes close. I'm impressed.

And then they tell me that since nothing touches the discs but a beam of light, they can't wear out the way records or tapes do. I'm even more impressed.

Of course, you may already have a stereo and a VCR, and you're thinking to yourself, 'Why do I need Pioneer LaserDisc?' I promise you, you need it. Because it does what neither of those can do. It puts a great picture and great sound together.

Do me a favor: check it out. I bet you're gonna see things my way."

⊕ PIONEER
Video for those who really care about audio.

If a video system isn't worth hearing, it isn't worth seeing.
by Ray Charles

"My word, have you ever seriously *listened* to most video systems? This is not great sound, my friend, this is noise. They may give you something pretty to look at, but they sure make you pay with your ears.

Then one day the Pioneer folks ask me to listen to their videodisc system called LaserDisc. And I'm amazed. The sound on LaserDisc is every bit as good as I ever heard on my stereo. Maybe better.

I think to myself, 'If the sound is so great, maybe the picture isn't so hot.' So I ask the experts. And they tell me that the picture on LaserDisc is so much better than any other video system, nothing else even comes close.

And then they tell me that because the disc is read by a beam of light instead of a video head or a needle, it can't wear out the way tapes or records do.

Suddenly it all becomes very clear to me: if you could get the best sound and the best picture from the same system, if you didn't have to give up one to get the other, how could you possibly consider anything else?

I don't care if you're a big video-music fan, or all you do is watch movies. Either way, you're not going to do better than LaserDisc nohow."

⊕ PIONEER
Video for those who really care about audio.

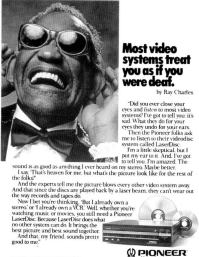

Most video systems treat you as if you were deaf.
by Ray Charles

"Did you ever close your eyes and *listen* to most video systems? I've got to tell you: it's sad. What they do for your eyes they undo for your ears.

Then the Pioneer folks ask me to listen to their videodisc system called LaserDisc.

I'm a little skeptical, but I put my ear to it. And, I've got to tell you, I'm amazed. The sound is as good as anything I ever heard on my stereo. Maybe better.

I say, 'That's heaven for me, but what's the picture look like for the rest of the folks?'

And the experts tell me the picture blows every other video system away. And that since the discs are played back by a laser beam, they can't wear out the way records and tapes do.

Now I bet you're thinking, 'But I already own a stereo,' or 'I already own a VCR.' Well, whether you're watching music or movies, you still need a Pioneer LaserDisc. Because LaserDisc does what no other system can do. It brings the best picture and best sound together.

And that, my friend, sounds pretty good to me."

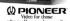

⊕ PIONEER
Video for those who really care about audio.

MAGAZINE CAMPAIGN

ART DIRECTOR
Robert Reitzfeld

DESIGN DIRECTOR
Robert Reitzfeld

WRITER
David Altschiller

PHOTOGRAPHER/ ILLUSTRATOR
Norman Seeff

AGENCY
Altschiller Reitzfeld, Inc.

CLIENT
Pioneer Video Inc. USA

The day touring riders come in out of the rain, so will we.

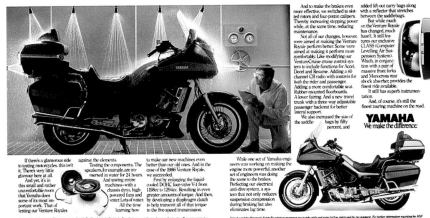

They said the mud in Louisiana could stop an ox. That's all we needed to hear.

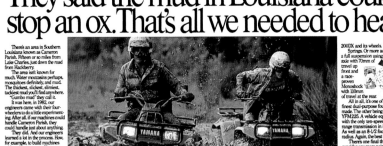

Without an oil-bathed ignition, we couldn't run this three-wheeler. Or this ad.

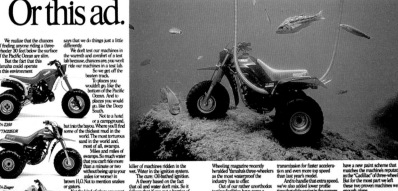

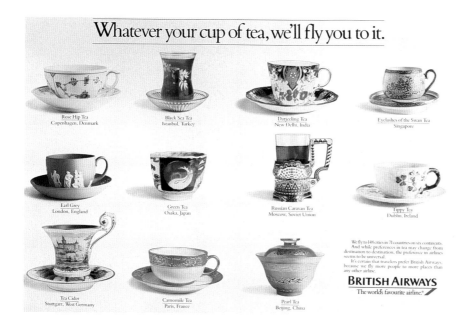

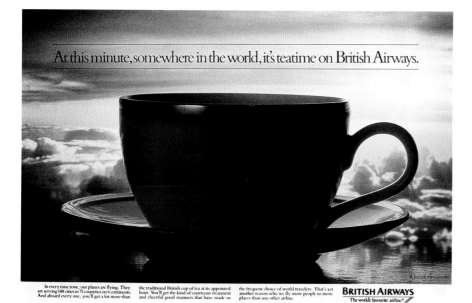

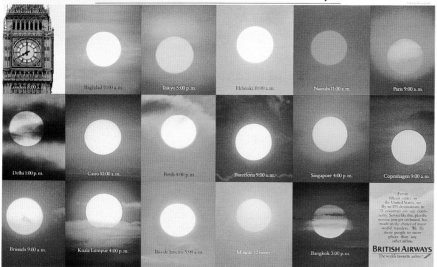

MAGAZINE
CAMPAIGN

ART DIRECTOR
Charlie Abrams
Douglas Levin
DESIGN DIRECTOR
David Herzbrun
Charlie Abrams
WRITER
David Herzbrun
PHOTOGRAPHER /
ILLUSTRATOR
Onofrio Paccione
AGENCY
Saatchi & Saatchi
Compton Inc.
CLIENT
British Airways

OUTDOOR

ART DIRECTOR
Jerry Gentile

PRODUCTION
MANAGER
Barry Brooks

WRITER
Tony Stern &
Barbara DeSantis

AGENCY
Doyle Dane Bernbach/
L.A.

CLIENT
Sea World-San Diego

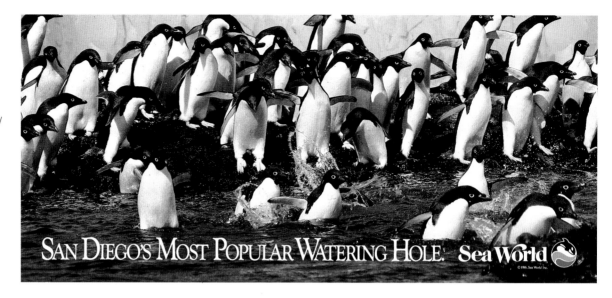

ART DIRECTOR
Sue Kruskopf

WRITER
Patrick Hanlon

AGENCY
Campbell-Mithun, Inc.

CLIENT
Minnesota Chapter
for the Prevention of
Child Abuse

ART DIRECTOR
David Breznau

PRODUCTION
MANAGER
Paul Newman

WRITER
Marty Lipkin

AGENCY
Doyle Dane Bernbach/
L.A.

CLIENT
Southern CA.
Volkswagen

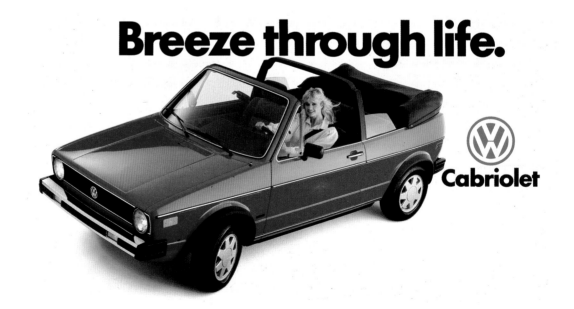

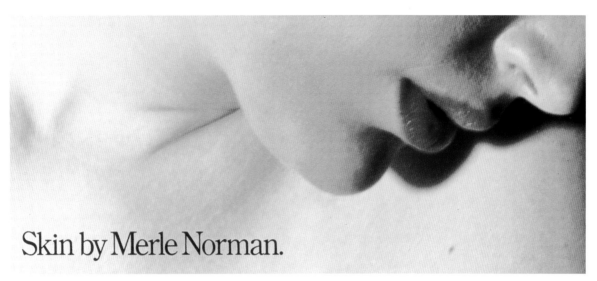

Skin by Merle Norman.

OUTDOOR

ART DIRECTOR
Jerry Gentile
WRITER
Steve Diamant
PRODUCTION MANAGER
Paul Newman
AGENCY
Doyle Dane Bernbach/
L.A.
CLIENT
Merle Norman

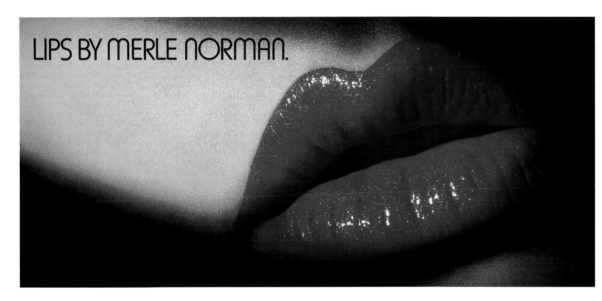

LIPS BY MERLE NORMAN.

ART DIRECTOR
Jerry Gentile
PRODUCTION MANAGER
Paul Newman
WRITER
Steve Diamant
AGENCY
Doyle Dane Bernbach/
L.A.
CLIENT
Merle Norman

OUTDOOR
ART DIRECTOR
Ivan Horvath
AGENCY
N W Ayer, Inc.
CLIENT
Santa Monica Bank

ALL'S WELL THAT LENDS WELL.

Santa Monica Bank

ART DIRECTOR
Lisa Doan
WRITER
Ivan Horvath
AGENCY
N W Ayer, Inc.
CLIENT
Santa Monica Bank

SAVE IT AGAIN, SAM.

Santa Monica Bank

ART DIRECTOR
Ivan Horvath
WRITER
Ivan Horvath
AGENCY
N W Ayer, Inc.
CLIENT
Santa Monica Bank

THE DRIVER DOESN'T CARRY CASH. WE DO.

Santa Monica Bank

OUTDOOR

ART DIRECTOR
Mike Schwabenland
WRITER
Lance Mald
AGENCY
BBDO
CLIENT
Ad Council / Citizens
Against Waste

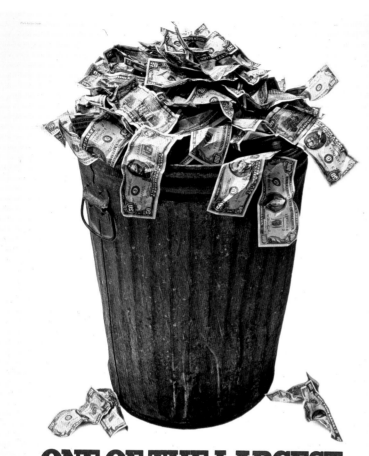

ONE OF THE LARGEST FEDERAL DEPOSITORIES FUNDED BY YOUR TAX DOLLARS.

Waste in government. Every year it consumes over $30 billion of your hard-earned tax money. For more information about how your tax dollars are being mismanaged and what you can do about it call 1-800-USA-DEBT. Our country can't afford this. And neither can you.

**CITIZENS AGAINST GOVERNMENT WASTE
1-800-USA-DEBT**

ART DIRECTOR
Don DeFilippo
John Porter
WRITER
Bob Monachino
AGENCY
DBK&O, Inc.
CLIENT
Great Expectations

We're Asking Princess Di To Relinquish Her Crown.

GREAT EXPECTATIONS
PRECISION HAIRCUTTERS

City Center, Minnetonka Mall, Burnhaven Mall, Knollwood Village, Signal Hills, Ridgedale, Southdale, Brookdale, and Rosedale.

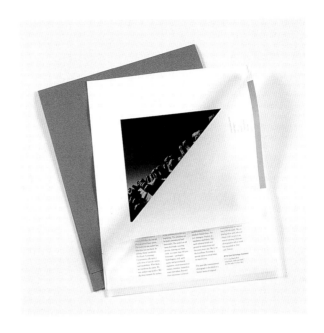

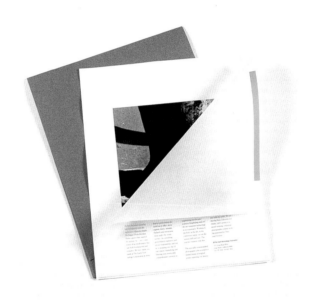

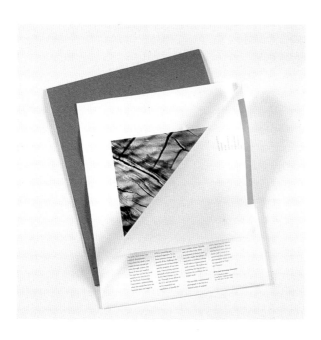

DIRECT MAIL

ART DIRECTOR
Josh Freeman

DESIGN DIRECTOR
Vicki Sawyer

DESIGNER
Vickie Sawyer
Josh Freeman

WRITER
Candace Pearson

PHOTOGRAPHER/
ILLUSTRATOR
Jeff Corwin

AGENCY
Josh Freeman
Design Office

CLIENT
Earth Technology
Corp. Inc.

ART DIRECTOR
Josh Freeman

DESIGN DIRECTOR
Vicki Sawyer

DESIGNER
Vickie Sawyer
Josh Freeman

WRITER
Candace Pearson

PHOTOGRAPHER/
ILLUSTRATOR
Jeff Corwin

AGENCY
Josh Freeman
Design Office

CLIENT
Earth Technology
Corp. Inc.

ART DIRECTOR
Bob Kuperman
Jum Hallowes
WRITER
Pacy Markman
Brandt Irvine
PRODUCER
Beth Hagen
AGENCY
Doyle Dane Bernbach/
L.A.
CLIENT
Compcare

"HOUSEWRECKER"

VO: When an alcoholic doesn't get help, it has a definite impact on his family.
DISSOLVE TO SUPER: CARE UNIT LOGO.
NOBODY CARES THE WAY WE DO.

"SKATEBOARD"

MUSIC:(UNDER THROUGHOUT)

OPEN ON A KID USING AN APPLE IIc IN HIS FATHER'S DEN. HIS DAD APPEARS IN THE DOORWAY WITH THE WORK HE NEEDS TO DO ON THE APPLE AND CHECKS THE TIME ON HIS WATCH.

ANNCR: Using an Apple IIc is very easy.

CUT TO ECU OF KID'S HANDS AT THE KEYBOARD.

The only hard part is getting your kid away from it.

CUT TO ECU OF KID'S FACE.

CUT TO DAD APPEARING WITH A SKATEBOARD IN HIS HANDS.

You see, Apples are the leading computers in schools.

CUT TO ECU OF KID INSERTING DISK. ECU OF KID'S FACE. DAD NOW HAS A BASKETBALL.

So, even though you bought it to help you work at home, your kid will want to use it for his own homework. Of course, if all else fails, there's one last thing you can try:

CUT TO CU OF DAD JINGLING CAR KEYS BY KIDS FACE. DAD LEAVES AGAIN.

CUT TO KID AT COMPUTER. DAD APPEARS IN DOORWAY HOLDING A NEW APPLE IIc. KID FINALLY LOOKS UP.

get him an Apple of his own.

DISSOLVE TO SUPER: APPLE LOGO. FADE TO BLACK.

ART DIRECTOR
Gary Johnston
Marten Tonnis

WRITER
Phil Lanier
Steve Rabosky

AGENCY
Chiat/Day
Advertising

CLIENT
Apple Computer, Inc.

ART DIRECTOR
Peter Moore
Rick Boyko

WRITER
Bill Hamilton

AGENCY
Chiat/Day
Advertising

CLIENT
Nike, Inc.

"FLIGHT 23"

CAMERA PANS DOWN ON MICHAEL JORDAN.

SFX: (JET ENGINE ROARS TO LIFE. JET TAXIS.)

STEWARDESS: Good morning, ladies and gentlemen. Welcome to Flight 23.

MICHAEL JORDAN WINKS AT CAMERA. CAMERA CONTINUES PANNING DOWN HIS LEGS.

STEWARDESS: Please make sure your seat belts are securely fastened, and extinguish all smoking materials.

CAMERA ARRIVES AT MICHAEL JORDAN'S SHOES.

SFX: (JET ENGINE BUILDS IN INTENSITY.)

CAMERA HOLDS ON SHOES AS THEY "TAKE OFF," LEAVING SMOKING MARKS ON COURT.

SFX: (SQUEAL, ROCKET ROAR, FULL JETS. DIMINISHING IN PERSPECTIVE.)

SUPER: AIR JORDAN LOGO. FADE TO BLACK.

ANNCR: Basketball, by Nike.

 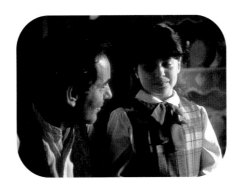

"MOTHER AND DAUGHTER"

MUSIC: (UNDER THROUGHOUT.)

LITTLE GIRL RUNNING THROUGH ITALIAN SQUARE.

SHE ENTERS KITCHEN AND KISSES HER MOTHER. MOTHER PUTS WHITE APRON ON DAUGHTER.

ANNCR: Today, Maria Coletti will make her father's…

DISSOLVE TO THE PAIR LEANING OVER STOVE. MOM SPOONS UP SAUCE FOR GIRL TO SMELL…

favorite Italian pie…

DISSOLVE TO THE PAIR KNEADING DOUGH ON LARGE WOODEN TABLE.

for the very first time. An age…

DISSOLVE TO C/U OF MEATBALLS SIM-MERING IN FRYING PAN, BEING MIXED WITH A WOODEN SPOON.

old family recipe that includes one…

DISSOLVE TO C/U OF GREEN BELL PEPPER BEING SLICED.

rather special ingredient.

DISSOLVE TO C/U OF GIRLS HAND PLACING MEATBALL ON PIE.

Meatballs.

DISSOLVE TO MOM HELPING GIRL PLACE TOP LAYER OF DOUGH OVER PIE.

At Pizza Hut…

DISSOLVE TO SIDE SHOT OF OVEN BEING SHUT BY GIRLS HANDS, MOM WATCHING IN BACKGROUND.

we're proud to introduce our own…

DISSOLVE TO GIRL ENTERING DINING ROOM CARRYING THE PRIAZZO ITAL-IAN PIE TOWARDS PARENTS WHO ARE SEATED AT DINING ROOM TABLE.

version of this classic. We call it Priazzo…

DISSOLVE TO SLICE OF PRIAZZO BEING PULLED FROM WHOLE PIE.

Verona Italian pie.

DISSOLVE TO C/U OF DAUGHTER STANDING BY FATHER AS HE TASTES THE PIE AND TURNS TO HER WITH HIS SMILE OF APPROVAL.

Perhaps today will be your first time too.

DISSOLVE TO SUPER ON BLACK: NEW PRIAZZO™ VERONA.

AT PARTICIPATING PIZZA HUT RESTAU-RANTS. HOURS LIMITED.

RED ROOF PIZZA HUT® LOGO POPS UP BETWEEN SUPER AND DISCLAIMER.

ART DIRECTOR
Tom Cordner
WRITER
Brent Bouchez
AGENCY
Chiat/Day
Advertising
CLIENT
Pizza Hut, Inc.

TELEVISION—PRODUCT

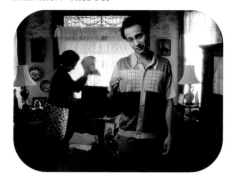 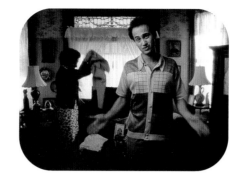

ART DIRECTOR
Jean Robaire
WRITER
John Stein
AGENCY
Chiat/Day
Advertising
CLIENT
Pizza Hut, Inc.

"PACKING"

MOMMA: (IN ITALIAN) I have raised him. I have clothed him. I have fed him. I gave him everything, everything.

SON: Look at Momma, she's beside herself. She found out I had Calizza™ for lunch at Pizza Hut. That wasn't so bad. Then she found out I loved it. That was bad.

They make one with Italian sausage and green peppers and another with five delicious cheeses, just like Momma does.

And it's served in five minutes guaranteed.

ANNCR: Calizza™ Italian turnover. At Pizza Hut.

SON: I can't believe Momma's going.

MOMMA: Momma is not.

"CHRISTMAS"

OPEN ON DAD SITTING ON THE LIVING ROOM FLOOR, ASSEMBLING APPLE IIc. IT'S THE NIGHT BEFORE CHRISTMAS.

ANNCR: The Apple IIc is the perfect computer to give your kids.

CUT AWAY TO TWO CHILDREN WATCH-ING DAD FROM THE TOP OF THE STAIRS.

KID#1: This should be good.

KID #2: Yeah.

CUT BACK TO DAD.

ANNCR: Because Apple's are the leading com-puters used in schools.

CUT BACK TO KIDS.

KID #1: Remember your bike last Christmas?

KID #2: Uh-oh . . .

CUT BACK TO DAD. HE PLUGS IT IN, SLIPS IN A DISKETTE AND STARTS PECKING AT THE KEYBOARD, INTRIGUED.

ANNCR: Yet it can run thousands of business and home finance programs. And it's so simple to set up and use, virtually anyone can do it.

CUT BACK TO THE KIDS. THEY TODDLE OFF TO BED. FADE TO BLACK WITH APPLE LOGO.

KID #2: Another Christmas miracle.

ART DIRECTOR
Gary Johnston
WRITER
Phil Lanier
AGENCY
Chiat / Day
Advertising
CLIENT
Apple Computer, Inc.

TELEVISION—PRODUCT

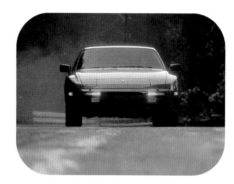

ART DIRECTOR
Jeff Roll
Andy Dijak
WRITER
Dave Butler
AGENCY
Chiat / Day
Advertising
CLIENT
Porsche Cars
North America

"944 TURBO"

MUSIC: THROUGHOUT.

ANNCR: Imagine you were a car.

SFX: A GENERIC CAR ACCELERATING.

SFX: CONTINUE

ANNCR: What would you be?

SFX: PORSCHE 944 ACCELERATING, WITH-OUT TURBOCHARGER.

ANNCR: You'd be a sports car.

SFX: ENGINE REVS

ANNCR: You'd be quick. . . .

SFX: CONTINUE.

ANNCR: . . . Agile.

SFX: CONTINUE.

ANNCR: You'd be . . .
turbo-charged.

SFX: ENGINE SOUND INCREASES, AMPLI-FIED BY TUNNEL, AS TURBOCHARGER KICKS IN.

ANNCR: And, of course . . .

ANNCR: . . . You'd be a Porsche.

"COMPUTER SNEAK"

VIDEO: A MAN'S HAND OPENS A DOOR CAREFULLY AND QUIETLY. HE'S ENTERING A DARKENED ROOM.

CUT TO THE REVERSE ANGLE. WE SEE THE MAN SNEAKING INTO A DARKENED CHILD'S ROOM.

ANNCR: This is how many parents, all across America, find out about the Apple IIc. Parents buy their kids an Apple IIc because Apples are the leading computers used in schools.

WE SEE HIM FUMBLING HIS WAY ACROSS THE KID'S DESK, WORKING HIS WAY TOWARD HIS SON'S APPLE IIc. WHILE FUMBLING, HE KNOCKS OVER A WIND-UP TOY, WHICH COMES TO LIFE AND STARTS MAKING NOISE. HE SILENCES IT QUICKLY.

ANNCR: Then they discover how easy it is to set up and use. How it can help them with things like business and home finance.

DAD SITS DOWN AT THE APPLE IIc AND STARTS WORKING.

ANNCR: And how that can help them spend more time with their kids.

WE HEAR A "CLICK!" AND SUDDENLY DAD IS ILLUMINATED IN A FLASHLIGHT BEAM. HE TURNS AND SMILES SHEEPISHLY AT HIS SON.

SFX: (CLICK.)

KID: Oh. Hi, Dad.

FADE TO BLACK WITH APPLE LOGO.

ART DIRECTOR
Gary Johnston
WRITER
Phil Lanier
AGENCY
Chiat/Day
Advertising
CLIENT
Apple Computer, Inc.

TELEVISION—PRODUCT

 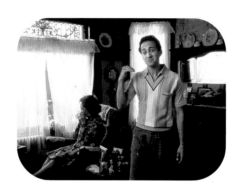 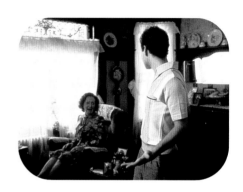

ART DIRECTOR
Jean Robaire
WRITER
John Stein
AGENCY
Chiat/Day
Advertising
CLIENT
Pizza Hut, Inc.

'YOU STILL GOTTA ME"

OPEN ON A LIVING ROOM AS AN APPROXIMATELY 30-YEAR-OLD MAN TALKS TO THE CAMERA. HIS MOTHER SITS IN A CHAIR NEXT TO THE WINDOW CRYING AS SHE STARES OUTSIDE.

SON: My momma's so upset. She found out that her special Italian turnover…Pizza Hut's now got one for lunch, too. Calizza they call it. How they got the recipe, I don't know.

HIS MOTHER TURNS OVER THE PICTURE OF ANGELO.

SON: Maybe my cousin Angelo gave it to 'em.

CUT TO A CALIZZA BEING PREPARED.

SON: It's got sausage and green peppers, a delicious tomato sauce—even a light crust just like Momma's.

CUT TO SON TALKING TO CAMERA. MOMMA IS SNIFFLING IN BACKGROUND.

SON: And they serve it in five minutes— Guaranteed.

SUPER: GUARANTEE APPLIES 11:30AM-1:00PM ON ORDERS OF FIVE OR LESS.

CUT TO SUPER: CALIZZA™ FOR LUNCH. AVAILABLE AT PARTICIPATING PIZZA HUT RESTAURANTS. PIZZA HUT® LOGO.

ANNCR: Calizza Italian turnover. At Pizza Hut.

CUT BACK TO SON.

SON: Momma, they might have a Calizza but you still gotta me.

MOMMA: (CRIES)

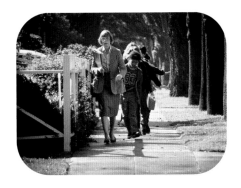
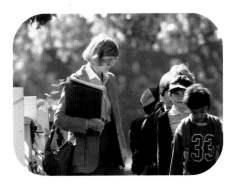

No other day makes
you feel this way.

SeaWorld

"MISS ROONEY'S CLASS"

ANNCR: Last month...

...Miss Rooney's fourth-grade class went to Sea World.

They played with dolphins.

They saw a seal and otter show.

And four-ton killer whales that were...actually cuddly.

But of all the wonderful things Miss Rooney's...

...fourth-graders saw that day...

...some cute black and white birds from the Antarctic...

...made the biggest impression of all.

ANNCR: No other day makes you feel this way.

ART DIRECTOR
Steve Diamant
WRITER
Pacy Markman
PRODUCER
Beth Hagen
AGENCY
Doyle Dane Bernbach/
L.A.
CLIENT
Sea World-San Diego

TELEVISION—PRODUCT

ART DIRECTOR
Rick Boyko
Lee Clow

WRITER
Bill Hamilton

AGENCY
Chiat/Day
Advertising

CLIENT
Nike, Inc.

"JORDAN HOLIDAY"

*MICHAEL JORDAN AND SANTA PLAYING
ONE ON ONE.
JORDAN MAKES SEVERAL DUNKS. GAME
ENDS. JORDAN TOSSES BALL TO SANTA
AND PUTS HIS ARM AROUND HIM. THEY
EXIT OUT DOOR.*

MUSIC: (THROUGHOUT.)

SANTA: Ahhh…

ANNCR: Think Air Jordan this season.

ANNCR: By Nike.

DISSOLVE TO SUPER: AIR JORDAN LOGO

"BEDROOM"

*OPEN ON A LIVING ROOM AS AN
APPROXIMATELY 30-YEAR-OLD MAN
TALKS TO THE CAMERA. HE OCCASION-
ALLY POINTS TO THE BEDROOM.*

SON: As you know, Momma's very upset. She
locked herself in the bedroom. Her special
Italian turnover...Pizza Hut's now got one for
lunch too, Calizza they call it.

MOMMA YELLS IN ITALIAN.

MOMMA: Vivia. (Go away.)

SON: No Momma, I didn't give them the recipe.

CUT TO A CALIZZA BEING PREPARED.

It's got five delicious cheeses, a tomato sauce,
even a light crust, just like Momma's.

*SUPER: GUARANTEE APPLIES
11:30AM-1:00PM ON ORDERS OF FIVE
OR LESS.*

And it's served in five minutes, guaranteed.

*MOMMA YELLS IN ITALIAN. THROWS
SOMETHING AT THE DOOR THAT
SHATTERS.*

MOMMA: Vivia. (Go away.)

SON: I swear, Momma, I didn't.

CUT TO LOGO.

*SUPER: CALIZZA™ FOR LUNCH.
PIZZA HUT® LOGO.*

ANNCR: Calizza™ Italian turnover. At
Pizza Hut.

*SUPER: AVAILABLE AT PARTICIPATING
PIZZA HUT RESTAURANTS.*

CUT BACK TO SON.

SON: She's never comin' out.

HE SMILES.

Hmmm.

ART DIRECTOR
Jean Robaire
WRITER
John Stein
AGENCY
Chiat/Day
Advertising
CLIENT
Pizza Hut, Inc.

TELEVISION—PRODUCT

ART DIRECTOR
Jill Bohannan

WRITER
Jim Kochevar

PRODUCER
Enid Katz

AGENCY
Young & Rubicam
Chicago

CLIENT
Chi-Chi's Mexican
Restaurants

"LIMO-GENERIC"

ANNCR: Sometimes you feel a little Mexican.

And when you feel a little Mexican, come to Chi-Chi's Mexican restaurant for grilled chicken. Try our tender marinated chicken entrees served with a Mexican flair.

Chi-Chi's. When you feel a little Mexican.

"HIPPO"

HIPPO: Those wine coolers. . .they all taste the same! But Champale Coolers taste like your favorite tropical drinks! Because. . .

SONG: We take de pina an we shake it up with de coconut. . .Got strawberry an de citrus to make it cooler. . .Sparkle in de orange taste like Mimosa. . .Champale Tropical Coolers!

HIPPO: Come. . .sip into Champale Tropical Coolers.

SONG: Champale Tropical Coolers!

ART DIRECTOR
Harold Rosen
DESIGN DIRECTOR
Charles Swenson
ANIMATOR
Charles Swenson
WRITER
Frank Izzo
AGENCY
North Castle
Partners Advertising /
Murakami Wolf
Swenson
CLIENT
Champale, Inc.

TELEVISION—PRODUCT

 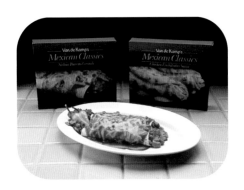

ART DIRECTOR
Ken Berris

DESIGN DIRECTOR
Ken Berris (Creative
Director)

WRITER
Ken Berris

*PHOTOGRAPHER/
ILLUSTRATOR*
River Run

AGENCY
D'Arcy Masius
Benton & Bowles

CLIENT
Van de Kamp's

"VIGNETTES"

ANNCR: Sometimes you want great
Mexican food without all the atmosphere.

WAITRESS: Sangria? Sangria?

WAITER: (OBVIOUSLY NOT MEXICAN)
So, like I'm your waiter Jose.

MARIACHIS: Blaring.

SINGERS: La Cucharacha. La Cucharacha.

WAITRESS: Sangria? Sangria?

WAITER: HOT PLATE! HOT PLATE!

ANNCR: That's why there's Van de Kamp's
Mexican Classics.
Real Jack Cheese.
Shredded beef.
Rich Ranchero sauce.
Van de Kamp's. Great Mexican food...

WAITRESS: Sangria? Sangria?

ANNCR: ...without the atmosphere.

WAITRESS: Or what?

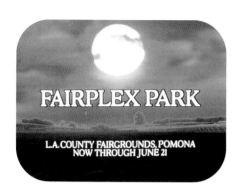

"RACING WITH THE MOON"

SFX: (HORSES, IN THE DISTANCE)

MUSIC: (BUILDS)

SFX: (HORSES LOUDER)

ANNCR: Racing with the moon.

SFX: (WIND)

ANNCR: Now at Fairplex Park
LA County Fairgrounds, Pomona.

ART DIRECTOR
Gary Larsen
Bill Snitzer

DIRECTOR
Lon Tinney

WRITER
Rick Colby
Julie Cohen

AGENCY
LarsenColbyKoralek

CLIENT
Fairplex Park: LA
County Fairgrounds

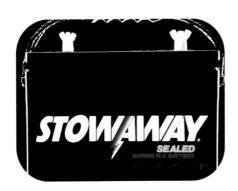

ART DIRECTOR
John Porter
DESIGN DIRECTOR
Eric Young
WRITER
Jim Offerman
PRODUCTION HOUSE
Wilson / Graik
PRODUCER
Monica McIntosh
AGENCY
DBK&O, Inc.
CLIENT
GNB Incorporated

"STOWAWAY"

SFX: (LOW END SYNTHESIZER SOUNDS. WAVES LAPPING. WIND. FOOTSTEPS ON DOCK. HEARTBEATS.)

SFX: (SYNTHESIZER TONE DROPS. BOAT BUMPERS SQUEAKING. FOOTSTEPS STOP. FLASHLIGHT BEAM FLARES LENS. WIND GUSTS. MAN STEPS INTO BOAT.)

SFX: (SYNTHESIZER UNDER. FOOTSTEPS IN BOAT. BATTERY BEING SET DOWN ON STERN COMPARTMENT.)

SFX: (SYNTHESIZER DROPS IN TONE. EXAGGERATED SOUND OF BATTERY DROPPING INTO COMPARTMENT.)

SFX: (SYNTHESIZER RISES IN INTENSITY. EXAGGERATED SOUND OF CABLE MEET-ING TERMINAL.)

SFX: (SYNTHESIZER CACOPHONY INCREASES. EXAGGERATED SOUND OF WING NUT BEING TIGHTENED.)

SFX: (SYNTHESIZER CACOPHONY INCREASES. EXAGGERATED SOUND OF KEY ENTERING IGNITION.)

SFX: (SYNTHESIZER CACOPHONY INCREASES. STRING OF ELECTRONIC SOUNDS SYNCHED TO SONAR.)

SFX: (SYNTHESIZER CACOPHONY NOW VERY LOUD. SOUND OF ENGINE CRANK-ING AND STARTING.)

SFX: (SYNTHESIZER CACOPHONY REACHES PEAK AND SUBSIDES. HIGH PITCHED SOUND SYNCHED TO SPOTLIGHT.)

SFX: (LOW END SYNTHESIZER UNDER. SOUND OF ENGINE IDLING. WIND GUSTS.)

ANNCR: Stowaway. The marine battery.

SFX: (SYNTHESIZER BUILDS TO BELL-LIKE CHORD. ENGINE (IN GEAR) REVS UP AND FADES UNDER SYNTHESIZER CHORD.)

"AMAZING STORIES PREMIERE"

MUSIC: John Williams, Composer
"Amazing Stories" Main Title Theme
May 1984 Scoring. Version #1.

WRITER
Bob Bibb
AGENCY
NBC Advertising
and Promotion
CLIENT
NBC Entertainment

TELEVISION—PRODUCT

ART DIRECTOR
Tom Cordner
WRITER
Brent Bouchez
AGENCY
Chiat/Day
Advertising
CLIENT
Pizza Hut, Inc.

"COOKING SCHOOL"

*MUSIC: "LA BOHEME" ADAPTATION
UNDER THROUGHOUT.*

SFX: DOG BARKS.

INSTRUCTOR: Parti li funghi Marco—vieni. (Cut the mushrooms Marco—come.)

Ma Vincenzo-che hal fatto qui? (But Vincenzo, what did you do here?)

Ah, buon jiourno, Maestro. Lavore! (Ah! Good morning "Maestro." Work!)

Fatto—Lavora. (Done—Work.)

Pui meglio. Pui meglio. (Even better. Even better.)

No! Che fai? (No! What are you doing?)

Beh! Mettilo, mettilo, mettilo. (Well, put it in, put it in, put it in.)

ANNCR: In Italy there are many...

...ways to make the classic Italian pie.

From blends of fine...

...meats to the best cheeses, even poultry.

Each recipe a closely guarded secret.

INSTRUCTOR: Ah! Piano, piano, piano, piano, bravo. (Ah! Slowly, slowly, slowly, slowly, good job.)

ANNCR: In America...

INSTRUCTOR: Lavora. Lavora. (Work. Work.)

ANNCR:...there is a special Italian pie. We call it Priazzo.™

You'll find it...

...baked fresh each day only at Pizza Hut.

INSTRUCTOR: Bravo.

And that's all we intend to tell you.

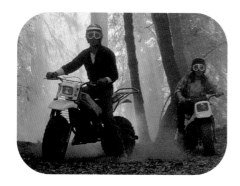 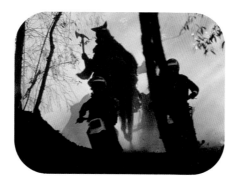

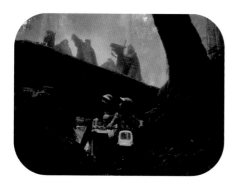

"CHASE"

MUSIC: FAST PACED.

ANNCR: The Yamaha Big Wheels come with extra-wide, extra-stable tires. . .

. . .and a low profile that makes them simple to ride. So it's fun and easy to get to places you might not go otherwise.

MOM: So what took you guys so long?

FATHER: (AS HE LOOKS AT DAUGHTER KNOWINGLY) Nothing.

ANNCR: The Yamaha Big Wheels. Perhaps they're the adventure you've been looking for.

ART DIRECTOR
Tom Cordner
WRITER
Brent Bouchez
AGENCY
Chiat/Day
Advertising
CLIENT
Yamaha Motor Corp.,
U.S.A.

TELEVISION—PRODUCT

ART DIRECTOR
Phil Raskin
Walt Maes
Gary Conroy

DIRECTOR
Leslie Dektor

WRITER
Phil Raskin
Walt Maes

PHOTOGRAPHER/
ILLUSTRATOR
Leslie Dektor

AGENCY
Petermann Dektor
Films

CLIENT
Seven-Up

"SUNNY LANE HOME"

COMMERCIAL TAKES PLACE ON THE GROUNDS OF THE SUNNY LANE RETIREMENT HOME.

STAFF MEMBER BRINGS OUT A TRAY OF SEVEN-UP FOR RESIDENTS ON A HOT SUNNY DAY.

MUSIC: (UNDER THROUGHOUT.)

WOMAN: Refreshments anyone?

MAN: What do you have in mind?

WOMAN: (SMILES.)

MAN: (OPENS CAN OF SEVEN-UP AS IT STARTS TO RAIN.)

RESIDENTS HAVE A WONDERFUL TIME PLAYING IN THE RAIN AS WE HEAR THE SEVEN-UP JINGLE.

JINGLE: Feels so good comin' down
Feels so good comin' down
Seven-Up splashin' on the fun
Pouring cool and clear on everyone
Seven-Up
Feels so good good good
Seven-Up

"TORPEDO"

ANNCR: Chemical Warfare
is threatening the fabric
of some of America's clothes.
(FIRE)
The enemy is chlorine bleach,
a liquid that can attack colors
and delicate whites.
(EXPLOSION)
But there is a bleach that's safe
For all your colors, all your whites,
Borateem® bleach, The Safe Great White.

ART DIRECTOR
Peter Coutroulis
DESIGN DIRECTOR
Fred Petermann
WRITER
Howie Krakow
*PRODUCTION
COMPANY*
Petermann / Dekor
AGENCY
DJMC—18th Floor
CLIENT
U.S. Borax

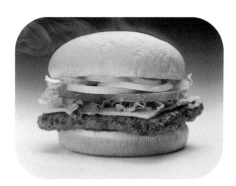

DIRECTOR
Nick Mendoza
WRITER
Andres Sullivan
PHOTOGRAPHER
Nick Mendoza
AGENCY PRODUCER
Douglas Magallon
ART DIRECTOR
Roberto Bojorges
AGENCY
Nick Mendoza
Productions
CLIENT
Wendy's International,
Inc.

"A WHILE AGO"

DON CUCUFATO: Young man, please make me a hamburger.

YOUNG MAN: We already did.

DON CUCUFATO: You already did what?

YOUNG MAN: Made your hamburger.

DON CUCUFATO: When?

YOUNG MAN: A while ago.

DON CUCUFATO: What if I'd gotten here "a while ago?"

YOUNG MAN: The ones from "a while ago" were made an hour before...

DON CUCUFATO: I see, no wonder your hamburgers taste an hour old!

ANNCR: On the other hand, at Wendy's we make your hamburgers the moment you order them, and not a moment before...That's why they're juicier...fresher. Think fresh...think Wendy's.

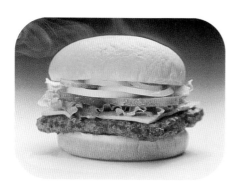

"HAMMERING"

ANNCR: In one of those other hamburger places they serve frozen hamburgers.

DON CUCUFATO: Young man, what *are* you doing?

SFX: HAMMER ON CHISEL.

EMPLOYEE: I'm fixing your hamburger.

DON CUCUFATO: By hammering it?

EMPLOYEE: That's because it's frozen...but we'll remove the ice right away.

DON CUCUFATO: What you've just "removed" is my appetite. Bah! Frozen hamburgers.

OTHER CUSTOMERS IN LINE: Blah!!!

ANNCR: On the other hand, Wendy's hamburgers are made from fresh ground beef that's never been frozen. That's why they are juicier...fresher. Think fresh. Think Wendy's.

DIRECTOR
Nick Mendoza
WRITER
Andres Sullivan
PHOTOGRAPHER
Nick Mendoza
AGENCY PRODUCER
Douglas Magallon
ART DIRECTOR
Roberto Bojorges
AGENCY
Nick Mendoza
Productions
CLIENT
Wendy's International,
Inc.

DIRECTOR
Nick Mendoza

WRITER
Andres Sullivan

PHOTOGRAPHER
Nick Mendoza

AGENCY PRODUCER
Douglas Magallon

ART DIRECTOR
Roberto Bojorges

AGENCY
Nick Mendoza
Productions

CLIENT
Wendy's International,
Inc.

"GOMITAS DE POLLO"

(MUSIC FX—"BAD GUYS" MUSIC)

DON CUCUFATO: Young man, Chicken Nuggets please.

YOUNG MAN: Here you are.

DON CUCUFATO: Mmmm! Rubber chicken chunks! Oooops!

SFX: BOING! BOING! BOING! BOING! BOING!

DON CUCUFATO: And do these little rubber chicken nuggets come with little rackets?

MUSIC FX: WENDY'S MUSIC.

ANNCR: Don't eat those rubber chicken nuggets anymore! Now Wendy's has the new Crispy Chicken Nuggets, golden and crunchy outside . . . tender and juicy white meat inside.

DON CUCUFATO: Take it easy! There are enough for all.

ANNCR: At Wendy's there's always something new. Think fresh . . . think Wendy's!

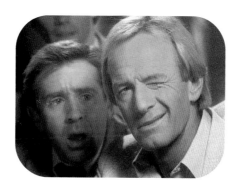
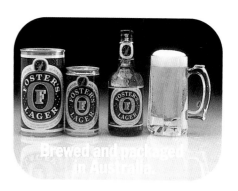

"SHARK WRESTLING"

HOGAN: G'day. America sure is a sporting nation. This one's my favorite over here:
Rap dancing.

SFX: (FOOTBALL GAME IN BACKGROUND)

HOGAN: Course, back home our favorite sport is shark wrestling.

MAN AT BAR: Shark wrestling?

HOGAN: Nothing better than sitting down to a few rounds of man versus hungry white pointer. With a drop of the amber nectar, Foster's.

MAN AT BAR: White pointer?

HOGAN: Yeah. Course, the hard part is getting the sharks into those tight little wrestling shorts.

SFX: (LAUGHTER)

HOGAN (V.O.): Foster's. It's Australian for beer, mate.

PRODUCER
Norman Zuppicich
Barry Orell

DIRECTOR
Stu Haggman

PRODUCTION CO.
H.I.S.K. Productions

WRITER
Fishing & Beach:
Jeff Seebeck
Shark Wrestling:
Mike Veach

AGENCY
Diener/Hauser/Bates
Advertising

CLIENT
Carlton United
Breweries - Foster's
Lager

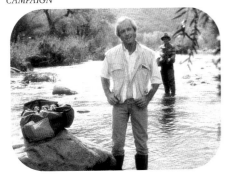
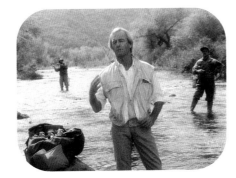
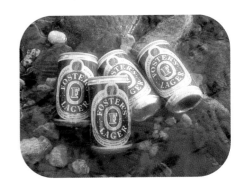

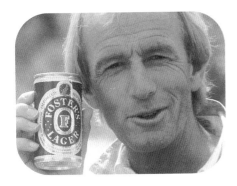

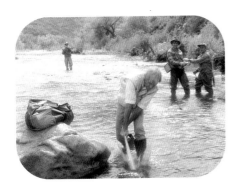
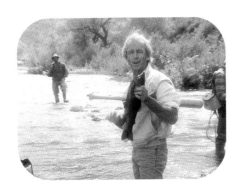

PRODUCER
Norman Zuppicich
Barry Orell

DIRECTOR
Stu Haggman

PRODUCTION CO.
H.I.S.K. Productions

WRITER
Fishing & Beach:
Jeff Seebeck
Shark Wrestling:
Mike Veach

AGENCY
Diener/Hauser/Bates
Advertising

CLIENT
Carlton United
Breweries - Foster's
Lager

"FISHING"

HOGAN: G'day. Ya know, trout fishing here in the
U.S. is a real art form.
The finesse of fly tying. The skill of laying out a
perfect cast.
And the chance for a Foster's or two at the end of
the day.
SFX: (DROPPING FOSTER'S INTO STREAM)
HOGAN: The golden throat charmer.
Think I'll try the Wombat Haired Waterbug.
Aussie bait...and American tackle.
SFX: (BAT HITTING WATER)
SFX: (LAUGHTER IN BACKGROUND)
HOGAN: Good combination, eh?
Foster's. It's Australian for beer, mate.

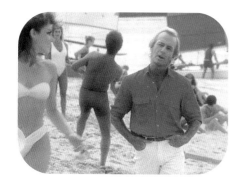

"BEACH"

HOGAN: G'day. Typical American beach. Surf,
sun...and the kind of scenery that reminds me
of home.

Especially when you can top it off with a genuine
Foster's.

Tastes like an angel crying on your tongue.
(GIRL GIGGLES.)

HOGAN: As Australian as a bikini on Bondi
Beach.

(CROWD CHEERING AND CLAPPING)

HOGAN: The only difference is...we don't chuck
our plates around after lunch.
(GIRL GIGGLES)

HOGAN (V.O.): Foster's. It's Australian for beer,
mate.

PRODUCER
Norman Zuppicich
Barry Orell

DIRECTOR
Stu Haggman

PRODUCTION CO.
H.I.S.K. Productions

WRITER
Fishing & Beach:
Jeff Seebeck
Shark Wrestling:
Mike Veach

AGENCY
Diener/Hauser/Bates
Advertising

CLIENT
Carlton United
Breweries - Foster's
Lager

TELEVISION—PRODUCT
CAMPAIGN

ART DIRECTOR
Harold Rosen

DESIGN DIRECTOR
Charles Swenson

DESIGNER
Charles Swenson

WRITER
Frank Izzo

AGENCY
North Castle
Partners Advertising /
Murakami Wolf
Swenson

CLIENT
Champale, Inc.

"LION"

FOX: My mane man always drinks Champale.
LION: MEOW!
ANNCR: Champale. Sparkly. Bubbly. Uncivilized.

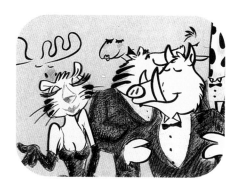

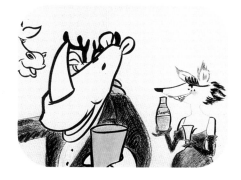
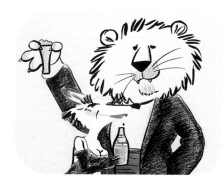

"PARTY ANIMALS"

BOAR: I was a total bore before I served Champale. Now they call me a party animal!

SFX: MUSIC, ANIMALS, PARTY SOUNDS.

FOX: My mane man always drinks Champale.

LION: MEOW!

ART DIRECTOR
Harold Rosen

DESIGN DIRECTOR
Charles Swenson

ANIMATOR
Charles Swenson

WRITER
Frank Izzo

AGENCY
North Castle
Partners Advertising /
Murakami Wolf
Swenson

CLIENT
Champale, Inc.

 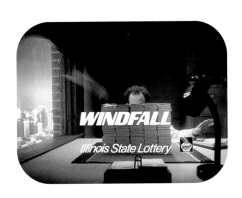

ART DIRECTOR
Tom McConnaughy

CREATIVE DIRECTOR
Tom McConnaughy

WRITER
Steve Fortier

PRODUCER
Lee Lunari

AGENCY
Bozell, Jacobs,
Kenyon & Eckhardt

CLIENT
Illinois State Lottery

"WINDFALL"

ANNCR: Play the Illinois Lottery's new Windfall
Instant Game.
You could win...
SFX: CRUNCH
ANNCR:...a million bucks.

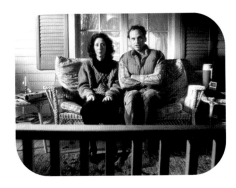 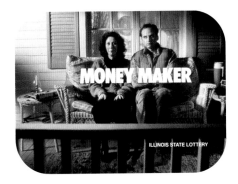

"I WOULD"

MAN: If I had a million dollars, I wouldn't spend a penny of it.

WOMAN: (SMILING) I would.

ANNCR: Play Money Maker Instant Lottery. You could win a million dollars.

ART DIRECTOR
Dennis Hagen

WRITER/CREATIVE DIRECTOR
Richard Coad

PRODUCER
Lee Lunardi

AGENCY
Bozell, Jacobs, Kenyon & Eckhardt

CLIENT
Illinois State Lottery

TELEVISION—PRODUCT
CAMPAIGN

 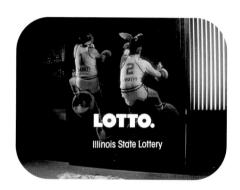

ART DIRECTOR
Brian Kelly

WRITER
Jim Schmidt

PRODUCER
Lee Lunardi

AGENCY
Bozell, Jacobs,
Kenyon & Eckhardt

CLIENT
Illinois State Lottery

"SUCTION CUPS"

DWAYNE: Darryl, Darryl it's a 110 stories high...

DARRYL: ...world's tallest building, you ready?

DWAYNE: Darryl, are you sure these will
hold us?

DARRYL: No problem, they'll take us all the way
to the top.

DWAYNE: But Darryl...

DARRYL: There'll be endorsements...

DWAYNE: But Darryl...

DARRYL: TV appearances, books. We'll make
millions. You ready?

DWAYNE: Are you sure these will hold?

DARRYL: Trust me, they'll stick like glue.

ANNCR: There's an easier way to reach new
financial heights...

ANNCR: Play Lotto.

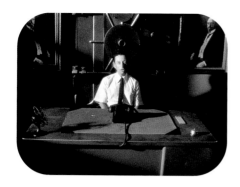 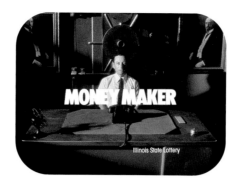

"COWBOY"

What would I do with a million dollars? Me...I'd go West...I'd become a cowboy...I'd get a 10 gallon hat and a big black stallion. I'd ride off into the sunset each night like Hopalong Cassidy. And at the end of the day I'd sit around the campfire with the boys and eat beans and listen to the coyotes play and sing Home On The Range...*(SINGS HOME ON THE RANGE)*

VO: With a million dollars, you can do practically anything you want. So Play Money Maker Instant Lottery.

ART DIRECTOR
Denis Hogen
CREATIVE DIRECTOR
Richard Coad
AGENCY
Bozell, Jacobs,
Kenyon & Eckhardt
CLIENT
Illinois State Lottery

TELEVISION—PRODUCT
CAMPAIGN

ART DIRECTOR
Jean Robaire

WRITER
John Stein

AGENCY
Chiat/Day
Advertising

CLIENT
Pizza Hut, Inc.

"YOU STILL GOTTA ME"

OPEN ON A LIVING ROOM AS AN
APPROXIMATELY 30-YEAR-OLD MAN
TALKS TO THE CAMERA. HIS MOTHER
SITS IN A CHAIR NEXT TO THE WIN-
DOW CRYING AS SHE STARES OUTSIDE.

SON: My momma's so upset. She found out
that her special Italian turnover...Pizza Hut's
now got one for lunch, too. Calizza they call it.
How they got the recipe, I don't know.

HIS MOTHER TURNS OVER THE PICTURE
OF ANGELO.

SON: Maybe my cousin Angelo gave it to 'em.

CUT TO A CALIZZA BEING PREPARED.

SON: It's got sausage and green peppers, a
delicious tomato sauce—even a light crust just
like Momma's.

CUT TO SON TALKING TO CAMERA.
MOMMA IS SNIFFLING IN BACKGROUND.

SON: And they serve it in five minutes—
Guaranteed.

SUPER: GUARANTEE APPLIES
11:30AM-1:00PM ON ORDERS OF FIVE
OR LESS.

CUT TO SUPER: CALIZZA™ FOR LUNCH.
AVAILABLE AT PARTICIPATING PIZZA
HUT RESTAURANTS. PIZZA HUT® LOGO.

ANNCR: Calizza Italian turnover. At Pizza Hut.

CUT BACK TO SON.

SON: Momma, they might have a Calizza but
you still gotta me.

MOMMA: (CRIES)

"BEDROOM"

*OPEN ON A LIVING ROOM AS AN
APPROXIMATELY 30-YEAR-OLD MAN
TALKS TO THE CAMERA. HE OCCASION-
ALLY POINTS TO THE BEDROOM.*

SON: As you know, Momma's very upset. She
locked herself in the bedroom. Her special
Italian turnover... Pizza Hut's now got one for
lunch too, Calizza they call it.

MOMMA YELLS IN ITALIAN.

MOMMA: Vivia. (Go away.)

SON: No Momma, I didn't give them the recipe.

CUT TO A CALIZZA BEING PREPARED.

It's got five delicious cheeses, a tomato sauce,
even a light crust, just like Momma's.

*SUPER: GUARANTEE APPLIES
11:30AM-1:00PM ON ORDERS OF FIVE
OR LESS.*

And it's served in five minutes, guaranteed.

*MOMMA YELLS IN ITALIAN. THROWS
SOMETHING AT THE DOOR THAT
SHATTERS.*

MOMMA: Vivia. (Go away.)

SON: I swear, Momma, I didn't.

CUT TO LOGO.

*SUPER: CALIZZA™ FOR LUNCH.
PIZZA HUT® LOGO.*

ANNCR: Calizza™ Italian turnover. At
Pizza Hut.

*SUPER: AVAILABLE AT PARTICIPATING
PIZZA HUT RESTAURANTS.*

CUT BACK TO SON.

SON: She's never comin' out.

HE SMILES.

Hmmm.

ART DIRECTOR
Jean Robaire
WRITER
John Stein
AGENCY
Chiat/Day
Advertising
CLIENT
Pizza Hut, Inc.

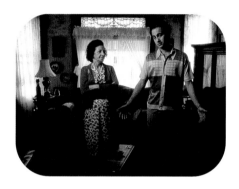 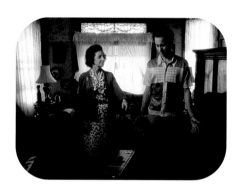

ART DIRECTOR
Jean Robaire

WRITER
John Stein

AGENCY
Chiat/Day
Advertising

CLIENT
Pizza Hut, Inc.

"PACKING"

*OPEN ON A LIVING ROOM AS AN APPROXI-
MATELY 30-YEAR-OLD MAN TALKS TO THE
CAMERA. ON THE COUCH BEHIND HIM HIS
MOTHER IS PACKING A SUITCASE, AS SHE
MUMBLES IN ITALIAN.*

MOMMA: (IN ITALIAN) I have raised him. I
have clothed him. I have fed him. I gave him
everything, everything.

SON: Look at Momma, she's beside herself. She
found out I had Calizza™ for lunch at Pizza Hut.
That wasn't so bad. Then she found out I loved
it. That was bad.

CUT TO CALIZZA™ BEING PREPARED.

They make one with Italian sausage and green
peppers and another with five delicious cheeses,
just like Momma does.

CUT BACK TO SON.

And it's served in five minutes guaranteed.

*SUPER: GUARANTEE APPLIES 11:30AM TO
1:30PM ON ORDERS OF 5 OR LESS.*

CUT TO LOGO.

SUPER: CALIZZA™ FOR LUNCH.

ANNCR: Calizza™ Italian turnover. At Pizza Hut.

*SUPER: AVAILABLE AT PARTICIPATING
PIZZA HUT® RESTAURANTS.*

*CUT BACK TO SON. MOTHER HAS CLOSED
THE SUITCASE AND IS STANDING BESIDE
SON WITH IT. SHE DROPS IT TO THE
FLOOR AT SON'S FEET.*

SON: I can't believe Momma's going.

MOMMA: Momma is not.

 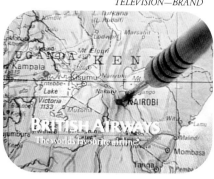

"DART"

ANNCR: Pick up a dart.
Close your eyes.
And throw it.
The odds are that British Airways flies there.
British Airways. The world's favorite airline.

ART DIRECTOR
Douglas Levin
DESIGN DIRECTOR
David Herzbrun
Charlie Adams
WRITER
David Herzbrun
AGENCY
Saatchi & Saatchi
Compton Inc.
CLIENT
British Airways

TELEVISION—BRAND

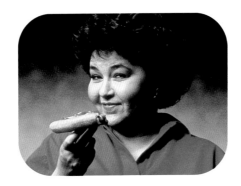 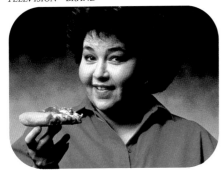

ART DIRECTOR
Doug Patterson
WRITER
Steve Kessler
AGENCY
Chiat/Day
Advertising
CLIENT
Pizza Hut, Inc.

"CLEAN KITCHEN"

OPEN ON A CLOSE-UP OF ROSEANNE BARR EATING A SLICE OF PIZZA.

MUSIC: (UNDER THROUGHOUT.)

ROSEANNE BARR: Let's say you got 3 kids and you take um to Pizza Hut for a pan pizza… OK. One kid probably won't be hungry so that leaves you with 2 kids. One kid, well they'll probably take a bite or two and they're already full so that leaves you with a piece you can still eat, no problem. Then another kid well, they'll eat a slice you know and that leaves you with almost a whole pie for yourself, a clear conscience and a clean kitchen.

SUPER: ROSEANNE BARR

SUPER: PAN PIZZA WITH EVERYTHING.

And to me, that's really what being a mother is all about.

SUPER: PIZZA HUT® LOGO.

"GLOBE"

SFX: AIRPLANE.

ANNCR: Spin the globe.
Point your finger.
The odds are that British Airways flies there.
British Airways. The world's favorite airline.

ART DIRECTOR
Douglas Levin
DESIGN DIRECTOR
David Herzbrun
Charlie Abrams
WRITER
David Herzbrun
AGENCY
Saatchi & Saatchi
Compton Inc.
CLIENT
British Airways

TELEVISION—BRAND

ART DIRECTOR
Doug Patterson

WRITER
Ed Cole

AGENCY
Chiat/Day
Advertising

CLIENT
Pizza Hut, Inc.

"UNIVERSE"

(MUSIC THROUGHOUT)
This is a slice of Pan Pizza. You can tell it's Pan Pizza because I can hold it by the crust and look, gravity is having no effect on it. And yet, I take a bite, it goes right down. It's an incredible universe we live in.

"FAST MOVES/HSA MAJOR/GF"

OPEN ON A LIVING ROOM.

*SUDDENLY, BY MEANS OF AN UNDER-
CRANKED CAMERA, A MOVING CREW
MOVES IN FURNITURE AND THE ROOM IS
FURNISHED INSTANTLY. ACTION STOPS
AND A YOUNG COUPLE ARE SITTING
COMFORTABLY ON THEIR COUCH.*

ANNCR: We can get you into a home loan…fast.

*DISSOLVE TO HOME SAVINGS OF
AMERICA SHIELD.*

ANNCR: Call Home Savings.

SUPER: AN EQUAL HOUSING LENDER (BUG)

SUPER: AN AHMANSON COMPANY

ART DIRECTOR
Dennis Mickaelian
WRITER
Elizabeth Hayes
AGENCY
Chiat/Day
Advertising
CLIENT
Home Savings
of America

TELEVISION—BRAND

ART DIRECTOR
Jean Robaire
WRITER
John Stein
AGENCY
Chiat/Day
Advertising
CLIENT
Pizza Hut, Inc.

"PIZZA FUN—B REV. #1"

OPEN ON FAMILY SITTING AT TABLE
ENJOYING THEIR PIZZA AT PIZZA HUT
RESTAURANT.

MOM: Honey wouldn't…a new rug in the den…
be just perfect?

CUT TO OUR BOY WHO TAKES A BITE
OF PIZZA.

HE CONTINUES TO EAT.

DAD NODS. A WALL IN THE BACK-
GROUND OPENS. BOY IS TRANSPORTED
IN A FANTASY-LIKE WAY ONTO STAGE
IN BACKGROUND.

MUSIC: (UPBEAT PIZZA HUT MUSIC
UNDER THROUGHOUT.)

CUT TO KIDS WALKING SINGLE-FILE
DRESSED IN HAND COSTUMES.

SINGERS: Pi, Pi, Pizza Hut.

CUT TO KIDS DRESSED AS PIZZA
SLICES—THEY JUMP.

SINGERS: Uh oh!

CUT TO BOY CLIMBING LADDER TO
DIVING BOARD.

SINGERS: Pi, Pi, Pi, Pi, Pi, Pi, Pizza Hut.

CUT TO BOY STANDING ON BOARD.

CUT TO BOY CLIMBING DOWN LADDER.

SINGERS: Pi, Pi, Pizza Hut.

CUT TO BOY WITH SUITCASE PREPARING
TO THROW PIZZA DISCUS.

CUT TO PIZZA SLIDING INTO PAN ON
TABLE TOP.

SINGERS: Pizza Hut.

CUT TO BOY SMILING AS HE EATS A SLICE
OF PIZZA.

CUT TO GIRL SINGING.

GIRL: Piz-za Hut!

CUT TO KIDS AT TABLE IDENTICALLY
DRESSED WHO JUMP UP AND DOWN.

CUT TO BOY TWIRLING AROUND.

CUT TO KIDS AT TABLE DANCING.

SINGERS: Pizza Hut.

CUT TO BOY CONTINUING TO TWIRL.

CUT TO FAMILY SITTING AT TABLE AT
PIZZA HUT RESTAURANT. BOY TWIRLS
INTO FRAME.

MOM: Let's go back to that…

CUT TO STAGE CURTAIN CLOSING.

SUPER: PIZZA HUT® LOGO.

OUR BOY COMES OUT TWIRLING. THEN
BITES SLICE OF PIZZA.

FADE OUT.

"MOTHER'S DAY"

MUSIC: (UNDER THROUGHOUT.)

*OPEN ON A CU OF GARRY SHANDLING
EATING A SLICE OF PIZZA.*

SHANDLING: You know, I'm very loyal in a
relationship, any relationship, even when I go out
with my Mom, I don't, I don't think, "Oh, I
wonder what that Mom is like. I wonder what her
macaroni and cheese tastes like."

I love my Mom. On Mother's Day, I take her out
for pizza. Say, "Mom, get whatever you want on
your half." She's in heaven.

SUPER: GARRY SHANDLING

SUPER: PAN PIZZA WITH A BIG HUG.

SUPER: PIZZA HUT® LOGO

ART DIRECTOR
Tom Cordner
Jean Robaire
WRITER
Brent Bouchez
John Stein
AGENCY
Chiat/Day
Advertising
CLIENT
Pizza Hut, Inc.

TELEVISION—BRAND

ART DIRECTOR
John LeeWong
WRITER
Bill Ryan
AGENCY
DYR
CLIENT
Sanyo Electric

"LEAP FROG"

OPEN ON A LILY POND.

SFX: (POND SOUNDS, CROAKING, BIRDS.)

WE PULL BACK TO SEE THAT IT'S ON A TV MONITOR.

ANNCR: Most people think the picture they get off their video recorder is pretty good.

A FROG HOPS INTO THE PICTURE.

SFX: (RIBBIT.)

THE CAMERA PULLS BACK AND PANS AS THE FROG CASUALLY HOPS ALONG, PASSING SEVERAL OTHER MONITORS.

ANNCR: At Sanyo, we don't think they're good enough.
So we're introducing Sanyo Super Beta…

HE STOPS IN FRONT OF 2 MONITORS, ONE THAT HAS A SANYO SUPER BETA HI-FI IN FRONT OF IT, AND AN ORDI-NARY MONITOR.

SFX: (RIBBIT.)

PAN OF EQUIPMENT.

ANNCR:…with a picture that's 20% better no matter what kind of TV you own,

CU FROG'S FACE.

SFX: (RIBBIT.)

FROG'S POV. A DRAGONFLY APPEARS ON THE SCREEN. HE'S TRYING TO DECIDE WHICH IS MORE REAL.

ANNCR: and stereo sound that's better than most audio equipment.

SFX: (DRAGONFLY BUZZ, RIBBIT.)

CU FROG'S FACE. THE FROG JUMPS ONTO THE SCREEN…AND BOUNCES HARMLESSLY OFF.

ANNCR: Sanyo Super Beta. It brings you 20% closer to reality.
And 20% is a lot.

FROG SITTING ON MONITOR.

SFX: (RIBBIT, RIBBIT.)

SUPER: SANYO. THE MODERN ART OF ELECTRONICS.

ANNCR: Super Beta from Sanyo. The Modern Art of Electronics.

"SALAD BAR"

VIDEO: OPEN ON ROSEANNE BARR EATING A SLICE OF PIZZA.

(MUSIC UNDER THROUGHOUT)

BARR: So my husband says to me, "Roseanne you've been workin' real hard. How 'bout if we take the kids out for pan pizza and you can eat at the salad bar?" So I said, "Well what a great idea, honey. While you and the kids are eatin' a hot, steamy, cheesy pizza, I can be off in the corner grazing on a delightful array of sprouts and garbanzo beans.

DISSOLVE TO SUPER: ROSEANNE BARR

Get real."

DISSOLVE TO SUPER: PAN PIZZA...HOT... STEAMY...CHEESY.

DISSOLVE TO PIZZA HUT® LOGO.

ART DIRECTOR
Doug Patterson
WRITER
Steve Kessler
AGENCY
Chiat/Day
Advertising
CLIENT
Pizza Hut, Inc.

TELEVISION—BRAND

*CREATIVE ART
DIRECTOR*
Frank Rizzo

*CREATIVE DIRECTOR,
WRITER*
Doug Rucker

AGENCY
Tracy-Locke

CLIENT
Haggar

"GALLERY / SURREAL."

MUSIC: (SYNTHESIZED JAZZ.)

ANNCR: Styles in pure wool have never been in better shape. The fit for the fit.

Gallery by Haggar.

"TABLES, REVISION 1"

MUSIC: (UNDER THROUGHOUT.)

*OPEN ON CU OF GARRY SHANDLING
EATING A SLICE OF PIZZA.*

SHANDLING: You know I'm single and a lot of
people assume that means I can't cook. And it's
just not true. A lot of times I'll invite a woman
over to my house, make her dinner, and they
don't seem to like oatmeal, and they'll leave.

But I haven't had that trouble since I discovered
Pan Pizza. I'll pick one up, take it home, women
love it.

TAKES A BITE OF PIZZA.

SHANDLING: I can fill 10, 15 tables a night at my
place now.

SUPER: GARRY SHANDLING

SUPER: PIZZA TO GO.

SHANDLING: Next week, I'm puttin' in video
games. You think that's too much?

SUPER: PIZZA HUT® LOGO

ART DIRECTOR
Tom Cordner
Jean Robaire
WRITER
Brent Bouchez
John Stein
AGENCY
Chiat/Day
Advertising
CLIENT
Pizza Hut, Inc.

TELEVISION—BRAND

ART DIRECTOR
Jean Robaire

WRITER
John Stein

AGENCY
Chiat/Day
Advertising

CLIENT
Pizza Hut, Inc.

"PIZZA FUN—A REV. #1"

OPEN ON FAMILY ENJOYING THEIR PIZZA AT PIZZA HUT.

DAD: Do you like the beige suit?

MOM: Um Hum.

CUT TO OUR BOY WHO TAKES A BITE OF PIZZA.

DAD: Yeah? I think I'll wear the beige suit.

FAMILY CONTINUES TO EAT. A WALL IN THE BACKGROUND OPENS, BOY IS TRANS-PORTED IN FANTASY-LIKE WAY TO STAGE IN BACKGROUND.

MUSIC: (UPBEAT PIZZA HUT® MUSIC UNDER THROUGHOUT.)

CUT TO LEVITATION SCENE.

SINGERS: Pi, Pi, Pi, Pizza Hut.

CUT TO CU OF BOY SMILING AND DRINK-ING FROM PIZZA HUT® PAPER CUP.

SINGERS: Pizza Hut.

CUT TO CU OF PIZZA IN PAN.

CUT TO DANCER PERFORMING JUMPING SPLITS.

SINGERS: Hut, Hut, Hut.

CUT TO 4 IDENTICALLY DRESSED DANCERS IN SYNCHRONIZED DANCE STEPS.

SOLO: Pizza Hut.

CUT TO BOY DRESSED AS MAGICIAN, PLAYFULLY SPINNING PIZZA PANS ON STICKS.

SINGERS: Pi, Pi, Pizza Hut.

CUT TO BOY SITTING NEXT TO SMILING FACE PERFORMING VENTRILOQUIST ACT.

SINGERS: Hut, Hut, Hut.

CUT TO FOOTBALL PLAYER DROPPING FOOTBALL ON END OF TEETER-TOTTER. BOY PREPARES TO JUMP.

CUT TO FAMILY SITTING IN SAME POSI-TIONS AS BEFORE. BOY SUDDENLY DROPS INTO HIS SEAT. HE CONTINUES TO EAT PIZZA.

MOM: Do you think you can remember to pick up the cake for the anniversary?

CUT TO STAGE CURTAIN CLOSING.

SUPER: PIZZA HUT® LOGO APPEARS ON CURTAIN.

BOY COMES OUT AND TAKES A BOW.

"DRIVING"

MUSIC: (UNDER THROUGHOUT)

OPEN ON TOM POSTON EATING A SLICE OF PAN PIZZA.

POSTON: When I'm bringing home a pizza from Pizza Hut, I drive very carefully. I don't change lanes much. I avoid jack-rabbit starts and stops, and I make turns extra carefully, too. I think instead of having traffic cops, everybody should drive around with a pizza in their car. "Pu'l over, let's see your toppings." "You old enough to drive that pizza?"

TAKES A BITE OF PIZZA.

SUPER: TOM POSTON

SUPER: PAN PIZZA TO GO AT NO MORE THAN 20 MPH.

SUPER: PIZZA HUT® LOGO.

ART DIRECTOR
Tom Cordner
Jean Robaire

WRITER
Brent Bouchez
John Stein

AGENCY
Chiat/Day
Advertising

CLIENT
Pizza Hut, Inc.

TELEVISION—BRAND

ART DIRECTOR
Tom Cordner
Jean Robaire
WRITER
Brent Bouchez
John Stein
AGENCY
Chiat/Day
Advertising
CLIENT
Pizza Hut, Inc.

"BLIND DATE—REVISED"

OPEN ON GARRY SHANDLING HOLDING A PERSONAL PAN. HE IS EATING ONE OF THE PIZZA SLICES FROM THE PAN AS HE TALKS TO US.

SHANDLING: You know the last blind date I had was a blind lunch date. I told this girl to meet me at Pizza Hut, cuz they have this lunch pizza that they guarantee they can serve in 5 minutes, right?

I ordered the pizza…turned out great. Ordered it, ate it, laughed, talked, had a great time… then my date showed up.

SUPER: GARRY SHANDLING

SUPER: SUPREME PERSONAL PAN PIZZA.

GUARANTEED IN FIVE MINUTES OR YOUR NEXT ONE IS FREE.

GUARANTEE APPLIES 11:30AM-1:00PM ON ORDERS OF FIVE OR LESS.

SUPER: PIZZA HUT® LOGO.

SAFETY TIP—NEVER TOUCH A HOT PAN WITH YOUR FINGERS.

"ON HOLD"

VIDEO: A Businessman sitting behind his desk calls his bank to ask a question. He is put on hold and grows more and more impatient.

AUDIO:
MAN: Yes, I'd like to know the date my CD matures.

WOMAN: Hold for Mr. Parks, please.

VO: If you have a simple question, you should get a simple answer.

ART DIRECTOR
Richard Smith
PRODUCER
Pam Poertner
WRITER
Jeff Millman
PHOTOGRAPHER/ ILLUSTRATOR
Big Picture Productions
AGENCY
Smith, Burke & Azzam
CLIENT
Bank of Baltimore

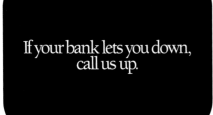

If your bank lets you down,
call us up.

THE BANK
OF BALTIMORE

800-223-2020

ART DIRECTOR
Richard Smith

PRODUCER
Pam Poertner

WRITER
Jeff Millman

*PHOTOGRAPHER/
ILLUSTRATOR*
Big Picture Productions

AGENCY
Smith, Burke & Azzam

CLIENT
Bank of Baltimore

"IN BOX"

*VIDEO: The camera begins at the base of a stack
of papers in a Banker's 'in box.' The camera
moves up the stack of papers until it comes to
rest on the loan application which the Banker is
discussing over the phone.*

*AUDIO: (The Banker is on the phone with a
customer. Only the Banker's end of the conversa-
tion is heard.)*

BANKER: Yes. Mr. North, the loan...Well, I
don't have an answer for you yet...Well, it
doesn't happen overnight, I'm afraid...I'm
not sure, Mr. North...Well, I have it right here
in front of me and we're working on it...Well,
we are working on it, Mr. North.

ANNCR: If you need the answer fast, you
should get the answer fast.

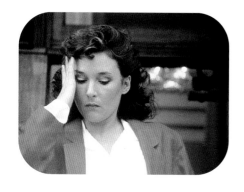 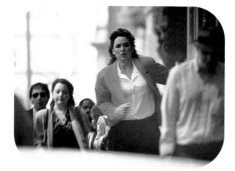 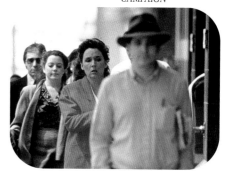

THE BANK
OF BALTIMORE

If your bank lets you down,
call us up.

800-223-2020

"WOMAN"

VIDEO: A woman leaves a bank and begins to walk down a busy street. She becomes overwhelmed with emotion as she recalls the conversation she just had.

AUDIO:
BANKER: I'm sorry, but your credit history isn't strong enough and your husband has mismanaged a lot...

WOMAN: Wait a minute. He's not my husband anymore.

BANKER: I understand.

WOMAN: You understand? Then why are you bringing it up?

BANKER: Look, I just can't sell this upstairs.

WOMAN: At least listen to me!

BANKER: There's really nothing I can do.

WOMAN: I'm trying to explain my situation, why are you brushing me off? At least let me...
(FADES)

VO: If you have a special situation, you should get special consideration.

ART DIRECTOR
Richard Smith
PRODUCER
Pam Poertner
WRITER
Jeff Millman
PHOTOGRAPHER/
ILLUSTRATOR
Big Picture Productions
AGENCY
Smith, Burke & Azzam
CLIENT
Bank of Baltimore

ART DIRECTOR
Tom Cordner
Jean Robaire
WRITER
Brent Bouchez
John Stein
AGENCY
Chiat/Day
Advertising
CLIENT
Pizza Hut, Inc.

"SALAD BAR"

*VIDEO: OPEN ON ROSEANNE BARR
EATING A SLICE OF PIZZA.*

(MUSIC UNDER THROUGHOUT)

BARR: So my husband says to me, "Roseanne
you've been workin' real hard. How 'bout if we
take the kids out for pan pizza and you can eat
at the salad bar?" So I said, "Well what a great
idea, honey. While you and the kids are eatin'
a hot, steamy, cheesy pizza, I can be off in the
corner grazing on a delightful array of sprouts
and garbanzo beans.

DISSOLVE TO SUPER: ROSEANNE BARR

Get real."

DISSOLVE TO SUPER: PAN PIZZA…HOT…
STEAMY…CHEESY.

DISSOLVE TO PIZZA HUT® LOGO.

"DRIVING"

MUSIC: (UNDER THROUGHOUT)

*OPEN ON TOM POSTON EATING A SLICE
OF PAN PIZZA.*

POSTON: When I'm bringing home a pizza
from Pizza Hut, I drive very carefully. I don't
change lanes much. I avoid jack-rabbit starts
and stops, and I make turns extra carefully, too.
I think instead of having traffic cops, every-
body should drive around with a pizza in their
car. "Pull over, let's see your toppings." "You
old enough to drive that pizza?"

TAKES A BITE OF PIZZA.

SUPER: TOM POSTON

*SUPER: PAN PIZZA TO GO AT NO MORE
THAN 20 MPH.*

SUPER: PIZZA HUT® LOGO.

ART DIRECTOR
Tom Cordner
Jean Robaire

WRITER
Brent Bouchez
John Stein

AGENCY
Chiat/Day
Advertising

CLIENT
Pizza Hut, Inc.

ART DIRECTOR
Tom Cordner
Jean Robaire

WRITER
Brent Bouchez
John Stein

AGENCY
Chiat / Day
Advertising

CLIENT
Pizza Hut, Inc.

"TABLES, REVISION 1"

MUSIC: (UNDER THROUGHOUT.)

*OPEN ON CU OF GARRY SHANDLING
EATING A SLICE OF PIZZA.*

SHANDLING: You know I'm single and a lot of
people assume that means I can't cook. And it's
just not true. A lot of times I'll invite a woman
over to my house, make her dinner, and they
don't seem to like oatmeal, and they'll leave.

But I haven't had that trouble since I discovered
Pan Pizza. I'll pick one up, take it home, women
love it.

TAKES A BITE OF PIZZA.

SHANDLING: I can fill 10, 15 tables a night at my
place now.

SUPER: GARRY SHANDLING

SUPER: PIZZA TO GO.

SHANDLING: Next week, I'm puttin' in video
games. You think that's too much?

SUPER: PIZZA HUT® LOGO

"BLIND CHILDREN'S CENTER"

SINGER: I can see clearly now, the rain is gone. I can see all obstacles in my way. Gone are the dark clouds that had me blind. . .Gonna be a bright, bright sunshiney day. Gonna be a bright, bright sunshiney day. Look all around, there's nothing but blue skies. . .look straight ahead nothing but blue skies. . .

ANNCR: With the extra love, care and support of the Blind Children's Center, you'd be amazed at how much a blind child can see.

SINGER: Gonna be a bright, bright sunshiney day.

ART DIRECTOR
Jeff Roll
WRITER
Dave Butler
AGENCY
Chiat/Day
Advertising
CLIENT
Blind Children's Center

RADIO

WRITER	*WRITER*		
Brent Bouchez	Phil Lanier		
John Stein	*AGENCY*		
AGENCY	Chiat/Day		
Chiat/Day	Advertising		
Advertising	*CLIENT*		
CLIENT	Apple Computer, Inc.		
Pizza Hut, Inc.			

"INTRO"

SFX: (PARTY HORNS.)

DOUG: Good day, eh?

BOB: Gee, sounds like something happened to a cat.

DOUG: I'm Doug McKenzie, this is my brother Bob.

SFX: (PARTY HORN.)

DOUG: And we're celebrating. Tell him why, Bob.

BOB: We're having a party to celebrate that Pizza Hut now delivers pizza.

DOUG: Yeah.

BOB: So we didn't have to go there to get our pizza. It came here.

SFX: (PARTY HORN.)

DOUG: So we're real happy, eh. We can get all the pizza we want delivered to our home.

SFX: (PARTY HORN.)

DOUG: We invited all our friends, too. As you can see no one came.

BOB: Huh.

DOUG: So, big deal.

BOB: We asked the delivery guy to come in and have it with us, but he was busy—having other deliveries.

DOUG: He took one look at us and said, "Err, no thanks, guys."

BOB: But remember, you can now call Pizza Hut and have your pizza delivered…right to your house.

SFX: (PARTY HORN.)

DOUG: So, why don't you join the party, eh?

ANNCR: (LOCAL 0:12 TAG GIVING PHONE NUMBER TO CALL.)

"TRICK OR TREAT"

SFX: (DING, DONG. KNOCK, KNOCK.)

KIDS: (ALL) Trick or treat!

SFX: (DOOR OPENING.)

MAN: Whooaa! Hey, you guys are pretty scary. (Ha, Ha.) Okay, open up those bags for some big Apples.

KIDS: (DISAPPOINTED) Apples…

KID #1: Okay, guys, let's fill his car with shaving cream.

MAN: Wait, wait, wait!

KID #2: And stuff his mailbox with dead fish. *(WALKING AWAY.)*

MAN: Apples are good for you.

KID #3: I'll squash his pumpkin. *(FARTHER.)*

MAN: Alright! Alright! I'll just give all these Apple IIc personal computers to the next bunch of kids that come along.

SFX: (DOOR SLAM. DING, DONG. THEN POUNDING ON DOOR.)

KIDS: Hey, Mister, just kidding. Yeah, we really like apples! Joke! Joke!

MUSIC: (UNDER ANNOUNCER.)

ANNCR: The Apple IIc personal computer is a real treat for kids. There are more Apple computers used in schools than all other brands combined. So they can run the same educational programs kids use in class. Not to mention thousands of business and home management programs for adults.

MUSIC: (OUT.)

MAN: Here's an Apple for you…And here's an Apple for you.

SFX: (KA-PLOP! BAG RUSTLING.)

KIDS: Wow! Totally rad.

KID #1: Hey, Mister, why are you giving away Apple computers for Halloween, huh?

MAN: Well, last year I tried giving away that other brand.

KID #1: Yeah?

MAN: Someone filled my swimming pool with cement.

KID #1: Oh…

MUSIC: (UP AND UNDER ANNOUNCER.)

ANNCR: Apple IIc personal computers. The Halloween treat that won't rot their teeth.

"HI, DAD"

FATHER: Billy, you've laid around long enough. If you want to go to college, you'll have to get out there and get a job.

BILLY: Goo…

MUSIC: (UNDER ANNOUNCER AND OUT.)

ANNCR #1: Studies show that the people most traumatized by college aren't students. They're parents.

SFX: (PHONE)

DAD: Hello.

SON: Hi, Dad, it's tuition time again.

DAD: Dad who?

SON: Put Mom on the phone.

DAD: Mom who?

ANNCR #2: So Apple, the company whose computers help kids get through school, is going to help parents get through school. It's Apple's $1,000,000 Education Sweepstakes. Grand Prize: $100,000 cash. Plus rebates of up to $250 on an Apple Computer system.

DAUGHTER: Stanford, Yale, Harvard—I was accepted everywhere!

MOM: That's wonderful darling. Your father and I always wanted to live in an RV.

ANNCR #3: There's thousands of prizes. And rebates of up to $250 when you buy an Apple computer at any participating authorized Apple dealer. So enter Apple's Education Sweepstakes. And maybe, your kid'll go off to college with $100,000 in their pocket.

SFX: (PHONE.)

DAD: Hi, son, it's mortgage time again.

SON: Son who?

ANNCR #4: No purchase necessary for sweepstakes entry. See dealer for details. Offer void where prohibited. Entrants must be 16 or older. Sweepstakes ends September 30th.

"THE OFFICE"

SFX: (OFFICE AMBIANCE THROUGHOUT.)

SON: Most people, when they get something to go for lunch take it back to their office. Not me… I take it to somebody else's office where no one can find me…not even Momma. I swing by Pizza Hut and grab a Calizza Italian turnover. Momma wouldn't like it, but hey, the stuff's perfect for carrying out. It's not messy so I can eat here in Mr., uh, Terwilliger's office, read his magazines and not get stuff on them. It's the perfect size. It stays hot real long, and Pizza Hut serves Calizza in five minutes guaranteed. What's this, a horseshoe paperweight?

SFX: (HORSESHOE CLANGING ON DESK.)

SON: Give me a break…I get Calizza with Italian sausage and green peppers, though sometimes I get the one with five cheeses. Anyway, they stuff everything in fresh dough, fold it over to seal in the flavor and bake it until golden-brown.

SFX: (PHONE RING.)

SON: Uh, jeez…*(IN FALSETTO VOICE)* "Mr. Terwilliger's office."

MOMMA: (IN ITALIAN) I found you!

SON: Momma???

ANNCR: When you order carryout Calizza™ Italian turnover for lunch at participating Pizza Hut® Restaurants, they'll serve you in five minutes or less guaranteed or the next one's free. Guarantee applies on orders of five or less between 11:30am and 1:00pm.

WRITER
Steve Kessler
AGENCY
Chiat/Day
Advertising
CLIENT
Apple Computer, Inc.

RADIO
WRITER
Brent Bouchez
John Stein
AGENCY
Chiat/Day
Advertising
CLIENT
Pizza Hut, Inc.

RADIO

WRITER
Phil Lanier

AGENCY
Chiat/Day
Advertising

CLIENT
Apple Computer, Inc.

ART DIRECTOR
David Lowenbein

WRITER
Jerry Brown

AGENCY
DiIorio, Wergeles, Inc.

CLIENT
All American
Gourmet Co.

"SPACE MONSTER RUNS AMOK"

DAD: Honey, look what I got for the kids!

MOM: Lemme see!

DAD: It's a radio-controlled model of the space monster that ate Tokyo!

SFX: (MONSTER MOVING, MECHANICAL WHINING.).

MOM: Oh, that's nice.

MUSIC: (UP AND UNDER ANNOUNCER.)

ANNCR: This Christmas, instead of giving your kids something to destroy Tokyo, why not help them attack life? With an Apple II personal computer.

MUSIC: (OUT.)

SFX: (MONSTER KEEPS WHIRRING AND WHINING.)

DAD: Yeah look! His eyes are really lasers. He's got the projectile knee caps. His feet are warheads.

MOM: Don't point it at me.

DAD: Oh, I'm sorry. I don't think it's loaded.

SFX: (MISSILE BLASTING OFF. LAMP CRASHING.)

MOM: It shot my lamp!

DAD: I never liked the lamp!

MUSIC: (UP.)

ANNCR: There are more Apple computers in schools than all other brands combined. So they're perfect for helping kids with their homework and school projects.

MUSIC: (OUT.)

SFX: (THE RELENTLESS MONSTER KEEPS MOVING.)

MOM: It's headed for the stereo!

DAD: Maybe it doesn't like easy listening.

MUSIC: (UP.)

ANNCR: Yet an Apple II is powerful enough to run business, personal finance and home management programs for adults.

MUSIC: (OUT.)

SFX: (MONSTER GETS LOUDER, COMING TOWARDS US.)

MOM: I don't like the way it's looking at me.

DAD: It's not looking. It's heatseeking.

ANNCR: And Christmas is actually a great time to buy an Apple II. Because your authorized Apple dealer is offering great prices on every Apple model and peripherals. See your authorized Apple dealer. And help your family attack life. With an Apple II.

SFX: (LOUDER, COMING TOWARDS US.)

DAD: Run for it, Marge!

SFX: (MISSILE FIRING.)

MOM: Ralph!

DAD: Tell the kids I love 'em.

SFX: (TWO MISSILES FIRING.)

MUSIC: (FADES OUT.)

"THE HOMECOMING"

ANNCR: The Budget Gourmet Slim Line presents "The Homecoming."

SFX: (DOORBELL.)

MOM: Yes?

BILLY: Hi! I'm home.

MOM: Who's home?

BILLY: Your son.

MOM: Where?

BILLY: Here.

MOM: Who?

BILLY: Me.

MOM: You?

BILLY: It's Bill, your boy. Don't you recognize me, Mom?

MOM: My Bill's a big, fat, roly-poly boy.

BILLY: I lost some weight.

MOM: You lost your mind, Mister. You're not my Billy.

BILLY: Mom, remember the lullaby you used to sing me?

MOM: You mean…?

BILLY (SINGING): "Heaps of mashed potatoes sitting on my plate…"

BOTH (SINGING): "Roast beef and pumpkin pie, candied yams…"

MOM: Oh, Bill, you look skinnier than a lizard! Let me make you dinner.

BILLY: I brought my own.

MOM: What?

BILLY: The Budget Gourmet Slim Line entrees—all under 300 calories.

MOM: Under 300?

BILLY: There's a huge variety, like Sirloin of Beef in Herb Sauce with Noodles…

MOM: No!

BILLY: Mandarin Chicken in savory Plum Sauce…

MOM: No!

BILLY: and Linguini with Scallops and Clams!

MOM: Yeah, but how much do they cost?

BILLY: Around $1.89.

MOM: $1.89? (WHISTLE) Pa!

PA: What?

MOM: From now on, we're eating the Budget Gourmet Slim Line entrees, like Billy boy here.

PA: Where?

MOM: There!

PA: Huh?

BILLY: Here!

PA: Who?

BILLY: Me!

PA: You?

BILLY AND MOM: Yeah!

ANNCR: The Budget Gourmet Slime Line entrees—at around $1.89 and under 300 calories, one of man's lighter creations.

"RAOUL"

RAOUL: (SINGING) "Allez-vous-en..."

MONSIEUR: Raoul, how long have you been our cook?

RAOUL: Ever since you stole me from zat little French cafe.

MONSIEUR: Um, could you explain these cardboard boxes I found in the kitchen?

RAOUL: Oui—zey are boxes made of cardboard.

MONSIEUR: They say the Budget Gourmet Dinners on them.

RAOUL: Oh ho ho—Monsieur is sticking ze nose into Raoul's kitchen!

MONSIEUR: Take last night's scrumptious Scallops and Shrimp Dinner with tender Rice and Broccoli—wasn't that really one of the Budget Gourmet Dinners?

RAOUL: Similar.

MONSIEUR: How similar?

RAOUL: Close.

MONSIEUR: How close?

RAOUL: It's ze same.

MONSIEUR: And what about the Budget Gourmet Veal Parmegian Dinner with Tortellini and Italian style Green Beans—isn't that what we had the night before last?

RAOUL: Similar.

MONSIEUR: How similar?

RAOUL: Close.

MONSIEUR: How close?

RAOUL: It's ze same.

MONSIEUR: Raoul—!

RAOUL: Well, you try making a wonderful dinner night after night.

MONSIEUR: Raoul, we've been paying you $1500 a week. The delicious Budget Gourmet Dinners are only around $2.09!

RAOUL: Uh oh, ze cat is out of ze sock—

MONSIEUR: What?

RAOUL: Or is it ze shoe?

MONSIEUR: Raoul, you're fired.

RAOUL: Okay, well I hope you can find someone to cut up your meat into teensy pieces.

MONSIEUR: OK, you can stay.

RAOUL: Who knows how to play "Here comes ze airplane—"

MONSIEUR: Alright, I won't fire you—

ANNCR: The Budget Gourmet Dinners— at around $2.09, yet another of man's more ingenious creations.

"MOORE"

SFX UNDER

ANNCR: There's the play of fountains in the morning air. There are beds of day lilies in the springtime and colorful camellias in the win There are sweeping lawns and quaint chapels tucked into glens filled with oak and cedar. But the real beauty of Forest Lawn is the helpfulness of Mortuary Counselors like Jim Moore.

JIM: My job is to help. For a few days, I become a part of every family I work with.

ANNCR: Jim has been with Forest Lawn Mortuaries 36 years.

JIM: I suppose I've made, uh, funeral arrangements for thousands of families. Oh, easy— thousands. And each one is different: Um... different backgrounds; different religions. And, uh, very personal feelings about what a funeral should be.

ANNCR: When he speaks, he speaks for all of us.

JIM: I...I would like people to feel that, uh, no matter who they are, or where they came from, or what they believe, I can take care of 'em. That's, uh, what I do, you know.

ANNCR: The real beauty of Forest Lawn is how much we care.

"VARIETY SPOT"

ANNCR: We're here at D'Lites talking with some of the health nuts who love D'Lites lower calorie food. You sir, at the salad bar.

MAN: Me?

ANNCR: Bet you jogged all the way over here.

MAN: Yeah. All the way from the parking lot. You're blocking the pickles, pal.

ANNCR: I'm sorry. And you ma'am, I'm guessing you're heavy into aerobics.

WOMAN: Actually, I'm heavy into this Italian pasta salad.

MAN: She's heavy into everything.

WOMAN: Why you...

SFX: Food Throw

ANNCR: Watch out for the flying Italian pasta salad. Now you know there's over 40 delicious items at D'Lites all-you-can-eat salad bar. But what about those great healthy D'Lites sandwiches? Now here we have a guy tearing into a D'Lites fish filet. You probably just played 12 straight games of squash.

MAN 2: Well, actually I hate squash but I don't like yams either. But I love their fish filet.

ANNCR: Oh well, apparently you don't have to be a health nut to love D'Lites. You just have to be nuts about good food. Whew. Boy is my face red. Yikes.

ART DIRECTOR
David Lowenbein
WRITER
Jerry Brown
AGENCY
DiIorio, Wergeles, Inc.
CLIENT
All American
Gourmet Co.

RADIO
WRITER
Jean Craig
AGENCY
Kresser, Craig / D.I.K.
CLIENT
Forest Lawn Mortuaries

PRODUCER
Jeff Millman
Pam Poertner
WRITER
Brian Klam
AGENCY
Smith, Burke & Azzam
CLIENT
D'Lites of America

RADIO

WRITER
Adam Kaufman
Jean Craig
AGENCY
Kresser, Craig/D.I.K.
CLIENT
ARCO - am/pm Mini
Markets

CREATIVE DIRECTOR
Scott Montgomery
Ken Sakoda
WRITER
Scott Montgomery
PRODUCTION STUDIO
L.A. Studios
AGENCY
Salvati Montgomery
Sakoda
CLIENT
International House
of Pancakes

"HOT DOG SOUND EFFECTS"

SFX: FANFARE

ANNCR: This is the sound of 2 hot dogs.

SFX: ROOF, ROOF, ROOF, ROOF.

ANNCR: This is the sound of 89¢.

SFX: CASH REGISTER.

ANNCR: You got that. Hot dogs.

SFX: ROOF, ROOF.

ANNCR: 2 for 89¢.

SFX: CASH REGISTER

ANNCR: Now this is the sound of ketchup.

SFX: GLOP, GLOP.

ANNCR: And mustard.

SFX: SPLAT, SPLAT.

ANNCR: On as you like. Because at AM/PM Mini Markets you can help yourself to the works...

SFX: JACKHAMMER.

ANNCR: For just 89¢.

SFX: CASH REGISTER.

ANNCR: And if you're daring, you can add onions...

SFX: SOB, SOB.

ANNCR: Relish.

SFX: SMACK, SMACK.

ANNCR: Or pickles.

SFX: PUCKER, PUCKER.

ANNCR: Which means you can have two...

SFX: ROOF, ROOF.

ANNCR: Smothered with...

SFX: GLOP, SPLAT, SOB, SMACK, PUCKER.

ANNCR: So, to sum it up, at AM/PM Mini Markets, now til March 16, you can get two hot dogs...

SFX: ROOF, ROOF, ROOF, ROOF.

ANNCR: With the works.

SFX: JACKHAMMER.

ANNCR: And remember, the suggested price is just 89¢.

SFX: (SINGERS) HALLELUJAH.

ANNCR: That's two for 89¢.

SFX: (SINGERS) HALLELUJAH, HALLELUJAH.

ANNCR: Offer good at participating stores. Prices may vary.

SFX: ROOF, ROOF.

ANNCR: Dog voices impersonated.

"ATTILA"

SFX: (MARCHING, ARMY SOUNDS UNDER THROUGHOUT)

ANNCR: Attila the Hun?

ATTILA: Bingo.

ANNCR: I'm curious. Where's a guy-on-the-go like you eat breakfast?

ATTILA: International House of Pancakes Restaurant.

ANNCR: No fast food?

ATTILA: Fast food? I'm into looting, pillaging, general mayhem...I'm gonna do all that on some wimpy biscuit topped with a rubber egg?

ANNCR: Good point.

ATTILA: You can't beat the International House of Pancakes for breakfast.

ANNCR: No.

ATTILA: Big, three-egg omelettes, fresh blintzes and waffles. Fresh, not frozen. My guys'll kill for 'em.

ANNCR: And those pancakes...

ATILLA: German, Swedish, French...Countries I've never even conquered yet.

ANNCR: Great food, cooked to order, served right to your table.

ATTILA: Yeah. Listen, we're scheduled to sack Rome tonight...What say we meet you at the International House of Pancakes there for breakfast?

ANNCR: You're on.

ATTILA: Say...eight-ish?

ANNCR: Right.

ATTILA: Maybe nine-ish. I could use an hour to freshen up.

"VOICES"

AGENT: Feelgood Insurance.

IRVING: Yes Sir, I'd like to get some health insurance for my company.

AGENT: Fine. How many employees?

IRVING: Oh...Uh...how many do I need?

AGENT: Well, the more you have the less the premiums.

IRVING: Oh...well...I have a lot of employees. Isn't that right, Mildred? *(IN WOMAN'S VOICE)* oh, yes. We're running out of space. *(IN GRUFF MAN'S VOICE)* They need you down in shipping, Irving. *(IN NORMAL VOICE)* Not now, Barney, please... *(IN YOUNG WOMAN'S VOICE)* Mr. Irving...

ANNCR: ...Now you don't have to have a lot of employees to get comprehensive health coverage. Because with Diamond Benefits Group, any size company can afford health insurance. No matter how big...

IRVING: *(IN WOMAN'S VOICE)*...we've got to make arrangements for the company picnic, Irving...

ANNCR: ...or how small.

IRVING: ...*(WOMAN'S VOICE)* Oh, it's so busy here, I...

AGENT: ...Uh, sir...just how many employees do you have?

IRVING: *(WOMAN'S VOICE)* Well I... *(NORMAL)*...you mean, counting Barney and Mildred and Suzy and...

AGENT: Yes.

IRVING: ...two.

ANNCR: Call your insurance agent or 1-800-826-0311 and ask about Diamond Benefits Group. Diamond Benefits Group. We're keeping America's businesses healthy.

"COLUMBUS"

SFX: *(WIND, SHIP CREAKING, SEAGULLS UP AND UNDER)*

ANNCR: Christopher Columbus?

CHRIS: Yo.

ANNCR: On your way to the New World?

CHRIS: *I* think so. But my crew thinks if we sail much further, we're history.

SFX: *(CREW GRUMBLES)*

ANNCR: Well, if you feed them right, I'm sure they'll stick around.

CHRIS: That's what *I* thought. So I bring along dozens of Mr. Whoopie fast food burgers, and they *still* complain.

ANNCR: Here. Try this leg.

CHRIS: Thanks.

SFX: *(CRUNCH)*

ANNCR: Ouch! Not *my* leg. This juicy chicken leg from the International House of Pancakes Restaurant.

CHRIS: The International House of Pancakes has chicken like this?

ANNCR: Sure. Not only do they serve fantastic breakfasts, they serve incredible dinners, too. Tender London broil, crunchy shrimp, sauteed fish, veal parmigian...

CHRIS: Veal parmigian?

ANNCR: With real spaghetti and garlic bread.

CHRIS: Sounds fabulisimo. How do we get there?

ANNCR: Go straight about 200 miles and hang a right at the edge of the world.

SFX: *(CREW PANICS)*

ANNCR: Just kidding, just kidding.

RADIO

WRITER
Rick Colby
AGENCY
LarsenColbyKoralek
CLIENT
Diamond Benefits
(multicolor)

CREATIVE DIRECTOR
Scott Montgomery
Ken Sakoda
PRODUCTION STUDIO
L.A. Studios
WRITER
Doug Reeves
AGENCY
Salvati Montgomery
Sakoda
CLIENT
International House
of Pancakes

RADIO

WRITER
Brent Bouchez
John Stein

AGENCY
Chiat/Day
Advertising

CLIENT
Pizza Hut, Inc.

ART DIRECTOR
Richard Smith

PRODUCER
Jeff Millman
Pam Poertner

WRITER
Jeff Millman

AGENCY
Smith, Burke & Azzam

CLIENT
Playboy Magazine

"LAST SLICE"

SFX: (DOOR OPEN.)

HUSBAND: Honey…

WIFE: Yeah.

HUSBAND: What happened to the Pizza Hut box that was in the refrigerator?

WIFE: Pizza?

HUSBAND: Yeah…in the Pizza Hut box.

WIFE: You mean the one that had two and a half pepperoni's and just the smallest sliver of green pepper and the left hand side of the crust was bent up a little and the cheese had slid to the right and it was sitting in the box with a couple of those delectable little mushrooms next to it?

HUSBAND: That sounds real close.

WIFE: I haven't seen it.

ANNCR: At Pizza Hut® Restaurants we know that pizza is no ordinary food. So we go out of our way to make you the best pizza we know how. Who gets the last slice is your problem.

"BORING"

(MUSIC)

SINGER: I've got a good job.
I've got a good car.
I make good money.
I eat in good restaurants.
Everything's good.
Good. Good. Good.
There's just one thing.
I feel like my Dad.

CHORUS: You're getting Boring, Boring.

SINGER: I've seen Don Johnson.
I've heard Lionel Ritchie.
We are the world.
I know about AIDS.
I know about Terrorism.
I know about Cocaine.
There's just one thing.
So does my Dad.

CHORUS: You're getting Boring, Boring.
(UNDER ANNCR)

ANNCR: This message is brought to you by Playboy because things are starting to get boring.

CHORUS: Boring, Boring…*(FADE)*

"MURANO"

SFX UNDER

ANNCR: You can hear the squawking and squabbling of ducks…the swoosh of water as it sprays and splashes into a fountain. You can hear the breeze rustle a million branches. You can hear songbirds trying to out-sing each other. But the real beauty of Forest Lawn is the personal interest of a Mortuary Counselor like Marta Murano.

MARTA: Most of the time people just don't know what to do; they're numb. So, what we have to offer is…is a lot of experience and understanding in…in helping these families get through it.

ANNCR: Marta has been with Forest Lawn Mortuaries 19 years.

MARTA: There isn't any difficulty we haven't faced by now…or…or any emotion we haven't responded to.

ANNCR: Her attitude toward people is one that we all share.

MARTA: People have the right to dignity and to respect. No matter who they are or what they have to spend…or…or how they want to handle their grief. Peoples feelings are very precious to me.

ANNCR: The real beauty of Forest Lawn is how much we care.

"BOAT"

(PHONE RINGS)

#1: Hello

#2: You the guy selling the boat?

#1: Yeah.

#2: Okay. *(CLICK)*

#1: Hello?

ANNCR: Running an ad in the classifieds can be frustrating. Zillions of calls at all hours of the night from people who may not be serious.

(PHONE RINGS)

#1: Hello.

#2: You the guy with the boat?

#1: Yeah.

#2: What color?

#1: It's a gorgeous blue.

#2: I want pink. *(CLICK)*

ANNCR: Stop the annoying calls. Advertise in The Washington Times. For as little as $7 extra, the Times will answer all the calls responding to your ad.

(PHONE RINGS)

#1: Hello.

#2: I wanna buy a boat.

#1: Great. Can I tell you a little bit about it?

#2: Okay. *(CLICK)*

#1: Hello?

ANNCR: Besides answering the calls, we'll give you the cheapest rate in town. $16. And we guarantee you'll find a buyer if you run your ad for 4 weeks. If you don't, we'll run the ad til you do.

(PHONE RINGS)

#1: Hello.

#2: You wanna buy a boat?

#1: No. Do you wanna buy a boat?

#2: (UNDER ANNCR) No. Do you wanna buy a boat?

ANNCR: We'll answer the calls and guarantee your ad will work. So all you have to do is call the Times and place your ad. Make life easier. Advertise in the Washington Times Classified. Call 636-3100. Private parties only.

#1: No. Do you want to buy a boat?

#2: No. *(FADE OUT)*

WRITER
Jean Craig
AGENCY
Kresser, Craig/D.I.K.
CLIENT
Forest Lawn Mortuaries

RADIO

PRODUCER
Jeff Millman
Pam Poertner
WRITER
Brian Klam
AGENCY
Smith, Burke & Azzam
CLIENT
Washington Times

RADIO

CREATIVE DIRECTOR
Patty Abel

WRITER
Steve Hogan

AGENCY
Dentsu, Young &
Rubicam, Inc.

CLIENT
Heublein

CREATIVE DIRECTOR
Scott Montgomery
Ken Sakoda

PRODUCTION STUDIO
L.A. Studios

WRITER
Doug Reeves

AGENCY
Salvati Montgomery
Sakoda

CLIENT
International House
of Pancakes

"ARDEN—FRIEND FROM COLLEGE"

WOMAN: I don't know how Arden does it but she's always six months ahead of everyone else.

I remember she was making jokes about rolfing before they even got me signed up.

Arden had a VCR before the rest of us would admit we watched TV.

She'll tell me about this great, little restaurant, and by the time I go, you've got to pack a lunch, the lines are so long.

I mean, she was saying romance was back while I was still video dating.

Did I tell you about Babycham? Babycham's this great new drink from England that comes in its own little bottle. It's a *pear* wine and it's incredibly light and refreshing.

Anyway, I took a case of Babycham to Arden's co-op conversion party, and before I could tell her about this great new drink, she said, "Oh, Babycham! That's all I drank the last time I was in London, you know, while the dollar was so high, the summer before you went."

Everyone should have a friend like Arden.

ANNCR: Babycham. The light pear wine from England that comes in its own little bottle and is at least six months ahead of its time, we think.

Babycham English Perry imported from Heublein, Hartford, Connecticut.

"HENRY THE VIIIth"

SFX: (FANFARE)

ANNCR: Henry the VIIIth?

HANK: Call me Hank.

ANNCR: That's quite a...physique you've got there, Hank.

HANK: Thank you. I do a lot of lifting.

ANNCR: You lift *weights?*

HANK: No. I lift a lot of drumsticks, a lot of steaks, a lot of ice cream...

ANNCR: Lots of fast food, huh?

HANK: Fast food? You think I get the strength to keep eating like this from wimp burgers? No, I go to the International House of Pancakes Restaurant.

ANNCR: For *dinner?*

HANK: Eventually. I start with breakfast, then eat my way through to dinner.

ANNCR: So you have pancakes for dinner.

HANK: Come on. That's ancient history. The International House of Pancakes serves great dinners, too. Juicy, golden chicken, tender London broil, crunchy shrimp, sauteed fish...

ANNCR: I take it you love their food.

HANK: The only thing I love more is getting married.

ANNCR: Women find *you* attractive?

HANK: Hey. I can name *five* women who've lost their heads over me.

ANNCR: Really?

HANK: So far.

"SCHEDULE"

MAN: Let's look at your schedule for tomorrow. 9 a.m. staff meeting. Scratch that out. Put 9 a.m., moon somebody out of the window. Good. O.K., for 10 a.m. you got; call stock-broker. That's good. Tell him to sell everything. Then go out and buy a motorcycle. Now 12:30-Lunch with Jerry? You hate Jerry. Stand him up. Get a hot dog, stand on the street and yell at girls.

ANNCR: This message has been brought to you by Playboy. Because things are starting to get boring.

"DAD"

MAN: I woke up this morning and I had turned into my Dad. I don't know how it happened. I just know I'm acting...old. I haven't gone to a concert in a long time, I haven't even bought an album. I'm driving an expensive car, and the haircuts. I'm always getting haircuts. My Dad and I used to battle over that, now he goes to the same place I go to. And I'm playing Golf, and I'm wearing suits. And I'm earning interest. And I haven't stayed up all night in years. I don't know, I'm gettin' real predictable. Is this happening to you?

ANNCR: This message is brought to you by Playboy because things are starting to get boring. Now you want to see who Stallone sleeps with? You want to hear Jackie Gleason's greatest drinking stories? You want to do something different? Buy the August Issue of Playboy. On sale at newsstands now.

"BORING"

(MUSIC)

SINGER: I've got a good job.
I've got a good car.
I make good money.
I eat in good restaurants.
Everything's good.
Good. Good. Good.
There's just one thing.
I feel like my Dad.

CHORUS: You're getting Boring, Boring.
I've seen Don Johnson
I've heard Lionel Ritchie.
We are the world.
I know about AIDS.
I know about Terrorism.
I know about Cocaine.
There's just one thing.
So does my Dad.

CHORUS: You're getting Boring, Boring.
(UNDER ANNCR)

ANNCR: This message is brought to you by Playboy because things are starting to get boring.

CHORUS: Boring, Boring...*(FADE)*

"TWAIN"

READER: Mark Twain had a daughter named Olivia Susan Clemens, who died August 14, 1896 at the age of 24. Following her tragic death, Mark Twain wrote this epitaph:
 Warm summer sun, shine kindly here;
 Warm southern wind, blow softly here;
 Green sod above, lie light, lie light—
 Good-night, dear heart, good-night,
 good-night.

ANNCR: When a loved one passes on, a funeral with dignity and simplicity in a setting of great, natural beauty is the most poignant way for those on both sides of life to say goodbye.
We're Rose Hills.
A place to remember.

"THOREAU"

READER: Henry David Thoreau, who immortalized Walden Pond in a book of the same name that immortalized him, was only 45 years old when he died in 1862. Commenting on his life, he wrote:
 My life is like a stroll upon the beach,
 As near the ocean's edge as I can go.
 My life has been the poem I would have
 writ,
 But I could not both live and utter it.

ANNCR: When a loved one passes on, a funeral with dignity and simplicity in a setting of great, natural beauty is the most poignant way for those on both sides of life to say goodbye.
We're Rose Hills.
A place to remember.

"WILL ROGERS"

READER: On May 24, 1919, in Chelsea, Oklahoma, Will Rogers deeply moved by his sister's funeral, wrote: "They came on foot, in buggies, cars and trains, and there wasn't a soul that come that she hadn't helped at one time or another. And all the honors I could ever hope to reach, would never equal the honor paid on a little western prairie hilltop to Maud Lane. If they love me like that at the finish, my life will not have been in vain."

ANNCR: When a loved one passes on, a funeral with dignity and simplicity in a setting of great, natural beauty is the most poignant way for those on both sides of life to say goodbye.
We're Rose Hills.
A place to remember.

PRODUCER
Jeff Millman
Pan Poertner
WRITER
Jeff Millman
AGENCY
Smith, Burke & Azzam
CLIENT
Playboy Magazine

RADIO—CAMPAIGN
ART DIRECTOR
Greg Koorhan
WRITER
Niel Klein
Alan Lawrence
AGENCY
Klein/Richardson
CLIENT
Rose Hills Memorial Park

RADIO—CAMPAIGN

CREATIVE DIRECTOR
Scott Montgomery
Ken Sakoda

PRODUCTION STUDIO
L.A. Studios

WRITER
Scott Montgomery
Doug Reeves

AGENCY
Salvati Montgomery
Sakoda

CLIENT
International House
of Pancakes

"ATTILA"

SFX: (MARCHING, ARMY SOUNDS UNDER THROUGHOUT)

ANNCR: Attila the Hun?

ATTILA: Bingo.

ANNCR: I'm curious. Where's a guy-on-the-go like you eat breakfast?

ATTILA: International House of Pancakes Restaurant.

ANNCR: No *fast* food?

ATTILA: Fast food? I'm into looting, pillaging, general mayhem...I'm gonna do all *that* on some wimpy biscuit topped with a rubber egg?

ANNCR: Good point.

ATTILA: You can't beat the International House of Pancakes for breakfast.

ANNCR: No.

ATTILA: Big, three-egg omelettes, fresh blintzes and waffles. *Fresh*, not frozen. My guys'll kill for 'em.

ANNCR: And those pancakes...

ATTILA: German, Swedish, French...countries I've never even conquered yet.

ANNCR: Great food, cooked to order, served right to your table.

ATTILA: Yeah. Listen, we're scheduled to sack Rome tonight...what say we meet you at the International House of Pancakes there for breakfast?

ANNCR: You're on.

ATTILA: Say...eight-ish?

ANNCR: Right.

ATTILA: Maybe nine-ish. I could use an hour to freshen up.

"PAUL BUNYAN"

SFX: (CHAIN SAW)

ANNCR: Paul Bunyan?

PAUL: Uh, you wanna step to your left a couple feet?

SFX: (TREE CRASH)

PAUL: Thanks.

ANNCR: I guess all this tree chopping really works up an appetite, huh, big guy?

PAUL: Rightio. In fact, right after I level Wisconsin, here, I'm gonna drop by the International House of Pancakes for breakfast.

ANNCR: For pancakes?

PAUL: For the whole menu.

ANNCR: Oh.

PAUL: Six or seven of those big International House of Pancakes three-egg omelettes. Dozen waffles. Blintzes. Crepes.

ANNCR: Uh huh.

PAUL: You know they've got more variety at breakfast than Minnesota's got lakes?

ANNCR: And those pancakes.

PAUL: Lots of 'em.

ANNCR: So you'd recommend the International House of Pancakes for good food and lots of it?

PAUL: Let's just say it beats the egg off one of those wimpy little fast food biscuits.

ANNCR: Nicely put. *(YELLING)* Say Babe, how 'bout a thick, juicy steak and eggs?

BABE: (MONSTROUS BELLOW)

PAUL: Oh, you don't wanna go teasing the Babe.

ANNCR: Uh, right.

"COLUMBUS"

SFX: (WIND, SHIP CREAKING, SEAGULLS UP AND UNDER)

ANNCR: Christopher Columbus?

CHRIS: Yo.

ANNCR: On your way to the New World?

CHRIS: I think so. But my crew thinks if we sail much further, we're history.

SFX: (CREW GRUMBLES)

ANNCR: Well, if you feed them right, I'm sure they'll stick around.

CHRIS: That's what *I* thought. So I bring along dozens of Mr. Whoopie fast food burgers, and they *still* complain.

ANNCR: Here. Try this leg.

CHRIS: Thanks.

SFX: (CRUNCH)

ANNCR: Ouch! Not *my* leg. This juicy chicken leg from the International House of Pancakes Restaurant.

CHRIS: The International House of Pancakes has chicken like this?

ANNCR: Sure. Not only do they serve fantastic breakfasts, they serve incredible dinners, too. Tender London broil, crunchy shrimp, sauteed fish, veal parmigian...

CHRIS: Veal parmigian?

ANNCR: With real spaghetti and garlic bread.

CHRIS: Sounds fabulisimo. How do we get there?

ANNCR: Go straight about 200 miles and hang a right at the edge of the world.

SFX: (CREW PANICS)

ANNCR: Just kidding, just kidding.

"LAST SLICE"

SFX: (DOOR OPEN.)

HUSBAND: Honey...

WIFE: Yeah.

HUSBAND: What happened to the Pizza Hut box that was in the refrigerator?

WIFE: Pizza?

HUSBAND: Yeah...in the Pizza Hut box.

WIFE: You mean the one that had two and a half pepperoni's and just the smallest sliver of green pepper and the left hand side of the crust was bent up a little and the cheese had slid to the right and it was sitting in the box with a couple of those delectable little mushrooms next to it?

HUSBAND: That sounds real close.

WIFE: I haven't seen it.

ANNCR: At Pizza Hut® Restaurants we know that pizza is no ordinary food. So we go out of our way to make you the best pizza we know how. Who gets the last slice is your problem.

"GIRLS"

SFX: (CRICKETS.)

GIRL #1: The guy is gorgeous.

GIRL #2: If you like skinny guys with buck teeth, maybe.

GIRL #1: You obviously have no taste in men.

GIRL #3: He'd make a great rake.

GIRL #1: He has a car.

GIRL #3: Material possessions... He does have a car?

GIRL #2: It's probably skinny, too.

GIRL #1: How can he have a skinny car?

GIRL #2: I don't know, but he'd have one.

GIRL #1: Very funny.

GIRL #2: Call him up, have him stop by Pizza Hut and bring over a large pepperoni...

GIRL #3: With black olives.

GIRL #2: Oh, and mushrooms.

GIRL #3: And onions.

GIRL #1: Onions!

GIRL #2: We're not going anywhere tonight.

GIRL #3: Here, call him.

GIRL #1: Hey, I thought you guys didn't like him.

GIRL #2: Well, hey, maybe this is his big break.

GIRL #3: Yeah!

GIRL #1: Wait a minute!

ANNCR: At Pizza Hut® we know that pizza is no ordinary food. So we go out of our way to make you the best pizza we know how. Totally.

"NURSE"

SFX: (HOSPITAL SOUNDS.)

NURSE: Did you buzz your buzzer?

MAN: Yes nurse. These pills...they must cause hallucinations.

NURSE: I doubt it. They're only vitamin supplements.

MAN: Oh...then I guess this is actually the lunch I'm supposed to eat?

NURSE: Do we not like it?

MAN: Well...we just keep hoping for something more appetizing.

NURSE: All the major food groups are represented here.

MAN: Oh, really.

NURSE: Straighten up. Let's start with these nice beets. Okay... Open up... here comes the airplane into the hangar.

MAN: I'd prefer to have pizza in my hangar, thank you.

NURSE: We don't serve pizza. But there is a Pizza Hut Restaurant right across the street.

MAN: What?

NURSE: Raise your bed up a little.

MAN: OK.

NURSE: You can see the red roof from here.

MAN: I see it now. Pizza Hut. Boy, that brings back memories.

NURSE: Yeah.

MAN: Pepperoni...Mushrooms...

NURSE: I hate mushrooms.

MAN: If it weren't for all these I.V. bottles and the traction wires, I'd...march right over there and order the biggest pizza they make.

NURSE: Sure...

MAN: Maybe you could—

SFX: (BEEP)

NURSE: Darn, there's that buzzer again.

MAN: Wait. I...

NURSE: Finish your beets!

ANNCR: At Pizza Hut® we know that pizza is no ordinary food. So we go out of our way to make you the best pizza we know how. Who knows, maybe a pizza a day will keep the doctor away.

RADIO—CAMPAIGN

WRITER
Brent Bouchez
John Stein
AGENCY
Chiat/Day
Advertising
CLIENT
Pizza Hut, Inc.

ANNUAL REPORT

ART DIRECTOR
Robert Miles Runyan

DESIGNER
Douglas Joseph

PHOTOGRAPHER/
ILLUSTRATOR
Arthur Meyerson

AGENCY
Robert Miles Runyan &
Associates

CLIENT
Castle & Cooke

ART DIRECTOR
Douglas Oliver
Emmett Morava

DESIGN DIRECTOR
Douglas Oliver

DESIGNER
Douglas Oliver

WRITER
Judith Lindquist

PHOTOGRAPHER
Rumio Sato

ILLUSTRATOR
Kyle Oliver

AGENCY
Morava & Oliver Design
Office

CLIENT
St. Francis Medical
Center

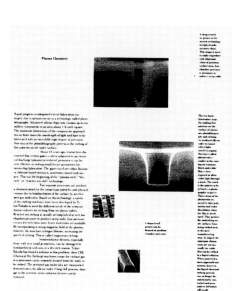
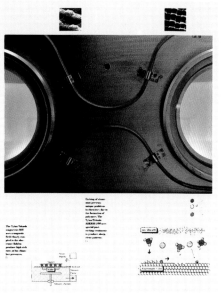

Plasma Chemistry

Rapid progress in integrated circuit fabrication was largely due to advancements in a technology called photolithography. Advanced silicon chips now contain up to one million components in an area about 1/4-inch square. The minimum dimensions of the components approach two or three times the wavelength of light and have to be fabricated with an incredible high precision of precision. Our step in the photolithography process is the etching of fine patterns on the wafer surface.

About 15 years ago, researchers discovered that certain gases—when subjected to an electrical discharge (glasma) at reduced pressures—can be very effective in etching small device geometries for microchip fabrication. The gases used are rather fluorine or chlorine-based mixtures, sometimes mixed with oxygen. This was the beginning of the "plasma etch," "dry etch" or "reactive ion etch" technology.

Two separate processes are involved: a chemical attack by the neutral gas particles and physical erosion due to bombardment of the surface by accelerated gas molecules. Based on this technology, a variety of dry-etching machines have been developed in Tellus-Tokuda to meet the different needs of the semiconductor industry for etching films on silicon wafers. Reactive ion etching is usually accomplished at very low chamber pressure to produce steep walls. Low pressure means low etch rates since fewer molecules are available. By incorporating a strong magnetic field in the plasma, however, the ions have a longer lifetime, increasing the speed of etching. This is called magnetron etching.

Semiconductor devices, especially those with very small geometries, can be damaged by bombardment with ions in a dry etch system. Tylan/Tokuda has found a solution to this problem: their CDE (Chemical Dry Etching) machines create the radiant gas in a microwave cavity remotely located from the wafer to be etched. The activated gas molecules are transported downstream to the silicon wafer. Using this process, damage to the sensitive semiconductor devices can be removed.

A chemical etch can be performed in medium chamber pressures.

The two basic fabrication steps for making fine patterns on the surface of silicon are photolithography and etching. To understand silicon wafer is coated with a light-sensitive compound similar to the coating used on common black-and-white film—then exposed to a visible light through a mask. The mask is the pattern to be printed—a photographic negative. Those areas of the photoresist exposed to light gain harder and resist dissolution when the film is developed. They promote the underlying surface from being etched away in the next manufacturing step. As long as the minimum dimensions are too small, the oxide film can be etched in a liquid solution. When pattern features become small, however, the liquid chemical etching process can no longer be satisfactorily controlled and the result.

Etching of silicon may presents unique problems in chemistry due to the formation of polymers. The Tylan/Tokuda MMRE-200 uses special processing treatments to produce sharp, clean patterns.

The Tylan/Tokuda magnetron RIE uses a magnetic field closely coupled to the plasma field to produce high etch rates in fine channels.

ANNUAL REPORT

ART DIRECTOR
Douglas Joseph

DESIGN DIRECTOR
Douglas Joseph

DESIGNER
Douglas Joseph

WRITER
Client

PHOTOGRAPHER
Burton Pritzker
Scott Morgan

ILLUSTRATOR
Douglas Joseph

AGENCY
Douglas Joseph &
Associates

CLIENT
Tylan Corporation

The nations of the Pacific Rim are home to more than half the world's population. Two people represent

both a major resource and major new market for the future. We have prospered on

the Pacific Rim trade and will continue to place much of our emphasis there

more normal levels relative to the end of 1984, we anticipate the business environment in 1986 to be stronger and expect to participate in the resulting growth. The protectionist sentiments that were broadcast so widely last year seem to have cooled. In addition, U.S. exports appear to be on the increase and we are hopeful that the current climate for international trade will continue to strengthen as the year progresses. There has been considerable speculation that the U.S. dollar will continue to decline in value relative to most other world currencies. On the surface, it would appear that a decline in the U.S. dollar would have a negative impact on Expeditors' business due to the fact that we are heavily dependent upon imports from the Pacific Rim.

n fact, just the opposite is true in three of our major markets: Hong Kong, Korea and Taiwan currencies are pegged to the U.S. dollar, so any decline in the U.S. dollar is likely to have minimal impact. Also, when the U.S. dollar weakens against the Japanese yen, Japanese goods become more expensive to sell in the U.S. To stay competitive, some Japanese manufacturers have shifted their operations to countries with lower wage scales such as Hong Kong, Singapore and Taiwan. This, of course, is good news for Expeditors. As we have discussed previously, one of our strategies is to continue to develop our export market from the United States during 1986.

ART DIRECTOR
John Van Dyke

DESIGN DIRECTOR
John Van Dyke

DESIGNER
John Van Dyke

WRITER
Tom McCarthy

PHOTOGRAPHER/
ILLUSTRATOR
Cliff Fiess

AGENCY
Van Dyke Company

CLIENT
Expeditors
International

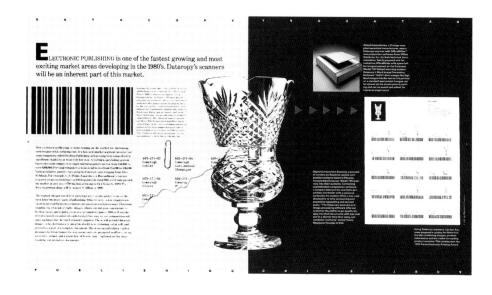

D A T A C O P Y

E LECTRONIC PUBLISHING is one of the fastest growing and most exciting market areas developing in the 1980's. Datacopy's scanners will be an inherent part of this market.

PUBLISHING

"Images into reality."

ART DIRECTOR
Mark Anderson

DESIGN DIRECTOR
Mark Anderson

DESIGNER
Earl Gee

WRITER
James P. McNaul, Ph.D.

PHOTOGRAPHER
Henrik Kam

AGENCY
Mark Anderson Design

CLIENT
Datacopy Corporation

DESIGN

ANNUAL REPORT

ART DIRECTOR
Jim Berte

DESIGNER
Jim Berte

*PHOTOGRAPHER/
ILLUSTRATOR*
Deborah Meyers

AGENCY
Robert Miles Runyan &
Associates

CLIENT
Times Mirror Company

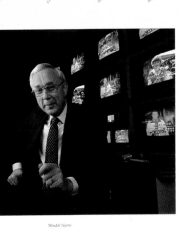

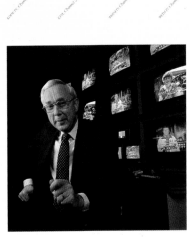

ART DIRECTOR
John Van Dyke

DESIGN DIRECTOR
John Van Dyke

DESIGNER
John Van Dyke

WRITER
Elaine Kraft

*PHOTOGRAPHER/
ILLUSTRATOR*
Terry Heffernan
Cliff Fiess

AGENCY
Van Dyke Company

CLIENT
Weyerhaeuser Paper Co.

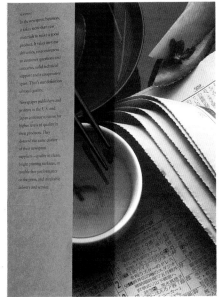

ART DIRECTOR
Steve Tolleson

DESIGN DIRECTOR
Steve Tolleson

DESIGNER
Steve Tolleson
Nancy Paynter

WRITER
Roy Parrin

*PHOTOGRAPHER/
ILLUSTRATOR*
Kenrik Kam

AGENCY
Tolleson Design

CLIENT
Modulaire Industries

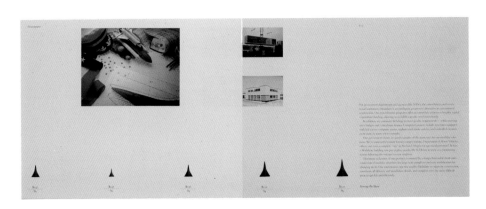

Wood Products

Pope & Talbot enters 1985 with four lumber mills operating at full capacity. The mills at Port Gamble, Washington; Midway and Grand Forks, British Columbia, Canada; and Spearfish, South Dakota are efficient, cost-competitive manufacturing facilities. Each mill has an excellent raw material supply: the British Columbia mills harvest their entire raw material requirements from 1.3 million acres of government timberlands, on which they have long-term renewable cutting contracts; the Spearfish mill harvests a significant part of its log requirements from 35,000 acres of Ponderosa Pine controlled under a long-term cutting contract; the Port Gamble mill can bid for timber from a variety of sources, including the adjacent Pope Resources tree farm.

The Wood Products Division had operating earnings of $10.6 million in the difficult year of 1984, about 63% higher than the previous year. Although this was disappointing when compared with the very good profits of several years ago, we believe the results compared well with other lumber operations in our industry.

Two important developments in our ability to serve customers in California are cargo-reload terminals at Crockett in Northern California and Port Hueneme in Southern California, opened in 1984 and 1985, respectively. Relatively inexpensive barge transportation from our Port Gamble sawmill allows our lumber to be competitive with other lumber in the California market.

Late in 1984 we closed the sawmill and green veneer plant at Oakridge, Oregon because the facilities have not been operating profitably and the outlook was for continued losses.

The solid-wood products industry has had several years of good housing starts, high demand for lumber and wood-panel products, very high levels of production—and poor profits. This anomaly seems to have been caused by a combination of aggressive production and marketing by hundreds of manufacturers combined with a cautious purchasing attitude on the part of thousands of customers. Any significant product price increase has produced caution on the part of buyers and enthusiastic production on the part of manufacturers, with the result that prices have fallen back to previous levels. Contrast this with the inflationary 1970s, when any significant price increase was likely to be met by a buyers' panic that only contributed to further upward price pressure.

We don't know where the industry profit picture will improve, but when it does, Pope & Talbot will be positioned favorably to benefit from the change. Accordingly, we will continue to invest the capital necessary to keep our mills highly efficient. These investments will be less than the cash generated even in this poor operating climate. The Division will continue to produce cash for reinvestment and other corporate programs.

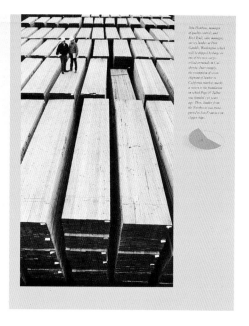

The Hospital of the Good Samaritan

Ophthalmology Outpatient Surgery Center

ANNUAL REPORT

ART DIRECTOR
Dawson Zaug

DESIGN DIRECTOR
Dawson Zaug

DESIGNER
Nancy Koc

WRITER
Bob Wolfe
Pope & Talbot, Inc.

PHOTOGRAPHER/
ILLUSTRATOR
Terry Heffernan
George Steinmetz

AGENCY
Cross Associates

CLIENT
Pope & Talbot, Inc.

ART DIRECTOR
Douglas Oliver
Emmett Morava

DESIGN DIRECTOR
Douglas Oliver

DESIGNER
Jane Kobayashi

WRITER
Betty Sheller

PHOTOGRAPHER
Dana Gluckstein

AGENCY
Morava & Oliver Design
Office

CLIENT
Hospital of the Good
Samaritan

ART DIRECTOR
Robert Miles Runyan

DESIGNER
Tom Devine

PHOTOGRAPHER/
ILLUSTRATOR
Neal Slavin

AGENCY
Robert Miles Runyan &
Associates

CLIENT
Fox Photo, Inc.

ANNUAL REPORT

ART DIRECTOR
Kit Hinrichs

DESIGN DIRECTOR
Kit Hinrichs

DESIGNER
Lenore Bartz

WRITER
Holly Hutchins

PHOTOGRAPHER
Tom Tracy

ILLUSTRATOR
Paul Fusco
Hank Osuna
Robert Arnold
Will Nelson
Lawrence Duke
Masami Miyamoto

AGENCY
Pentagram Design, Ltd.

CLIENT
Potlatch Corporation

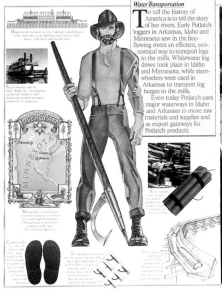

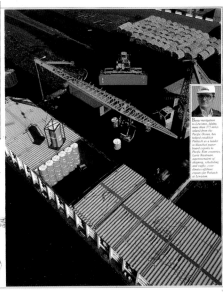

ART DIRECTOR
John Van Dyke

DESIGN DIRECTOR
John Van Dyke

DESIGNER
John Van Dyke

WRITER
Stu Clugston

*PHOTOGRAPHER/
ILLUSTRATOR*
various

AGENCY
Van Dyke Company

CLIENT
British Columbia Forest
Products

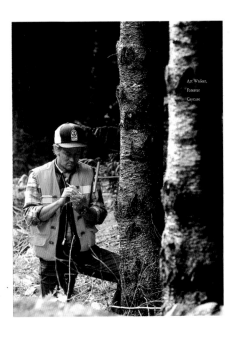

ART DIRECTOR
Rose Srebro

DESIGN DIRECTOR
Rose Srebro

DESIGNER
Rose Srebro

WRITER
Marilyn Levine

*PHOTOGRAPHER/
ILLUSTRATOR*
Richard Pasley

AGENCY
Rose Srebro Design

CLIENT
Haley & Aldriche, Inc.

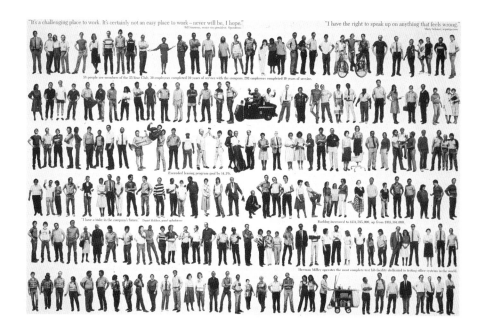

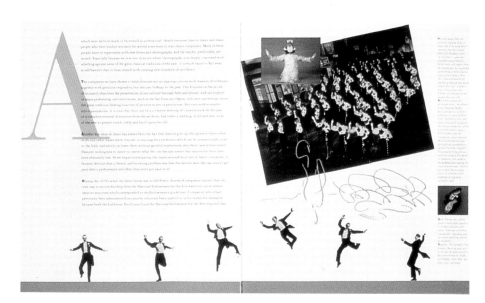

ANNUAL REPORT

ART DIRECTOR
Stephen Frykholm
Sara Giovanitti

DESIGN DIRECTOR
Stephen Frykholm

DESIGNER
Sara Giovanitti

WRITER
Nancy Green

PHOTOGRAPHER
Bill Lindhout
Kerry Rasikas
Andy Sacks
Brad Trent

AGENCY
Sara Giovanitti Design

CLIENT
Herman Miller Inc.
▲

ART DIRECTOR
Jim Berte

DESIGNER
Jim Berte

PHOTOGRAPHER/ ILLUSTRATOR
Deborah Meyers

AGENCY
Robert Miles Runyan &
Associates

CLIENT
Caremark, Inc.

ART DIRECTOR
Michael Vanderbyl

DESIGN DIRECTOR
Michael Vanderbyl

DESIGNER
Michael Vanderbyl

AGENCY
Vanderbyl Design

CLIENT
Skaggs Foundation

ANNUAL REPORT

ART DIRECTOR
Bennett Robinson

DESIGN DIRECTOR
Bennett Robinson

DESIGNER
Bennett Robinson
Meera Singh

WRITER
Oscar Shefler

PHOTOGRAPHER/
ILLUSTRATOR
Alen MacWeeney

AGENCY
Corporate Graphics Inc.

CLIENT
JH Heinz Company

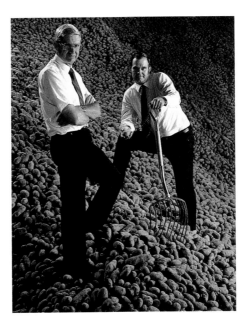

ART DIRECTOR
Michael Vanderbyl

DESIGN DIRECTOR
Michael Vanderbyl

DESIGNER
Michael Vanderbyl

AGENCY
Vanderbyl Design

CLIENT
Skaggs Foundation

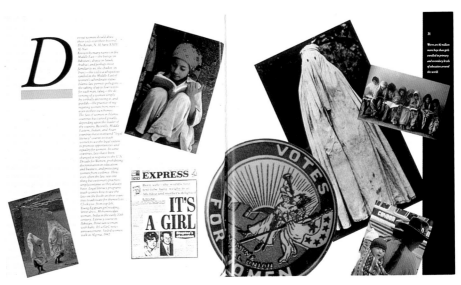

ART DIRECTOR
Kit Hinrichs

DESIGN DIRECTOR
Kit Hinrichs

DESIGNER
Francesca Bator

WRITER
Jack Burke

PHOTOGRAPHER/
ILLUSTRATOR
John Blaustein

AGENCY
Pentagram Design, Ltd.

CLIENT
Consolidated
Freightways

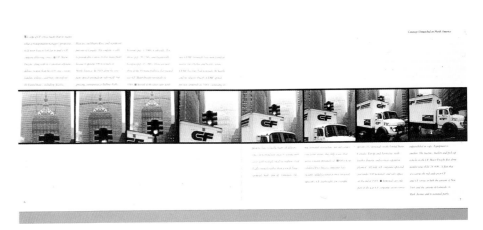

B [body text column too small to read clearly]

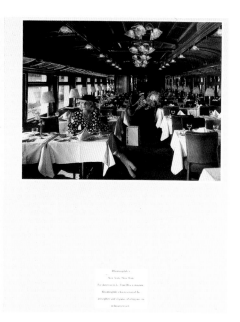

ANNUAL REPORT

ART DIRECTOR
Robert Miles Runyan

DESIGNER
Douglas Joseph

*PHOTOGRAPHER/
ILLUSTRATOR*
Neal Slavin

AGENCY
Robert Miles Runyan &
Associates

CLIENT
MICOM Systems, Inc.

ART DIRECTOR
Jim Berte

DESIGNER
Jim Berte

*PHOTOGRAPHER/
ILLUSTRATOR*
Burton Pritzker

AGENCY
Robert Miles Runyan &
Associates

CLIENT
Compact Video, Inc.

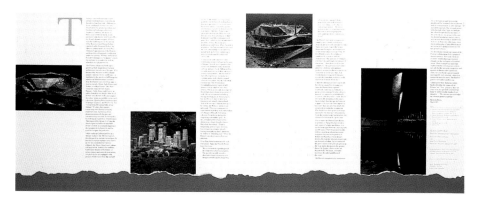

ART DIRECTOR
Byron Jacobs

DESIGNER
Byron Jacobs

AGENCY
Jacobs Design

CLIENT
Newport Harbor Art
Museum

ANNUAL REPORT

DESIGNER
Judith Lausten
Renee Cossutta

AGENCY
Lausten/Cossutta
Design

CLIENT
The Getty
Conservation Institute

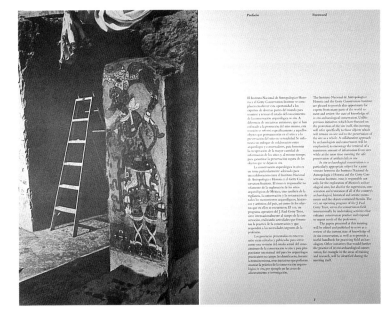

ART DIRECTOR
Robert Cipriani

DESIGN DIRECTOR
Robert Cipriani

DESIGNER
Robert Cipriani

WRITER
Brian Flood
Paul Wesel
Thinking Machines

PHOTOGRAPHER
Steve Grohe

AGENCY
Cipriani Advertising
Inc.

CLIENT
Thinking Machines

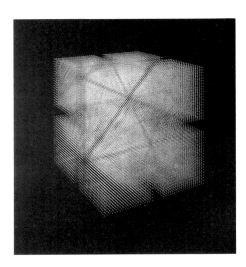

ART DIRECTOR
Sheila L. de Bretteville
Mario Zamparelli

DESIGNER
Debbie Dritz

WRITER
Cornelia Emerson

*PHOTOGRAPHER/
ILLUSTRATOR*
Hugo Espinosa
Debbie Dritz
Rowan Moore

AGENCY
Brooklyn
Design Group
of Otis/Parsons

CLIENT
Roger Workman,
Dean, Otis/Parsons

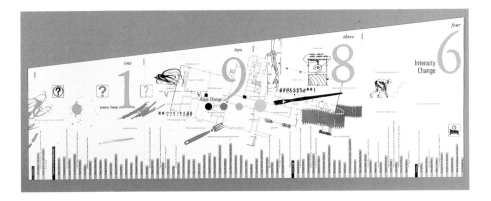

BROCHURE, FOLDER

ART DIRECTOR
Walter Bernard
Milton Glaser

DESIGN DIRECTOR
Walter Bernard
Milton Glaser

DESIGNER
Walter Bernard
Milton Glaser

AGENCY
Adweek

CLIENT
Adweek Portfolios

ART DIRECTOR
Tamotsu Yagi

DESIGNER
Tamotsu Yagi

PHOTOGRAPHER/
ILLUSTRATOR
Oliviero Toscani
Robert Carra

AGENCY
Esprit Graphic Design
Studio

CLIENT
Esprit De Corp.

BROCHURE, FOLDER

ART DIRECTOR
George Tscherny

DESIGN DIRECTOR
George Tscherny

DESIGNER
George Tscherny
Tracy Stora

*PHOTOGRAPHER/
ILLUSTRATOR*
Guy Gillette

AGENCY
George Tscherny, Inc.

CLIENT
William A. Dreher &
Associates

ART DIRECTOR
Steff Geissbuhler

DESIGNER
Steff Geissbuhler
Susan Schunick

WRITER
Rose DeNeve

*PHOTOGRAPHER/
ILLUSTRATOR*
Alan Shortall

AGENCY
Chermayeff & Geismar
Associates

CLIENT
Crane & Co.

ART DIRECTOR
Michael Mabry

DESIGNER
Michael Mabry
May Liang

WRITER
ARTSPACE

AGENCY
Michael Mabry Design

CLIENT
Artspace

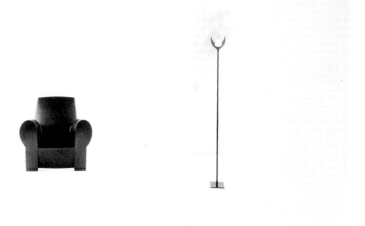

BROCHURE, FOLDER

ART DIRECTOR
Robert Petrick

DESIGN DIRECTOR
Robert Petrick

DESIGNER
Robert Petrick

WRITER
Robert Petrick

PHOTOGRAPHER/
ILLUSTRATOR
Tom Vack
Corinne Pfister

AGENCY
Petrick Design

CLIENT
City
▲

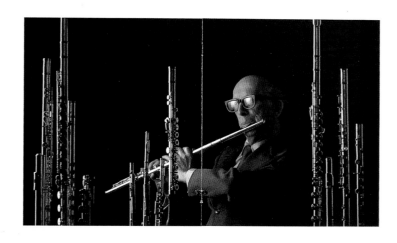

ART DIRECTOR
Bennett Robinson

DESIGN DIRECTOR
Bennett Robinson

DESIGNER
Benett Robinson

WRITER
Lawrence Locke

AGENCY
Corporate Graphics
Inc.

CLIENT
Mead Paper

ART DIRECTOR
Kevin B. Kuester

DESIGN DIRECTOR
Kevin B. Kuester

DESIGNER
Kevin B. Kuester

WRITER
Wells and Company

PHOTOGRAPHER
Arthur Meyerson

AGENCY
Madsen & Kuester, Inc.

CLIENT
Potlatch Corp.

BROCHURE, FOLDER

ART DIRECTOR
James Sebastian

DESIGNER
James Sebastian
Rose Biondi

PHOTOGRAPHER
Bruce Wolf

INTERIOR DESIGNER
William Walter

AGENCY
Designframe
Incorporated

CLIENT
Martex/West Point
Pepperell

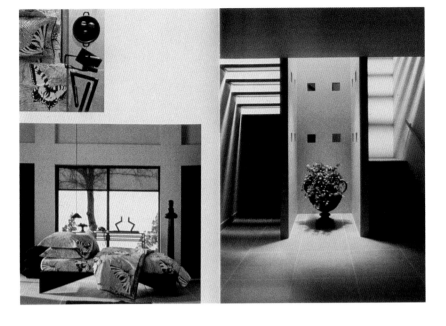

ART DIRECTOR
Robert Miles Runyan

DESIGNER
Douglas Joseph

*PHOTOGRAPHER/
ILLUSTRATOR*
various

AGENCY
Robert Miles Runyan &
Associates

CLIENT
Maguire Thomas
Partners

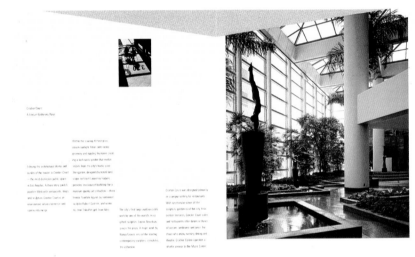

ART DIRECTOR
Carson Pritchard

DESIGNER
Carson Pritchard

WRITER
Elaine Hollifield

*PHOTOGRAPHER/
ILLUSTRATOR*
Donald Miller

AGENCY
Carson Pritchard
Design

CLIENT
Arita Dinnerware

This piece is rather evocative, without being at all romantic here.

BROCHURE, FOLDER

ART DIRECTOR
Michael Vanderbyl

DESIGN DIRECTOR
Michael Vanderbyl

DESIGNER
Michael Vanderbyl

AGENCY
Vanderbyl Design

CLIENT
Hickory Business
Furniture
▲

ART DIRECTOR
James Sebastian

DESIGNER
James Sebastian
Pen-Ek Ratanaruang

PHOTOGRAPHER
Bruce Wolf

INTERIOR DESIGNER
William Walter

AGENCY
Designframe
Incorporated

CLIENT
Martex / West Point
Pepperell

ON INSPIRATION

ON CRITIQUING DESIGN

ON COLLECTING

ABOUT FILM

ON TYPOGRAPHY

ART DIRECTOR
Kathleen Boss

DESIGN DIRECTOR
Kathleen Boss

DESIGNER
Kathleen Boss

COPYWRITER
Thomas Fuszard
Chris Wall

PHOTOGRAPHER
Norman Seeff

TYPOGRAPHER
Andresen Typographics

PRINTER
George Rice & Sons

AGENCY
Kathleen Boss Design

CLIENT
Andresen Typographics

BROCHURE, FOLDER

ART DIRECTOR
Kit Hinrichs

DESIGN DIRECTOR
Kit Hinrichs

DESIGNER
Lenore Bartz

WRITER
Dennis Foley

*PHOTOGRAPHER/
ILLUSTRATOR*
Tom Tracy
Terry Heffernan

AGENCY
Pentagram Design, Ltd.

CLIENT
Allen & Dorward

ART DIRECTOR
Craig Bernhardt
Janice Fudyma

DESIGNER
Janice Fudyma

*PHOTOGRAPHER/
ILLUSTRATOR*
Kinuko Y. Craft

AGENCY
Bernhardt Fudyma
Design Group

CLIENT
Citibank/Citicorp

ART DIRECTOR
John Clark

DESIGN DIRECTOR
John Clark

DESIGNER
Marquita Stanfield

*PHOTOGRAPHER/
ILLUSTRATOR*
Modular Designs

AGENCY
Cross Associates

CLIENT
Modular Designs, Inc.

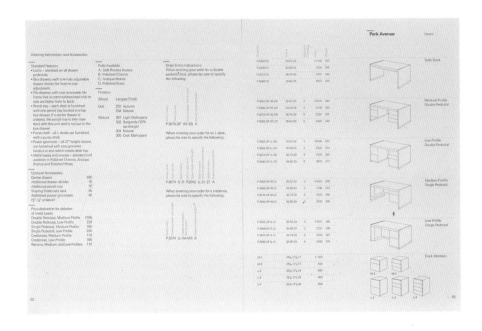

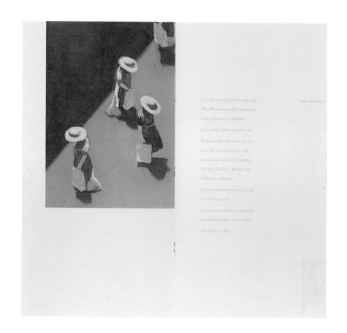

BLOCK HOUSE CREEK

BROCHURE, FOLDER

ART DIRECTOR
Michael Mabry

DESIGNER
Michael Mabry
Peter Soe Jr.

WRITER
Sherry Matthews
Advertising

PHOTOGRAPHER/
ILLUSTRATOR
John Collier

AGENCY
Michael Mabry Design

CLIENT
Parklane Development
Company

ITALIAN
GRAPHIC
DESIGN

ART DIRECTOR
James Cross

DESIGN DIRECTOR
Michael Mescall
James Cross

DESIGNER
Michael Mescall

WRITER
John Adams
of Cole & Weber

PHOTOGRAPHER/
ILLUSTRATOR
various

AGENCY
Cross Associates

CLIENT
Simpson Paper
Company

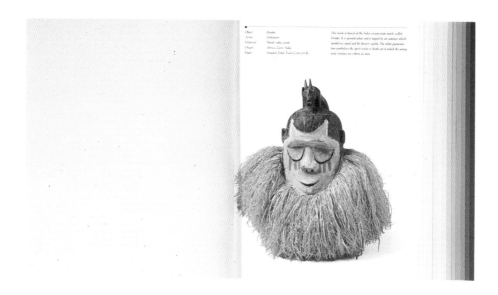

ART DIRECTOR
James Cross

DESIGN DIRECTOR
James Cross

DESIGNER
Michael Mescall

INTRO
Maxwell Arnold of
Cole & Weber

AGENCY
Cross Associates

CLIENT
Simpson Paper
Company

BROCHURE, FOLDER

ART DIRECTOR
Neil Shakery

DESIGN DIRECTOR
Neil Shakery

DESIGNER
Alisa Rudloff

WRITER
Delpine Hirasuna

PHOTOGRAPHER/
ILLUSTRATOR
Burton Pritzker

AGENCY
Pentagram Design, Ltd.

CLIENT
Impell Corporation

ART DIRECTOR
John Coy

DESIGN DIRECTOR
John Coy

DESIGNER
Laurie Handler

PHOTOGRAPHER/
ILLUSTRATOR
Douglas M. Parker
Studio, L. A.

AGENCY
COY, Los Angeles

CLIENT
Gemini G.E.L.

▲

ART DIRECTOR
James Cross
Michael Mescall

DESIGN DIRECTOR
James Cross

DESIGNER
Michael Mescall
David Mellon
Shari Gray

PHOTOGRAPHER/
ILLUSTRATOR
Michael Mescall
David Mellon

AGENCY
Cross Associates

CLIENT
Simpson Paper
Company

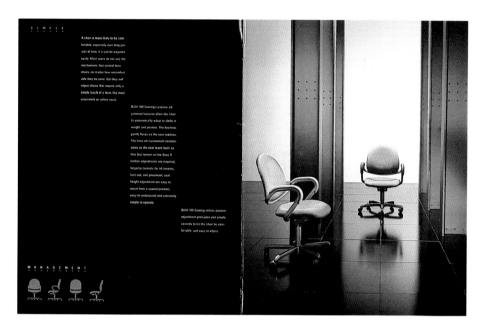

BROCHURE, FOLDER

ART DIRECTOR
Michael Vanderbyl

DESIGN DIRECTOR
Michael Vanderbyl

DESIGNER
Michael Vanderbyl

AGENCY
Vanderbyl Design

CLIENT
Allsteel

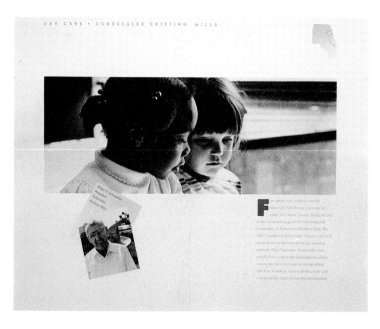

ART DIRECTOR
Pat Samata

DESIGN DIRECTOR
Pat Samata

DESIGNER
Pat and Greg Samata

WRITER
Patrice Boyer

PHOTOGRAPHER
Michael Vollan

AGENCY
Samata Assoc.

CLIENT
YMCA of Metropolitan
Chicago

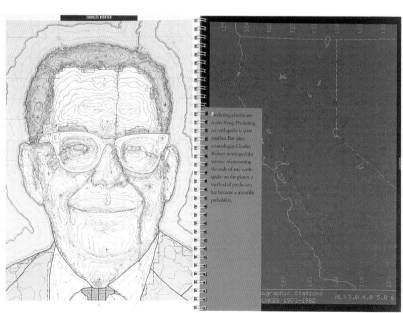

ART DIRECTOR
Kit Hinrichs

DESIGN DIRECTOR
Kit Hinrichs

DESIGNER
Franca Bator

WRITER
Maxwell Arnold

PHOTOGRAPHER
Henrik Kam
Michele Clement
Terry Heffernan
John Blaustein

ILLUSTRATOR
David Stevenson
Carole Onasch
Antonio Lopez
Gary Overacre
Ward Schumaker
Tanya Stringham
Daniel Pelavin
John Craig
Will Nelson
John Mattos
Douglas Smith

AGENCY
Pentagram Design, Ltd.

CLIENT
Simpson Paper Co.

BROCHURE, FOLDER

ART DIRECTOR
John Coy

DESIGN DIRECTOR
John Coy

DESIGNER
Kevin Consales

WRITER
California Institute of
the Arts

*PHOTOGRAPHER/
ILLUSTRATOR*
Steven A. Gunther

AGENCY
COY, Los Angeles

CLIENT
California Institute of
the Arts
▲

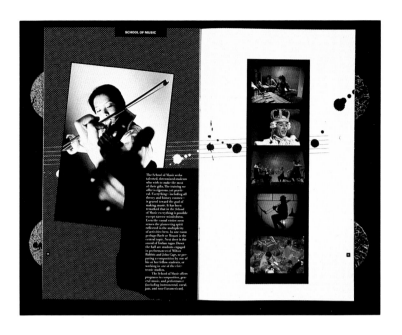

ART DIRECTOR
Cheri Gray

DESIGNER
Cheri Gray

WRITER
Deborah Perrin

AGENCY
Cheri Gray Design
Studio

CLIENT
Ron Rezek Lighting &
Furniture

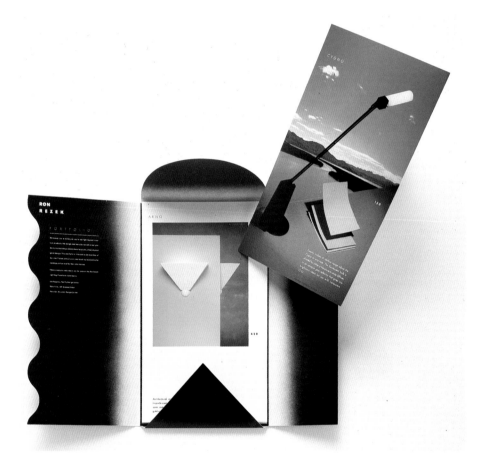

BRALDT BRALDS

"The funny thing is that when I do something funny I usually never intended it to be funny. I make a much more conscious effort to be funny socially. And I don't know how well I do there. The only time I'm conscious of trying to be humorous is when I'm doing something for children. Then out of the blue someone will say, 'How'd you like to do a pipe smoking fish?' If I like the image I just do it."

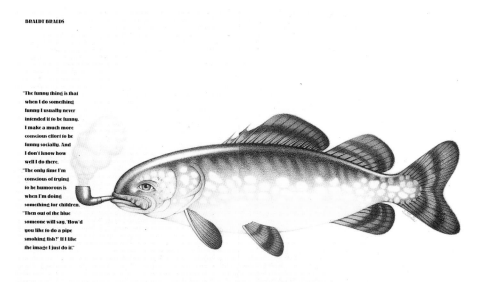

16.

BROCHURE, FOLDER

ART DIRECTOR
Bennett Robinson

DESIGN DIRECTOR
Bennett Robinson

DESIGNER
Bennett Robinson
Adam Shanosky

WRITER
Chris Infante

PHOTOGRAPHER/
ILLUSTRATOR
various

AGENCY
Corporate Graphics Inc.

CLIENT
Simpson Paper
Company

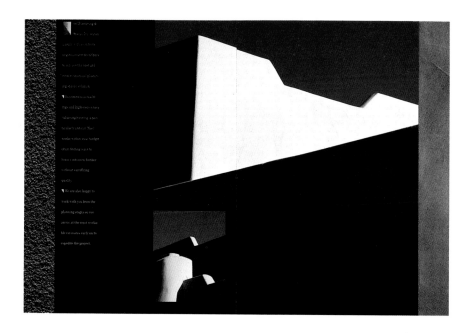

ART DIRECTOR
Brad Ghormley

DESIGNER
Steve Smit

PHOTOGRAPHER/
ILLUSTRATOR
Craig Wells

PRINTER
Wood's Lithographics

AGENCY
Smit Ghormley Sanft

CLIENT
Noel Plastering

ART DIRECTOR
Sam Smidt

DESIGN DIRECTOR
Sam Smidt

DESIGNER
Sam Smidt

WRITER
Morgan Thomas

PHOTOGRAPHER/
ILLUSTRATOR
Raja Muna

AGENCY
Sam Smidt

CLIENT
[íxi:z]

BROCHURE, FOLDER

ART DIRECTOR
Paul Hauge

DESIGN DIRECTOR
Paul Hauge

DESIGNER
John Vince

AGENCY
Art Center College of
Design

CLIENT
Art Center College of
Design

ART DIRECTOR
Tamotsu Yagi

DESIGNER
Tamotsu Yagi

PHOTOGRAPHER
Oliviero Toscani
Robert Carra
Ballo and Ballo

AGENCY
Esprit Graphic Design
Studio

CLIENT
Esprit De Corp.

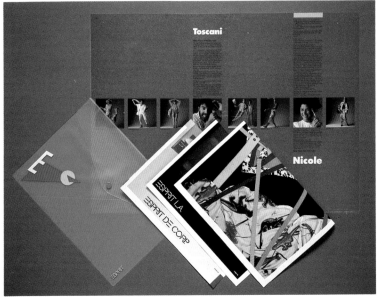

ART DIRECTOR
Michael Skjei

DESIGN DIRECTOR
Michael Skjei

DESIGNER
Michael Skjei

WRITER
Delphine Kirasuna
Larry Williams

*PHOTOGRAPHER /
ILLUSTRATOR*
Terry Heffernan

AGENCY
Cross Associates

CLIENT
Bank of America

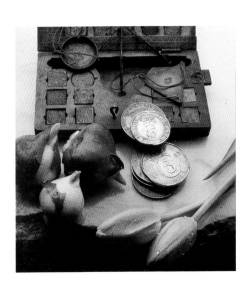

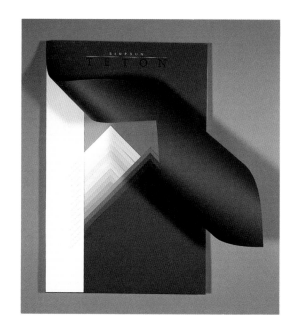

BROCHURE, FOLDER

ART DIRECTOR
James Cross

DESIGN DIRECTOR
James Cross
Michael Mescall

DESIGNER
Michael Mescall
Shari Gray

AGENCY
Cross Associates

CLIENT
Simpson Paper
Company

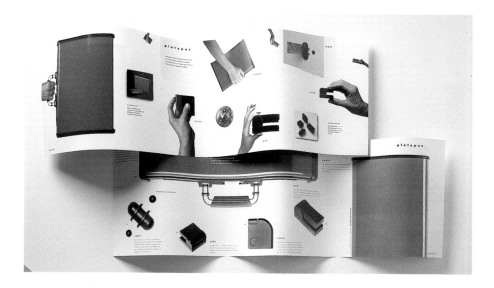

ART DIRECTOR
Cheri Gray

DESIGNER
Cheri Gray
Kotaro Shimogori

WRITER
Deborah Perrin

*PHOTOGRAPHER /
ILLUSTRATOR*
Roger Marchutz

AGENCY
Cheri Gray Design
Studio

CLIENT
Platypus, Inc.
▲

ART DIRECTOR
John Coy

DESIGN DIRECTOR
John Coy

DESIGNER
Kevin Consales

WRITER
California Institute of
the Arts

*PHOTOGRAPHER /
ILLUSTRATOR*
Steven A. Gunther
and contributing
photographers

AGENCY
COY, Los Angeles

CLIENT
California Institute of
the Arts

BROCHURE, FOLDER

ART DIRECTOR
Michael Mazza

DESIGN DIRECTOR
Stan Richards

DESIGNER
Michael Mazza

WRITER
Michael Mazza
Mike Kirby
Rob Schapiro

*PHOTOGRAPHER/
ILLUSTRATOR*
John Kleber

AGENCY
The Richards Group

CLIENT
Junior Group of the
Dallas Symphony
Orchestra League
▲

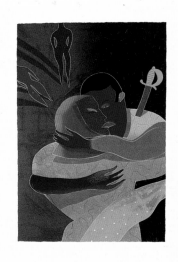

ART DIRECTOR
Antony Milner

DESIGN DIRECTOR
Mark Anderson

DESIGNER
Earl Gee

WRITER
Ann Fenimore

PHOTOGRAPHER
Henrik Kam

AGENCY
Mark Anderson Design

CLIENT
Datacopy Corporation

ART DIRECTOR
John Coy

DESIGN DIRECTOR
John Coy

DESIGNER
Laurie Handler

WRITER
Suzanne Muchnic

*PHOTOGRAPHER/
ILLUSTRATOR*
Stan Klimek

AGENCY
COY, Los Angeles

CLIENT
South Coast Plaza

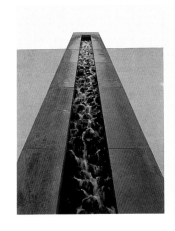

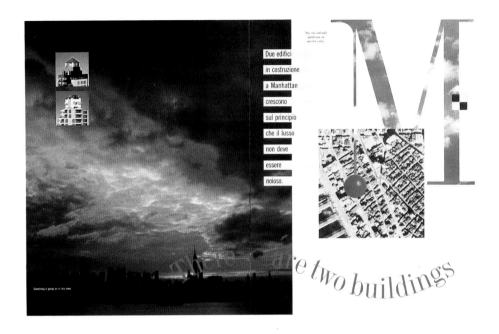

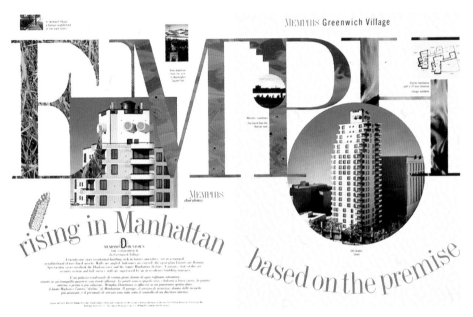

BROCHURE, FOLDER

ART DIRECTOR
Tibor Kalman
DESIGNER
Alexander Isley
WRITER
Danny Abelson
*PHOTOGRAPHER/
ILLUSTRATOR*
Jock Pottle/ESTO
AGENCY
M & Co.
CLIENT
Aaron Green
Companies

ART DIRECTOR
Terence Mitchell
DESIGNER
Yee-Ping Cho
AGENCY
Community
Redevelopment Agency
CLIENT
Community
Redevelopment Agency

BROCHURE, FOLDER
ART DIRECTOR
Douglas Wadden
DESIGN DIRECTOR
Douglas Wadden
DESIGNER
Douglas Wadden
AGENCY
Design Collaborative /
Seattle
CLIENT
Henry Art Gallery /
University of
Washington

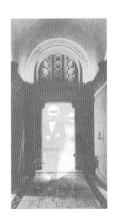

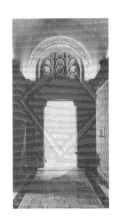

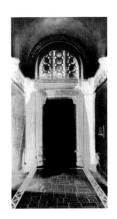

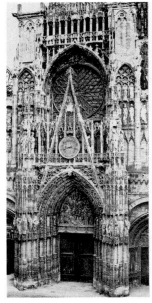

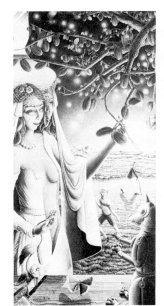

BROCHURE, FOLDER

ART DIRECTOR
Michael Vanderbyl

DESIGN DIRECTOR
Michael Vanderbyl

DESIGNER
Michael Vanderbyl

AGENCY
Vanderbyl Design

CLIENT
Bernhardt Furniture

R ecalling classic Regency elegance, the Como Chair is a handsome complement to the executive office. This lightly scaled chair lends an air of grace to all contract interiors, contemporary or traditional.

The Como Chair, crafted in Maple hardwood, is available in standard Bernhardt hand-rubbed lacquer finishes.

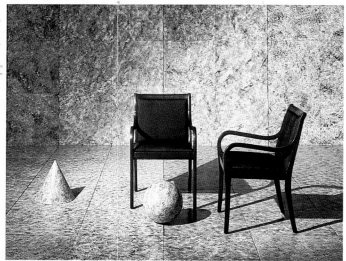

BROCHURE, FOLDER

ART DIRECTOR
Mark Galarneau

DESIGNER
Mark Galarneau

WRITER
Mark Fulton

*PHOTOGRAPHER/
ILLUSTRATOR*
Ron Turner

AGENCY
Galarneau & Sinn, Ltd.

CLIENT
Accolade

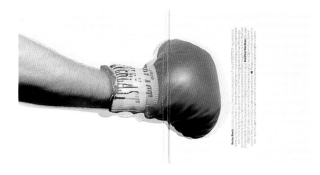

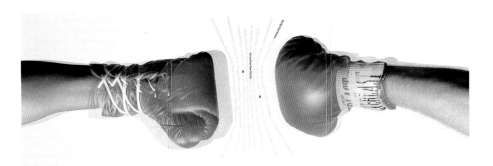

ART DIRECTOR
Mark Galarneau

DESIGNER
Mark Galarneau

WRITER
Larry April

*PHOTOGRAPHER/
ILLUSTRATOR*
Ron Turner
Mel Lindstrom

AGENCY
Galarneau & Sinn, Ltd.

CLIENT
Accolade

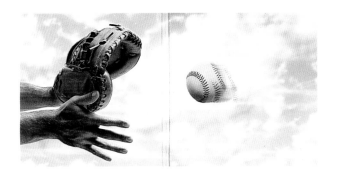

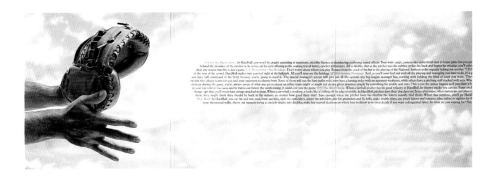

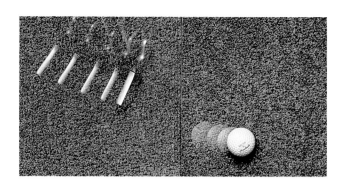

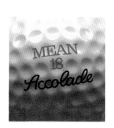

BROCHURE, FOLDER

ART DIRECTOR
Mark Galarneau
DESIGNER
Mark Galarneau
WRITER
Lisa Layne
PHOTOGRAPHER/
ILLUSTRATOR
Lawrence Bartone
AGENCY
Galarneau & Sinn, Ltd.
CLIENT
Accolade

BROCHURE, FOLDER

ART DIRECTOR
Michael Vanderbyl

DESIGN DIRECTOR
Michael Vanderbyl

DESIGNER
Michael Vanderbyl

AGENCY
Vanderbyl Design

CLIENT
Simpson Paper Co.

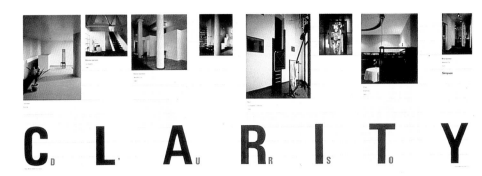

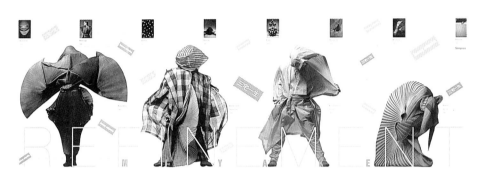

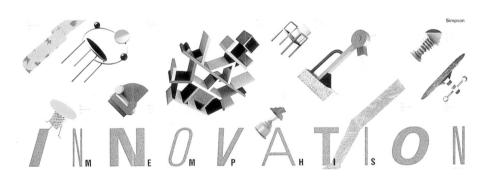

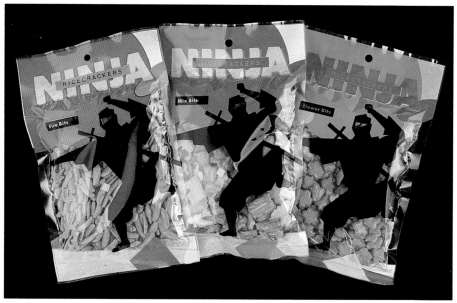

3-D PACKAGING

DESIGNER
April Greiman

WRITER
April Greiman

AGENCY
April Greiman Studio

CLIENT
Mike Sagara

ART DIRECTOR
Michael Mabry

DESIGNER
Michael Mabry
Noreen Fukumori

PHOTOGRAPHER/
ILLUSTRATOR
Michael Mabry

AGENCY
Michael Mabry Design

CLIENT
SEH Importers
▲

3-D PACKAGING

ART DIRECTOR
Jack Anderson

DESIGN DIRECTOR
Jack Anderson

DESIGNER
Jack Anderson
Cheri Huber

ILLUSTRATOR
Jack Anderson
John Fortune

AGENCY
Hornall Anderson
Design Works

CLIENT
MacB Sports

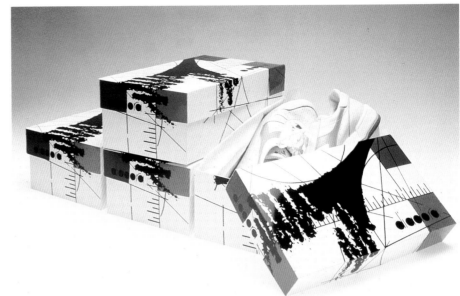

ART DIRECTOR
Maureen Erbe

DESIGNER
Maureen Erbe

AGENCY
Maureen Erbe Design

CLIENT
Phil Schwartz /
Chanins

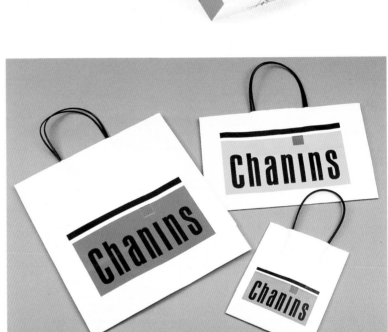

ART DIRECTOR
Sam Smidt

DESIGN DIRECTOR
Sam Smidt

DESIGNER
Sam Smidt
Linda Wong

WRITER
Morgan Thomas

AGENCY
Sam Smidt

CLIENT
[íxi:z]

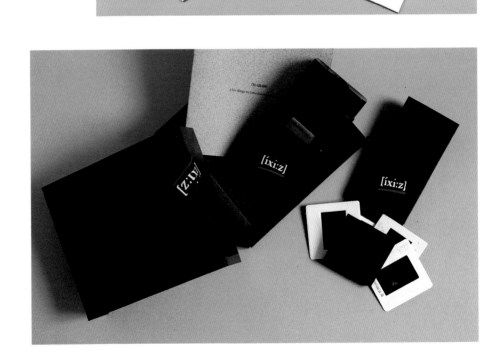

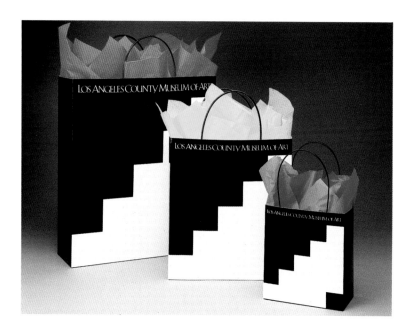

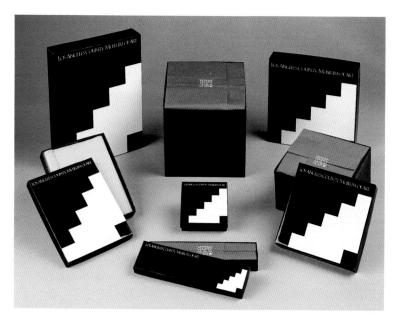

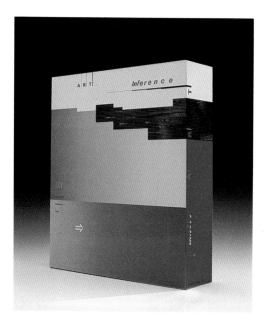

3-D PACKAGING

ART DIRECTOR
Patrick SooHoo
DESIGN DIRECTOR
Paula Yamasaki-Ison
DESIGNER
Tricia Rauen
Katherine Lam
AGENCY
Patrick SooHoo, Inc.
CLIENT
LA County Museum
of Art

ART DIRECTOR
April Greiman
DESIGN DIRECTOR
April Greiman
DESIGNER
April Greiman
ILLUSTRATOR
Computer Graphic:
April Greiman
AGENCY
April Greiman Studio
CLIENT
Inferrence /Alex
Jacobson
▲

3-D PACKAGING

ART DIRECTOR
Gerald Reis

DESIGN DIRECTOR
Gerald Reis

DESIGNER
Gerald Reis
Wilson Ong

AGENCY
Gerald Reis & Co.

CLIENT
Victorian Pantry

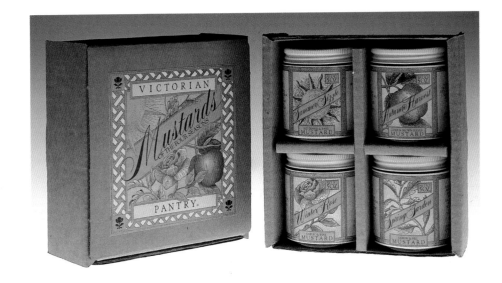

ART DIRECTOR
Ralph Colonna

DESIGN DIRECTOR
Ralph Colonna

DESIGNER
Ralph Colonna
Joann Ortega
John Nickels

ILLUSTRATOR
Robert Swartly

AGENCY
Colonna, Farrell:
Design

CLIENT
Chateau Chevalier
John Nickels
Gil Nichols

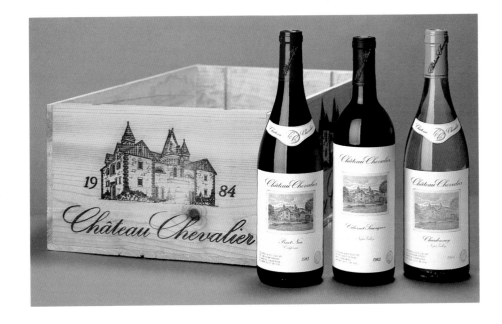

ART DIRECTOR
Craig Frazier

DESIGN DIRECTOR
Craig Frazier

DESIGNER
Craig Frazier
Grant Peterson

*PHOTOGRAPHER/
ILLUSTRATOR*
Suzanne Frazier
Craig Frazier

AGENCY
Craig Frazier Design

CLIENT
Merlion Winery

ART DIRECTOR
Peter Coutroulis

DESIGNER
Peter Coutroulis

WRITER
Howie Krakow

*PHOTOGRAPHER/
ILLUSTRATOR*
Bob Hickson

AGENCY
DJMC—18th Floor

CLIENT
U.S. Borax

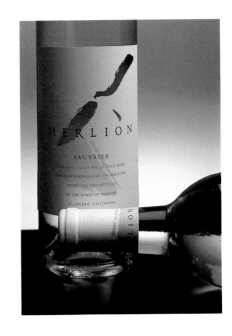

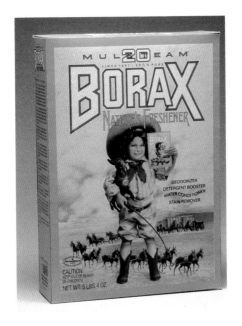

ART DIRECTOR
Laura M. Stahlberg
DESIGN DIRECTOR
Laura M. Stahlberg
DESIGNER
Laura M. Stahlberg
WRITER
Laura M. Stahlberg
Susan Webber
*PHOTOGRAPHER/
ILLUSTRATOR*
Laura M. Stahlberg
AGENCY
October Night
Graphics
CLIENT
Self

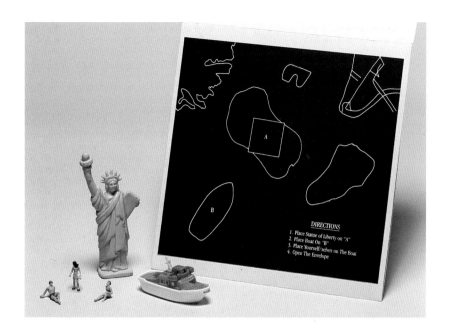

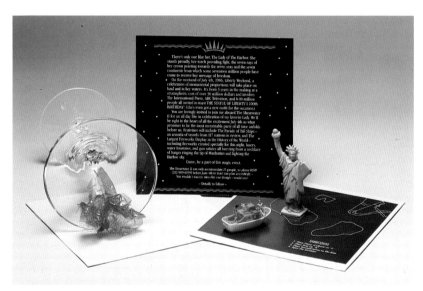

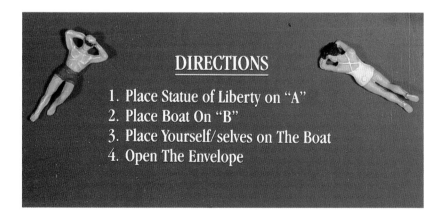

3-D PACKAGING

ART DIRECTOR
Cheri Gray

DESIGNER
Cheri Gray

WRITER
Deborah Perrin

AGENCY
Cheri Gray Design
Studio

CLIENT
Platypus, Inc.

▲

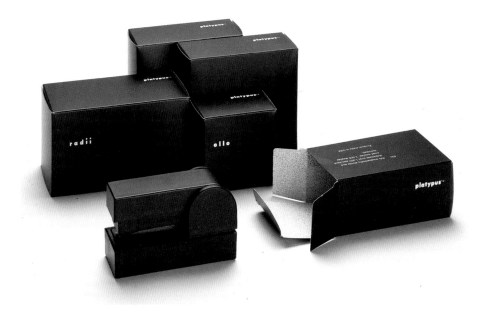

ART DIRECTOR
Robert Bornhoeft

DESIGN DIRECTOR
Robert Bornhoeft

DESIGNER
Robert Bornhoeft

AGENCY
AD3, Inc.

CLIENT
Black Tie Roses

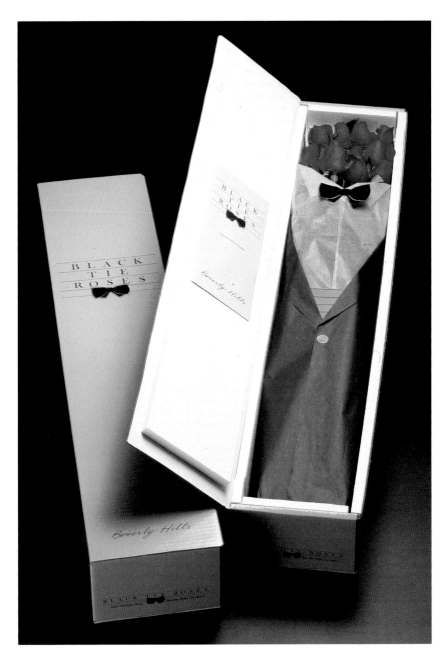

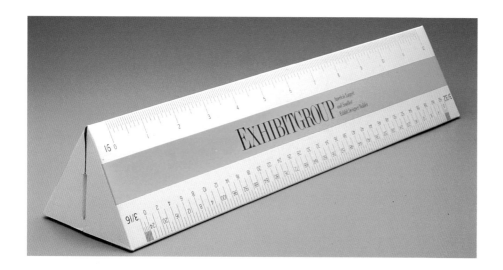

3-D PACKAGING

ART DIRECTOR
Michael Patrick Cronan

DESIGN DIRECTOR
Michael Patrick Cronan

DESIGNER
Michael Patrick Cronan
Nancy Paynter

AGENCY
Cronan Design, Inc.

CLIENT
Exhibitgroup

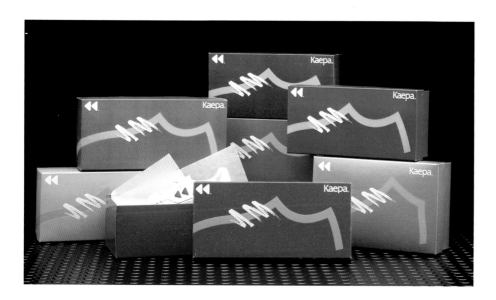

ART DIRECTOR
Keith Bright

DESIGN DIRECTOR
Keith Bright

DESIGNER
Raymond Wood

PHOTOGRAPHER/
ILLUSTRATOR
Raymond Wood

AGENCY
Bright & Associates

CLIENT
Kaepa, Inc.
▲

POINT OF PURCHASE

ART DIRECTOR
Jean Robaire

WRITER
John Stein

*PHOTOGRAPHER /
ILLUSTRATOR*
Richard Drayton

AGENCY
Chiat / Day Advertising

CLIENT
Pizza Hut, Inc.

ART DIRECTOR
Jean Robaire

WRITER
John Stein

*PHOTOGRAPHER /
ILLUSTRATOR*
Richard Drayton

AGENCY
Chiat / Day Advertising

CLIENT
Pizza Hut, Inc.

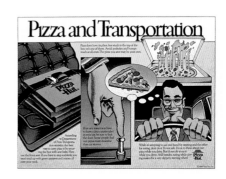

ART DIRECTOR
Jean Robaire

WRITER
John Stein

*PHOTOGRAPHER /
ILLUSTRATOR*
Richard Drayton

AGENCY
Chiat / Day Advertising

CLIENT
Pizza Hut, Inc.

ART DIRECTOR
Jean Robaire

WRITER
John Stein

*PHOTOGRAPHER /
ILLUSTRATOR*
Richard Drayton

AGENCY
Chiat / Day Advertising

CLIENT
Pizza Hut, Inc.

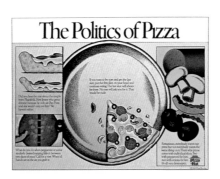

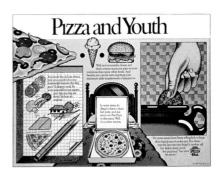

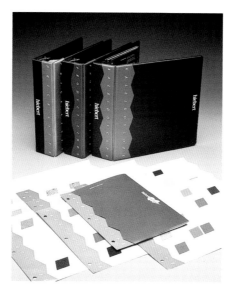

SALES KIT, PRESS KIT

ART DIRECTOR
Jeff Fear
Ken White
DESIGN DIRECTOR
Lisa Levin Pogue
DESIGNER
Vernon Hahn
AGENCY
White + Associates
CLIENT
Hiebert

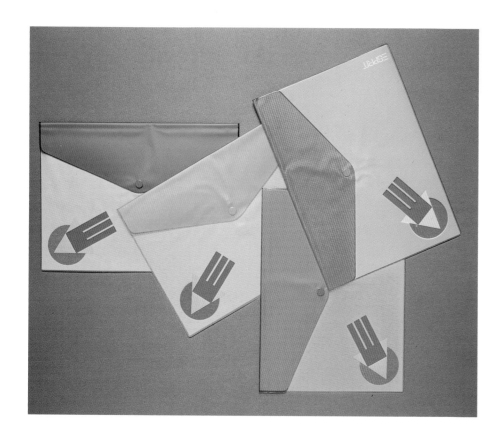

ART DIRECTOR
Tamotsu Yagi
DESIGNER
Tamotsu Yagi
AGENCY
Esprit Graphic Design
Studio
CLIENT
Esprit De Corp.

HOUSE ORGAN,
NEWSLETTER

DESIGN DIRECTOR
Craig Minor

DESIGNER
Kenny Kane

WRITER
Client

PHOTOGRAPHER/
ILLUSTRATOR
Client

AGENCY
Creel Morrell, Inc.

CLIENT
Innova (Houston
Design Center)

ART DIRECTOR
Michael Mabry

DESIGN DIRECTOR
Michael Mabry

DESIGNER
Michael Mabry
Peter Soe, Jr.

WRITER
Marjorie Wilkins,
Editor

PHOTOGRAPHER/
ILLUSTRATOR
various

AGENCY
Michael Mabry Design

CLIENT
Pacific Telephone

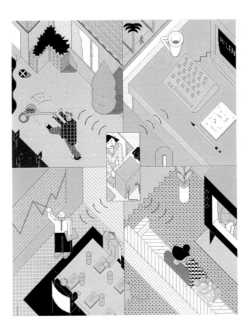

THE NETWORK OF THE 1990s

March, 1995: it's late in the day and your office is quiet. Many of your co-workers are telecommuters now, or they are working flexible schedules. You've spent most of the afternoon refining your company's telecommunications network: setting up telecommuter lines for a new employee, adding some custom features to the computer-phones in the sales office, and selecting a slower transmission rate for sending low-priority data to corporate headquarters. Although your "private" telecommunications network is actually provided entirely by Pacific Bell, you haven't had to call them about any of these changes.

Dramatic changes in the Pacific Bell network—and how we all use it—are already on the boards.

Much easier than in the 1980s, you think, and also more exciting; the number of ways to use the Pacific Bell network is growing all the time. To check your afternoon's work, you ask NetServe to simulate an average day's telecommunications traffic on your new network configuration. Sure enough, the changes you have made are projected to increase sales efficiency and reduce telephone and data communication costs. Now you can relax and turn your thoughts toward home. You again consult the NetServe Terminal, but this time you request your own Home Security/Energy Management Profile. Your home alarms have not been disturbed, you notice, but the house temperature has slipped a few degrees during the afternoon rain. With a few keystrokes you adjust the house thermostat upward a few degrees, and also turn on the oven to begin cooking tonight's dinner. Finally, you see that there is some electronic mail waiting for you, so you respond to some of it before deciding to read the rest when you get home....

ART DIRECTOR
Tamotsu Yagi

DESIGNER
Tamotsu Yagi

AGENCY
Esprit Graphic Design
Studio

CLIENT
Esprit De Corp.

▲

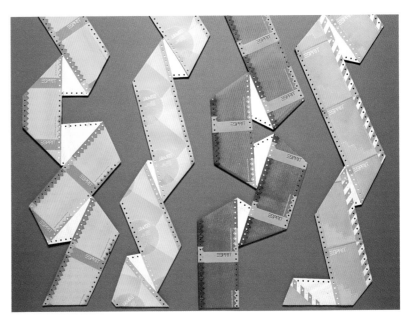

HOUSE ORGAN,
NEWSLETTER

ART DIRECTOR
Kit Hinrichs

DESIGN DIRECTOR
Kit Hinrichs

DESIGNER
Lenore Bartz

WRITER
Delphine Hirasuna

PHOTOGRAPHER
Henrik Kam
Tom Tracy
Terry Heffernan

ILLUSTRATOR
Hank Osuna
Kuniko Craft (Cover)

AGENCY
Pentagram Design, Ltd.

CLIENT
Potlatch Corporation

DESIGNER
Bob Feie or Vicky Hsu

WRITER
Joan Kufrin
Wally Petersen
Cheri Carpenter
Jane Cray

*PHOTOGRAPHER/
ILLUSTRATOR*
various

AGENCY
Boller/Coates/Spadaro,
Ltd.

CLIENT
Leo Burnett Co., Inc.

ART DIRECTOR
George Tscherny

DESIGN DIRECTOR
George Tscherny

DESIGNER
George Tscherny
Amy Henderson
Julia Wieczkowski

*PHOTOGRAPHER/
ILLUSTRATOR*
various

EDITOR
Robert K. Brown

AGENCY
George Tscherny, Inc.

CLIENT
The Poster Society

DESIGN

*HOUSE ORGAN,
NEWSLETTER*

ART DIRECTOR
Martin Solomon

DESIGN DIRECTOR
Martin Solomon

DESIGNER
Martin Solomon

WRITER
Martin Solomon

*PHOTOGRAPHER/
ILLUSTRATOR*
Martin Solomon

AGENCY
Royal Composing
Room, Inc.

CLIENT
Royal Composing
Room, Inc.

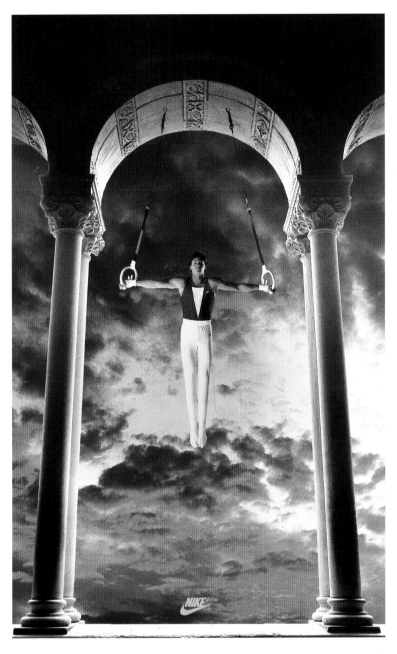

POSTER

ART DIRECTOR
Peter Moore
DESIGN DIRECTOR
Peter Moore
DESIGNER
Peter Moore
PHOTOGRAPHER/
ILLUSTRATOR
Bill Robbins
AGENCY
Bill Robbins
Photography
CLIENT
Nike Sportswear

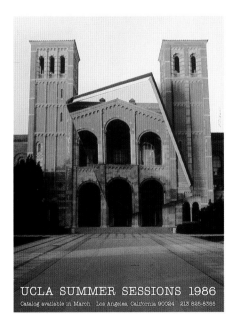

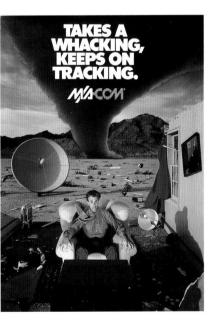

ART DIRECTOR
James Cross
DESIGN DIRECTOR
James Cross
DESIGNER
James Cross
PHOTOGRAPHER/
ILLUSTRATOR
James Cross
AGENCY
Cross Associates
CLIENT
University of
California,
Los Angeles

ART DIRECTOR
David Ayriss
WRITER
David Ayriss
PHOTOGRAPHER/
ILLUSTRATOR
Eric Myer
AGENCY
Hamilton Advertising,
Inc.
CLIENT
M/A-Com Satellite
Dishes

POSTER

ART DIRECTOR
April Greiman

DESIGN DIRECTOR
April Greiman

DESIGNER
John Coy
Michael Cronan
April Greiman
Linda Hinrichs
Michael Manwaring
Michael Vanderbyl

*PHOTOGRAPHER /
ILLUSTRATOR*
Michael Cronan
Linda Hinrichs
Michael Manwaring
Michael Vanderbyl
Eric Martin

AGENCY
Cronan Design, Inc.

CLIENT
American Institute of
Graphic Arts

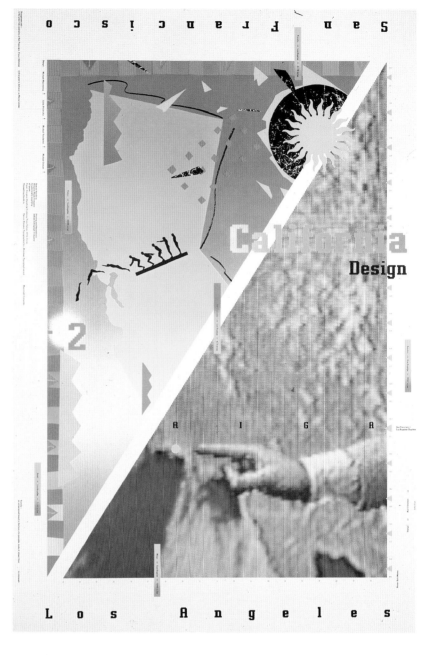

ART DIRECTOR
Milton Glaser

DESIGN DIRECTOR
Milton Glaser

DESIGNER
Milton Glaser

ILLUSTRATOR
Milton Glaser

AGENCY
Milton Glaser, Inc.

CLIENT
Indiana University
of Music

ART DIRECTOR
Tom Geismar

DESIGNER
Tom Geismar

*PHOTOGRAPHER /
ILLUSTRATOR*
Alan Shortall

AGENCY
Chermayeff & Geismar
Associates

CLIENT
The Shoshin Society
▲

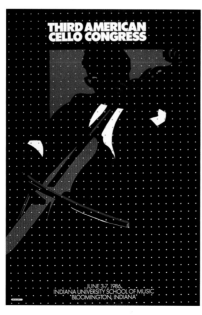

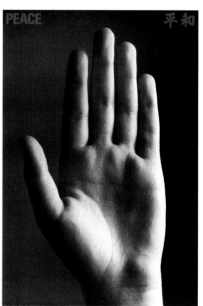

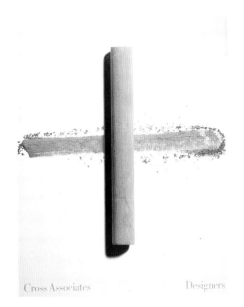

Cross Associates Designers

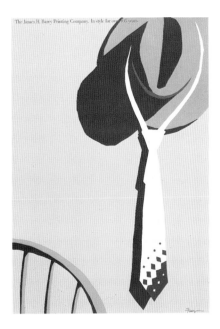

The James H. Barry Printing Company. In style for over 116 years.

ART DIRECTOR
James Cross
DESIGN DIRECTOR
John Clark
DESIGNER
John Clark
PHOTOGRAPHER
David Randle
AGENCY
Cross Associates
CLIENT
Cross Associates

POSTER
ART DIRECTOR
Craig Frazier
DESIGN DIRECTOR
Craig Frazier
DESIGNER
Craig Frazier
WRITER
Craig Frazier
ILLUSTRATOR
Craig Frazier
AGENCY
Craig Frazier Design
CLIENT
James H. Barry
Company

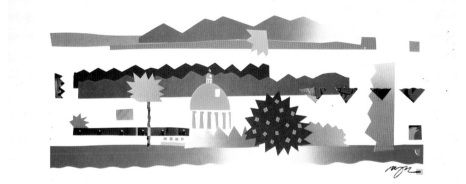

The Art Directors and Artist's Club of Sacramento A.D.A.C.

ART DIRECTOR
Michael Patrick Cronan
DESIGN DIRECTOR
Michael Patrick Cronan
DESIGNER
Michael Patrick Cronan
PHOTOGRAPHER/
ILLUSTRATOR
Michael Patrick Cronan
AGENCY
Cronan Design, Inc.
CLIENT
Art Directors & Artists
Club of Sacramento

two hundred nineteen

POSTER

ART DIRECTOR
Steff Geissbuhler
DESIGNER
Steff Geissbuhler
AGENCY
Chermayeff & Geismar
Associates
CLIENT
The Shoshin Society
▲

ART DIRECTOR
Alan Lidji
Michael Morris
DESIGN DIRECTOR
Alan Lidji
Michael Morris
DESIGNER
Alan Lidji
Michael Morris
*PHOTOGRAPHER/
ILLUSTRATOR*
Alan Lidji
Michael Morris
AGENCY
Rosenberg & Company
CLIENT
Trammell Crow Co.
▲

ART DIRECTOR
Milton Glaser
DESIGN DIRECTOR
Milton Glaser
DESIGNER
Milton Glaser
ILLUSTRATOR
Milton Glaser
AGENCY
Milton Glaser, Inc.
CLIENT
The Merchandise Mart,
Chicago

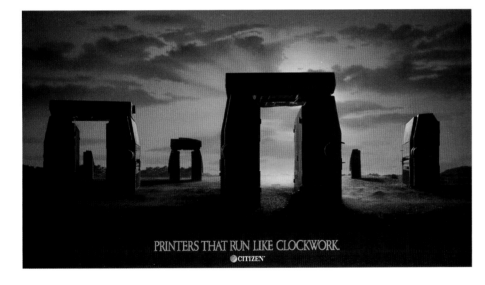

POSTER

ART DIRECTOR
Rudolph de Harak

DESIGN DIRECTOR
Rudolph de Harak

DESIGNER
Rudolph de Harak
Frank Benedict

AGENCY
Rudolph de Harak &
Assoc., Inc.

CLIENT
American Institute of
Graphic Arts

ART DIRECTOR
Tris Bovich Caserio

WRITER
Paul Cross Blanchard

PHOTOGRAPHER/
ILLUSTRATOR
Bo Hylan

AGENCY
Abert, Newhoff & Burr

CLIENT
Citizen America

POSTER

DESIGN DIRECTOR
Michael Schwab

DESIGNER
Michael Schwab

*PHOTOGRAPHER/
ILLUSTRATOR*
Michael Schwab

AGENCY
Michael Schwab Design

CLIENT
Art Directors &
Designers of Orange
County

ART DIRECTOR
Alan Lidji

DESIGN DIRECTOR
Alan Lidji

DESIGNER
Alan Lidji

*PHOTOGRAPHER/
ILLUSTRATOR*
Alan Lidji

AGENCY
Rosenberg & Company

CLIENT
NHAB

The 1986 McSam Awards

DESIGN DIRECTOR
Marty Neumeier

DESIGNER
Marty Neumeier

WRITER
Marty Neumeier

AGENCY
Neumeier Design Team

CLIENT
Designworks

Ten artists interpret ten years of Designworks architecture 1976-1986

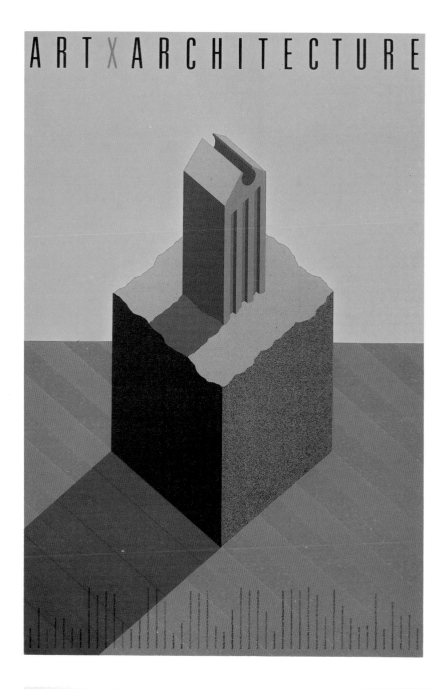

POSTER

DESIGN DIRECTOR
Michael Vanderbyl

DESIGNER
Michael Vanderbyl

AGENCY
Vanderbyl Design

CLIENT
San Francisco Museum
of Modern Art

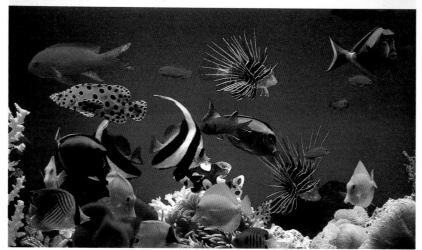

ART DIRECTOR
Mel Abert
Iz Leibowitz

WRITER
Mel Newhoff
Kim Blessington

PHOTOGRAPHER/
ILLUSTRATOR
Paul Sanders

AGENCY
Abert, Newhoff & Burr

CLIENT
Tahiti Tourist Board

POSTER

ART DIRECTOR
Victor Hugo Zayas

DESIGN DIRECTOR
Victor Hugo Zayas

DESIGNER
Victor Hugo Zayas

PHOTOGRAPHER/
ILLUSTRATOR
Victor Hugo Zayas

AGENCY
Art Center College of
Design

CLIENT
National Symphony
Orchestra

ART DIRECTOR
Alan Lidji

DESIGN DIRECTOR
Alan Lidji

DESIGNER
Alan Lidji

WRITER
Mike Kirby

PHOTOGRAPHER/
ILLUSTRATOR
Robert Latorre

AGENCY
Rosenberg & Company

CLIENT
The Registry Hotel
▲

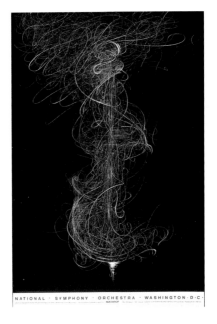

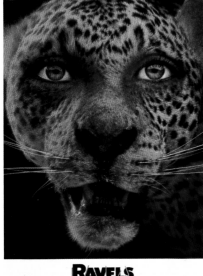

ART DIRECTOR
Tom Nikosey
Don Baker

DESIGN DIRECTOR
Joey Cummings

DESIGNER
Tom Nikosey

WRITER
Don Baker

ILLUSTRATOR
Tom Nikosey

AGENCY
Nikosey Design

CLIENT
Pepsi

ART DIRECTOR
Gerald Reis

DESIGN DIRECTOR
Gerald Reis

DESIGNER
Gerald Reis

PHOTOGRAPHER/
ILLUSTRATOR
Gerald Reis/
Wilson Ong

AGENCY
Gerald Reis & Co.

CLIENT
Mitsamura Printing

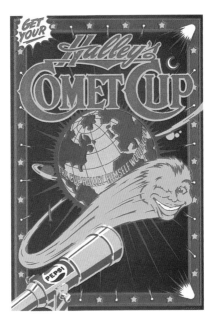

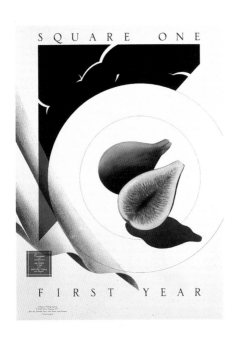

ART DIRECTOR
William Wondriska

PHOTOGRAPHER/
ILLUSTRATOR
William Wondriska

AGENCY
Wondriska Associates
Inc.

CLIENT
Martin Luther King Jr.
Youth Foundation

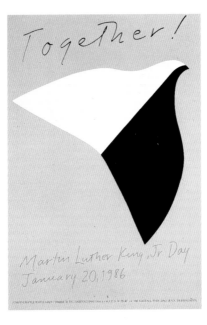

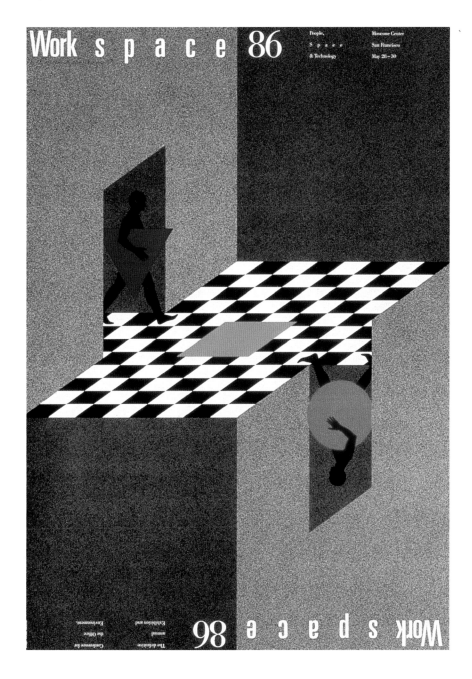

POSTER

ART DIRECTOR
Michael Vanderbyl

DESIGN DIRECTOR
Michael Vanderbyl

DESIGNER
Michael Vanderbyl

AGENCY
Vanderbyl Design

CLIENT
Workspace

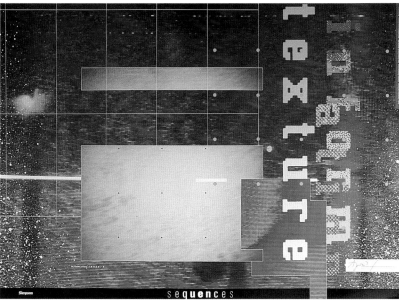

ART DIRECTOR
April Greiman

DESIGN DIRECTOR
April Greiman

DESIGNER
April Greiman

VIDEO
PHOTOGRAPHER
April Greiman

AGENCY
April Greiman Studio

CLIENT
Simpson Paper
▲

MENU, CALENDAR,
ANNOUNCEMENT

ART DIRECTOR
George Tscherny

DESIGN DIRECTOR
George Tscherny

DESIGNER
George Tscherny

*PHOTOGRAPHER/
ILLUSTRATOR*
Ben Swedowski

AGENCY
George Tscherny, Inc.

CLIENT
S.D. Scott
Printing Co., Inc.

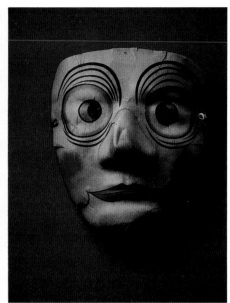

ART DIRECTOR
Kit Hinrichs

DESIGN DIRECTOR
Kit Hinrichs

DESIGNER
Belle How

WRITER
Peterson & Dodge

PHOTOGRAPHER
Terry Heffernan

AGENCY
Pentagram Design, Ltd.

CLIENT
American President
Lines

ART DIRECTOR
Michael Mabry

DESIGNER
Michael Mabry
Noreen Fukumori

*PHOTOGRAPHER/
ILLUSTRATOR*
Various

AGENCY
Michael Mabry Design

CLIENT
Overseas Printing
Corporation

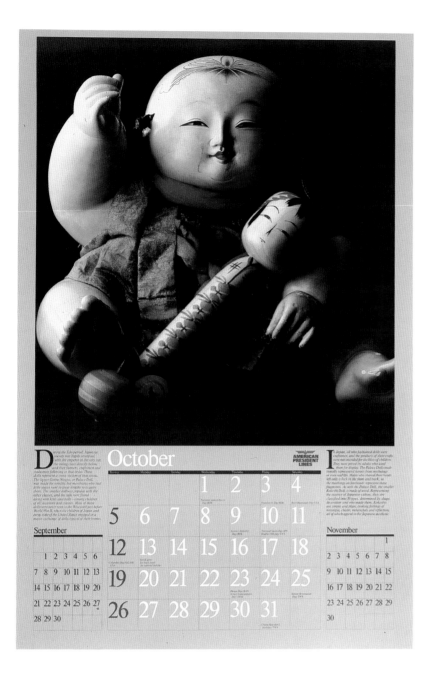

MENU, CALENDAR,
ANNOUNCEMENT
ART DIRECTOR
Kit Hinrichs
DESIGN DIRECTOR
Kit Hinrichs
DESIGNER
Belle How
WRITER
Peterson & Dodge
PHOTOGRAPHER/
ILLUSTRATOR
Terry Heffernan
AGENCY
Pentagram Design, Ltd.
CLIENT
American President
Lines

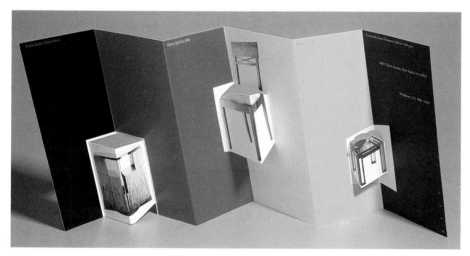

ART DIRECTOR
John Coy
DESIGN DIRECTOR
John Coy
DESIGNER
Felice Mataré
AGENCY
COY, Los Angeles
CLIENT
Luten Clarey Stern

*MENU, CALENDAR,
ANNOUNCEMENT*

ART DIRECTOR
Tamotsu Yagi

DESIGNER
Tamotsu Yagi

AGENCY
Esprit Graphic Design
Studio

CLIENT
Esprit De Corp.

ART DIRECTOR
James Robie

DESIGN DIRECTOR
Karen Knecht

DESIGNER
Karen Knecht

TYPOGRAPHER
Vernon Simpson

AGENCY
James Robie
Design Associates

CLIENT
Manning, Selvage
& Lee

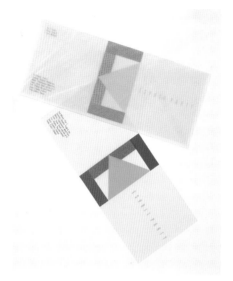 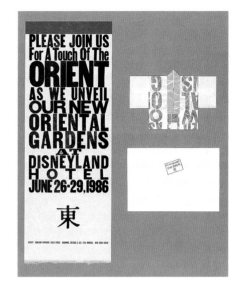

ART DIRECTOR
Tibor Kalman

DESIGNER
Alexander Isley

*PHOTOGRAPHER/
ILLUSTRATOR*
NY Yellow Pages

AGENCY
M & Co.

CLIENT
Restaurant Florent

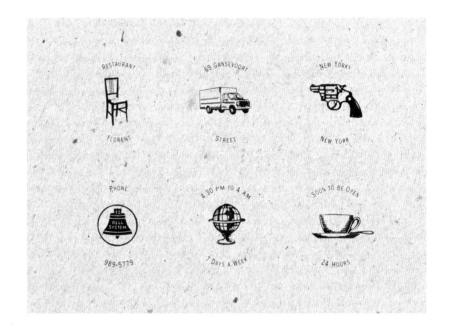

ART DIRECTOR
Michael Mabry

DESIGNER
Michael Mabry

*PHOTOGRAPHER/
ILLUSTRATOR*
Michael Mabry

AGENCY
Michael Mabry Design

CLIENT
Limn

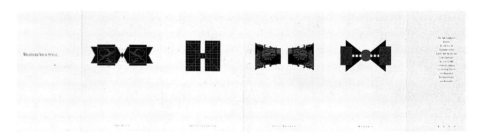

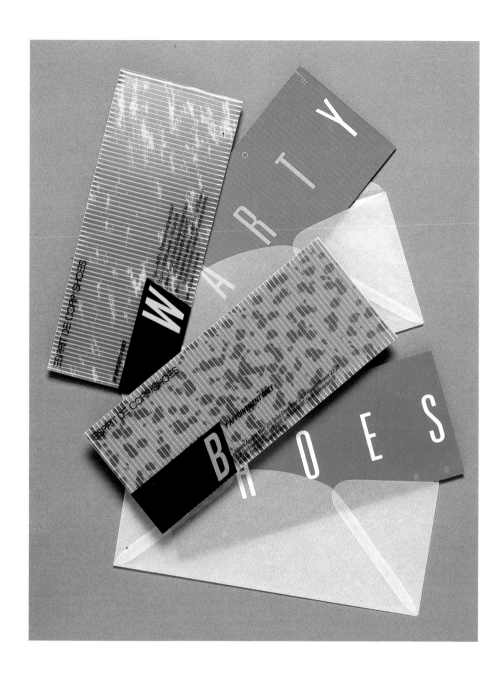

MENU, CALENDAR,
ANNOUNCEMENT

ART DIRECTOR
Tamotsu Yagi
DESIGNER
Tamotsu Yagi
AGENCY
Esprit Graphic Design
Studio
CLIENT
Esprit De Corp.

ART DIRECTOR
Michael R. Abramson
DESIGN DIRECTOR
Caroline Woolley
DESIGNER
Caroline Woolley
WRITER
Michael R. Abramson
AGENCY
Michael R. Abramson
& Associates
CLIENT
Casaform

DESIGN

SELF PROMOTION

ART DIRECTOR
Craig Butler

DESIGN DIRECTOR
Craig Butler

*PHOTOGRAPHER/
ILLUSTRATOR*
Tom Zimberoff

AGENCY
Butler, Inc.

CLIENT
Tom Zimberoff

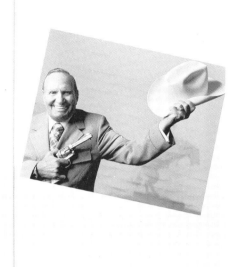

GENE AUTRY
HOLLYWOOD, CALIFORNIA

ART DIRECTOR
Keith Bright

DESIGN DIRECTOR
Keith Bright

DESIGNER
Raymond Wood

AGENCY
Bright & Associates

CLIENT
Bright & Associates

ART DIRECTOR
Russell K. Leong

DESIGNER
Russell K. Leong

ILLUSTRATOR
Emiko Oyama

SHAPER
Pat Taylor

AGENCY
Russell Leong Design

CLIENT
Self promo

SELF PROMOTION

ART DIRECTOR
Kathleen Boss

DESIGN DIRECTOR
Kathleen Boss

DESIGNER
Kathleen Boss

COPYWRITER
Thomas Fuszard
Chris Wall

*PHOTOGRAPHER/
ILLUSTRATOR*
Norman Seeff

AGENCY
Kathleen Boss Design

TYPOGRAPHER
Andresen Typographics

PRINTER
George Rice & Sons

CLIENT
Andresen Typographics

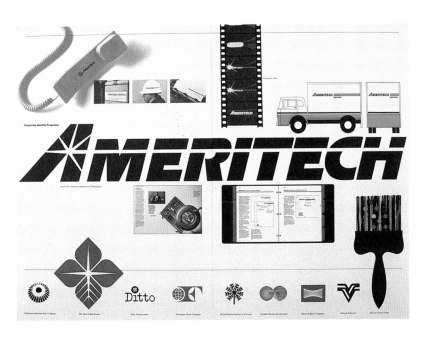

ART DIRECTOR
Morton Goldsholl

DESIGN DIRECTOR
John Rieben

DESIGNER
Jeff Callender

WRITER
Morton Goldsholl

*PHOTOGRAPHER/
ILLUSTRATOR*
Nick Kolias

CALLIGRAPHER
John Weber

AGENCY
Goldsholl Design
& Film

CLIENT
Goldsholl Design
& Film

ART DIRECTOR
Michael Mabry

DESIGNER
Michael Mabry
Peter Soe, Jr.

WRITER
Peterson & Dodge

*PHOTOGRAPHER/
ILLUSTRATOR*
Michael Mabry

AGENCY
Michael Mabry Design

CLIENT
Forman/Leibrock
Printers

SELF PROMOTION

ART DIRECTOR
Michael Manwaring

DESIGN DIRECTOR
Michael Manwaring

DESIGNER
Michael Manwaring

*PHOTOGRAPHER/
ILLUSTRATOR*
Michael Manwaring
Paul Chock

AGENCY
The Office of
Michael Manwaring

CLIENT
Mitsumura Printing
Company

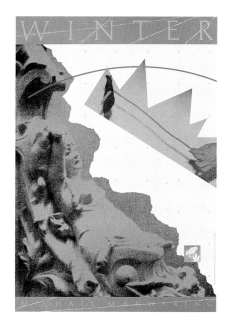

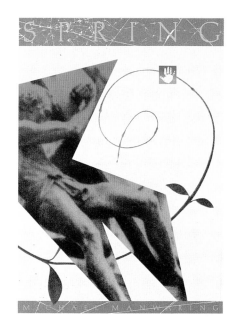

SELF PROMOTION

DESIGN DIRECTOR
Michael Vanderbyl

DESIGNER
Michael Vanderbyl

AGENCY
Vanderbyl Design

CLIENT
Vanderbyl Design

DIRECT MAIL

ART DIRECTOR
Sam Smidt

DESIGN DIRECTOR
Sam Smidt

DESIGNER
Sam Smidt

WRITER
Morgan Thomas

PHOTOGRAPHER/ ILLUSTRATOR
Raja Muna

AGENCY
Sam Smidt

CLIENT
[íxi:z]

▲

ART DIRECTOR
Mark Galarneau
Fred Vanderpoel

DESIGN DIRECTOR
Mark Galarneau

DESIGNER
Mark Galarneau

WRITER
Fred Vanderpoel
Mark Galarneau

PHOTOGRAPHER/ ILLUSTRATOR
Fred Vanderpoel

AGENCY
Galarneau & Sinn, Ltd.

CLIENT
Vanderpoel
Productions, Inc.

NO MORE PRETTY PICTURES FROM VANDERPOEL.

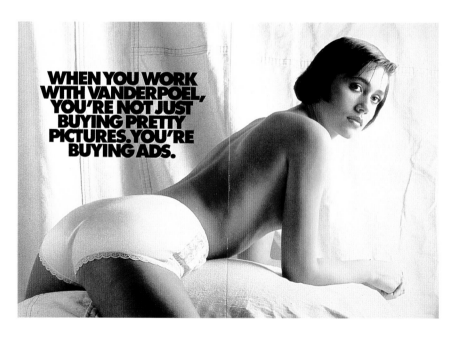

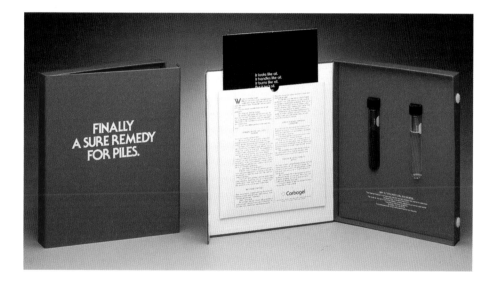

_____ bells,
_____ bells.

We don't do jingles.

DIRECT MAIL

ART DIRECTOR
Neil Shakery

DESIGN DIRECTOR
Neil Shakery

DESIGNER
Sandra McHenry

PHOTOGRAPHER/
ILLUSTRATOR
Ward Schumaker

HAND TINTING
Sara Anderson

AGENCY
Pentagram Design, Ltd.

CLIENT
Banana Republic

ART DIRECTOR
Tom Roth

DESIGNER
Mary Ellen Butkus

WRITER
Steve Trygg

AGENCY
Anderson & Lembke

CLIENT
Carbogel

ART DIRECTOR
Andy Dijak
Jeff Roll

WRITER
Phil Lanier
Dave Butler

AGENCY
Chiat/Day
Advertising

CLIENT
Chiat/Day
Advertising

VISUAL IDENTITY

ART DIRECTOR
Michael Manwaring

DESIGN DIRECTOR
Michael Manwaring

DESIGNER
Michael Manwaring

PHOTOGRAPHER/
ILLUSTRATOR
Michael Manwaring
Paul Chock

AGENCY
The Office of
Michael Manwaring

CLIENT
Heffalump

DESIGN DIRECTOR
Michael Mabry

DESIGNER
Michael Mabry

PHOTOGRAPHER/
ILLUSTRATOR
Michael Mabry

AGENCY
Michael Mabry
Design

CLIENT
Parklane Development
Company

ART DIRECTOR
Jerry Leibowitz

DESIGN DIRECTOR
Jerry Leibowitz

DESIGNER
Jerry Leibowitz

PHOTOGRAPHER/
ILLUSTRATOR
Jerry Leibowitz

AGENCY
Metroart

CLIENT
Desert Popsicle
Company

ART DIRECTOR
Suzanne Dvells

DESIGN DIRECTOR
Suzanne Dvells

DESIGNER
Victoria Adjami

AGENCY
Suzanne Dvells
Design

CLIENT
A.F. Gilmore Company

BEER & WINE

ART DIRECTOR
Gerald Reis

DESIGN DIRECTOR
Gerald Reis

DESIGNER
Gerald Reis

AGENCY
Gerald Reis
& Company

CLIENT
Caffe Quadro

VISUAL IDENTITY

ART DIRECTOR
Michael Manwaring

DESIGN DIRECTOR
Michael Manwaring

DESIGNER
Michael Manwaring

PHOTOGRAPHER/
ILLUSTRATOR
Michael Manwaring
Paul Chock

AGENCY
The Office of
Michael Manwaring

CLIENT
Home Express

ART DIRECTOR
Kevin Mason

DESIGNER
Kevin Mason

ILLUSTRATOR
Kevin Mason

AGENCY
Pepperdine University
University Publications
Department

CLIENT
Smothers Theatre—
Pepperdine University

ART DIRECTOR
Jerry Leibowitz

DESIGN DIRECTOR
Jerry Leibowitz

DESIGNER
Jerry Leibowitz

PHOTOGRAPHER/
ILLUSTRATOR
Jerry Leibowitz

AGENCY
Metroart

CLIENT
Pearblossom, Inc.

ART DIRECTOR
Michael Mabry

DESIGN DIRECTOR
Michael Mabry

DESIGNER
Michael Mabry

PHOTOGRAPHER/
ILLUSTRATOR
Michael Mabry

AGENCY
Michael Mabry
Design

CLIENT
Artspace

VISUAL IDENTITY
ART DIRECTOR
Suzanne Dvells
DESIGN DIRECTOR
Suzanne Dvells
DESIGNER
Victoria Adjami
AGENCY
Suzanne Dvells
Design
CLIENT
Suzanne Dvells

ART DIRECTOR
Leah Toby Hoffmitz
DESIGN DIRECTOR
Leah Toby Hoffmitz
DESIGNER
Leah Toby Hoffmitz
AGENCY
Letterform Design
CLIENT
Letterform Design
▲

ART DIRECTOR
April Greiman
DESIGN DIRECTOR
April Greiman
DESIGNER
April Greiman
AGENCY
April Greiman Studio
CLIENT
Akbar Alijamshid
▲

VISUAL IDENTITY

DESIGN DIRECTOR
Michael Patrick Cronan

DESIGNER
Michael Patrick Cronan
Michael Shea

AGENCY
Cronan Design, Inc.

CLIENT
University of
California,
San Francisco

ART DIRECTOR
Josh Freeman

DESIGN DIRECTOR
Vickie Sawyer

DESIGNER
Vickie Sawyer

AGENCY
Josh Freeman
Design Office

CLIENT
Jennings/Des Anges

ART DIRECTOR
Michael Patrick Cronan
Linda Lawler

DESIGN DIRECTOR
Michael Patrick Cronan
Linda Lawler

DESIGNER
Linda Lawler

*PHOTOGRAPHER/
ILLUSTRATOR*
Linda Lawler

AGENCY
Cronan Design, Inc.

CLIENT
French American
International School

VISUAL IDENTITY
ART DIRECTOR
Christine Linné Smith
DESIGN DIRECTOR
Christine Linné Smith
PHOTOGRAPHER/
ILLUSTRATOR
Christine Linné Smith
AGENCY
Christine Smith
& Associates
CLIENT
Laguna Sun, Inc.

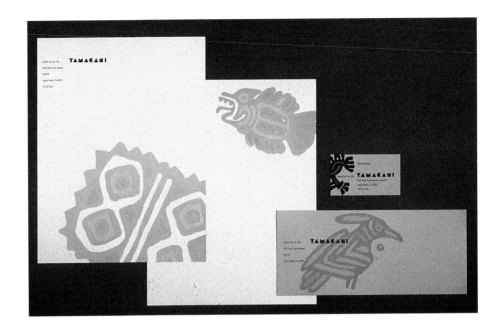

ART DIRECTOR
Rod Dyer
DESIGN DIRECTOR
Rod Dyer
DESIGNER
Rod Dyer
AGENCY
Dyer/Khan
CLIENT
Kipper Commodities

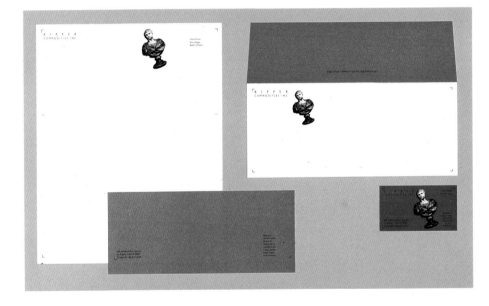

ART DIRECTOR
Jennifer Morla
DESIGN DIRECTOR
Jennifer Morla
DESIGNER
Jennifer Morla
AGENCY
Morla Design
CLIENT
Rick Wahlstrom

VISUAL IDENTITY

ART DIRECTOR
Jeff Kerns

DESIGN DIRECTOR
Jeff Kerns

DESIGNER
Peter Zaleski
Michael Rambo

AGENCY
Kerns & Associates
Advertising & Design

CLIENT
Kerns & Associates
Advertising & Design

ART DIRECTOR
Tom Antista

DESIGN DIRECTOR
Tom Antista

DESIGNER
Tom Antista

AGENCY
Antista Design Studio

CLIENT
Bob Ware Photography

VISUAL IDENTITY

ART DIRECTOR
Steff Geissbuhler
Ivan Chermayeff

DESIGNER
Michael Cervantes
Steff Geissbuhler
Danielle Dimston
Chermayeff & Geismar
Associates

WRITER
Michael Cervantes
Paul Rosenthal
Chermayeff & Geismar
Associates

AGENCY
Chermayeff & Geismar
Associates

CLIENT
NBC

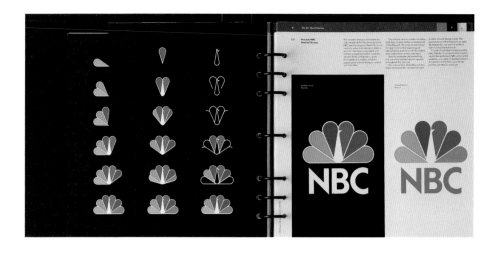

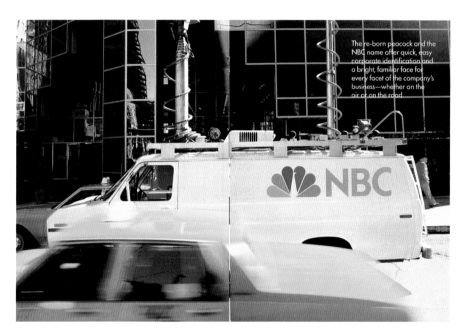

The re-born peacock and the NBC name offer quick, easy corporate identification and a bright, familiar face for every facet of the company's business—whether on the air or on the road.

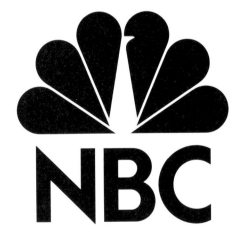

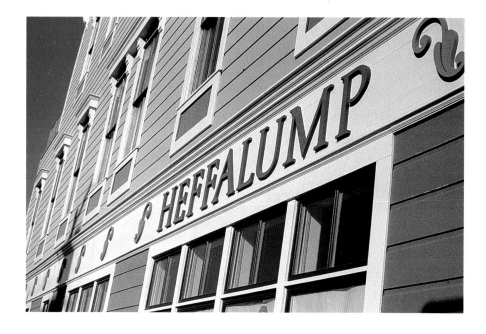

VISUAL IDENTITY

ART DIRECTOR
Michael Manwaring

DESIGN DIRECTOR
Michael Manwaring

DESIGNER
Michael Manwaring

AGENCY
The Office of
Michael Manwaring

CLIENT
Heffalump

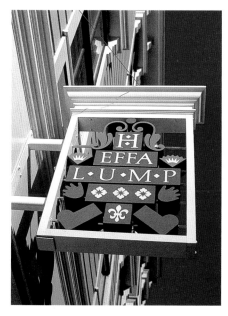

ART DIRECTOR
Michael Kaminski

DESIGNER
Kaminski Kertesz
Design

AGENCY
Kaminski Kertesz
Design

CLIENT
Held Properties

two hundred forty three

EDITORIAL

BOOK DESIGN
COVER

ART DIRECTOR
Lili Lakich

DESIGNER
Lili Lakich

WRITER
Lili Lakich

PHOTOGRAPHER/
ILLUSTRATOR
Lili Lakich

AGENCY
Calko & Lakich

CLIENT
Museum of Neon Art

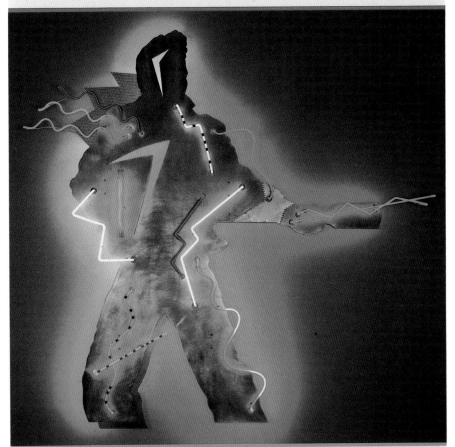

ART DIRECTOR
Rudolph de Harak
DESIGN DIRECTOR
Rudolf de Harak
DESIGNER
Rudolph de Harak
AGENCY
Rudolph de Harak
& Associates, Inc.
CLIENT
Rizzoli International

*BOOK DESIGN
COVER*
ART DIRECTOR
Toni Hollander
Susan Bell
DESIGN DIRECTOR
Toni Hollander
DESIGNER
Susan Bell
PHOTOGRAPHER
Jordan Miller
AGENCY
The Design Works
CLIENT
ADLA

ART DIRECTOR
Craig Butler
Larry Brooks
Betsy Rodden
DESIGN DIRECTOR
Craig Butler
PUBLISHER
Alexis Scott
EDITOR
Susan Haller
*PHOTOGRAPHER /
ILLUSTRATOR*
Various
AGENCY
Butler, Inc.
CLIENT
Scott & Daughters
Publishing

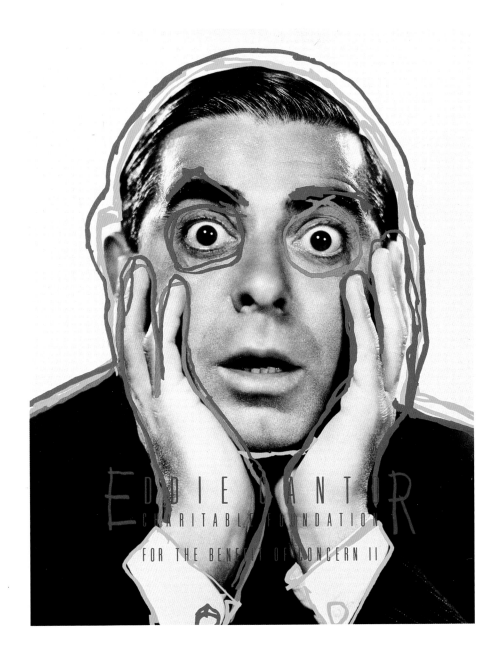

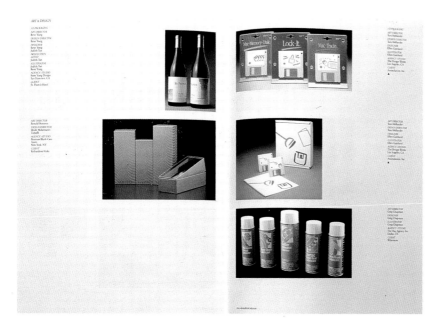

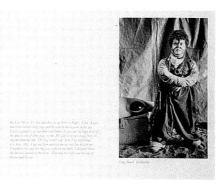

two hundred eleven

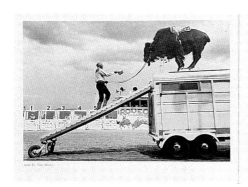

Santa Fe, New Mexico

Long Beach, California

THE FORTIES

The year 1940 brought forth one powerful burst of nightclub activity that would sustain the motion picture colony through its gradual demise in the period following the war. Hollywood, the sleepy suburb of a mere twenty-five years before, was now a town of mythic proportions. The hamlet of silent picture stars had spread out all over the Los Angeles area by the 1940s, and what was referred to as "Hollywood" was really meant to encompass anything having to do with the motion picture industry. Stars had settled down in Bel Air, Brentwood, and the Valley. Studios were established in all directions, from Culver City to Burbank. Spending millions was commonplace.

Two entertainment ventures debuted in January. The first was Casa Mañana, which revamped Frank Sebastian's Cotton Club into a moderne dance ballroom. With the demise of the Palomar, Casa Mañana took up the lead, and top bands added it to their agenda as one of the West Coast "musts." Skinnay Ennis opened the place to a hall full of big band devotees, who were still plentiful in the movie colony.

On the Strip, entrepreneur Billy Wilkerson was at it again—this time, planning another legendary showplace of magnificent proportions on the site of the old Club Seville. Ciro's opened at the end of January, 1940, and, as was the case with his other enterprise, it was an instant hit. The stars, abandoning the recent trend of staying home, flocked to Hollywood's newest in-spot. What greeted them was a sophisticated exterior facade by George Vernon Russell and inside a Baroque confection by interior designer Tom Douglas. Under the supervision of Wilkerson, Mr. Douglas created the latest in Hollywood glamour, with walls draped in heavy, ribbed silk, dyed pale reseda green, and a ceiling painted American Beauty red. The stars sank themselves into wall sofas also of silk, dyed to match the ceiling. Bronze columns and urns served as lighting fixtures that flanked the bandstand. Everywhere, the endless attention of a Wilkerson business was evident. Ads preceding the opening were a daily occurrence in the Hollywood Reporter, wherein readers were reminded that "Everybody that's anybody will be at Ciro's." And pretty much everybody in Hollywood turned up for the two openings on subsequent nights. Emil Coleman's orchestra initiated the bandstand, and it was reported that as a tip a bartender received five shares of Grand National stock. For weeks after the opening, the only place to be was Ciro's. Post-premiere parties, benefits, and birthdays were all celebrated there. Certainly one of the oddest occasions in its early days was a fashion show by a local farmer who paraded models in his expensive pelts accompanied by a live animal with the same fur she wore. Beavers, leopards, and minks got a firsthand view of Hollywood nightlife in the hallowed halls of Ciro's.

The latest hotspot naturally was under surveillance by the leading columnists,

183

Ciro's 1940 near New York

BOOK DESIGN

ART DIRECTOR
Rudolph de Harak

DESIGN DIRECTOR
Rudolph de Harak

DESIGNER
Rudolph de Harak

AGENCY
Rudolph de Harak
& Associates, Inc.

CLIENT
Rizzoli International

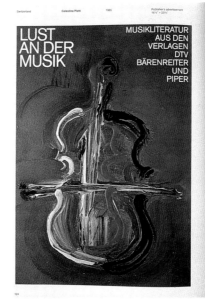

ART DIRECTOR
Stephen Frykholm

DESIGNER
Sara Giovanitti

WRITER
Bill Houseman
Clark Malcolm

PHOTOGRAPHER
Enrico Ferorelli
George Heinrich
Camille Vickers

AGENCY
Sara Giovanitti Design

CLIENT
Herman Miller, Inc.

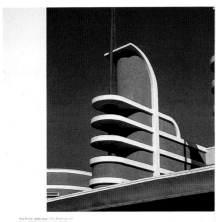

the '30s

The Streamline Moderne style of the 1930s in Los Angeles was a convincing dress rehearsal for the democratic technological future of the 1950s. Even the Great Depression could not completely dampen the elan.

Throughout the depression, the hope of a brighter tomorrow was a popular theme. Advancing technology seemed to offer the most promising road. The evidence of mass production, household appliances, and air travel supported the promise; as a symbol of this new technology, the Streamline Moderne became widely popular.

The smooth Streamline forms carried the eye easily around corners, reducing resistance for efficient movement, a visual metaphor of the reduced wind resistance of streamlined locomotives and airplanes. The teardrop form, its continuous planes submerging individual elements under a single organic shape, became a symbol of the movement, despite the fact it was not, scientifically speaking, the ideal wind-resistant form. It certainly looked like it was; for symbolic purposes of design announcing a new age, that was enough.

Designers were not looking for the scientific fact; they were imagining what invisible forces of speed and energy would look like. In the public mind, streamlining lines came to be associated with modern technology. High art critics labeled the Streamline merely cosmetic, but in the public eye its curves relieved some of the austere lines of boxlike Bauhaus modernism.

Nothing in the East compares with the best things of this sort in Los Angeles.
—Henry-Russell Hitchcock, 1940

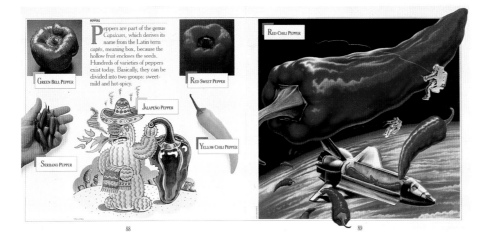

PEPPERS

Peppers are part of the genus *Capsicum*, which derives its name from the Latin term *capto*, meaning box, because the hollow fruit encloses the seeds. Hundreds of varieties of peppers exist today. Basically, they can be divided into two groups: sweet-mild and hot-spicy.

GREEN BELL PEPPER

RED SWEET PEPPER

JALAPEÑO PEPPER

SERRANO PEPPER

YELLOW CHILI PEPPER

RED CHILI PEPPER

88 89

BOOK DESIGN

ART DIRECTOR
Jim Heimann

DESIGN DIRECTOR
David Barich

DESIGNER
Mike Fink

PHOTOGRAPHER/
ILLUSTRATOR
Mike Fink

AGENCY
Jim Heimann Design

CLIENT
Chronicle Books

ART DIRECTOR
Kit Hinrichs

DESIGN DIRECTOR
Kit Hinrichs

DESIGNER
Lenore Bartz
D.J. Hyde

WRITER
Delphine Hirasuna
Kiane Hirasuna

PHOTOGRAPHER/
ILLUSTRATOR
Tom Tracy
Phillipe Weisbecker
Sarah Waldron
Regan Dunnick
John Hyatt
Tim Lewis
John Mattos
Will Nelson
Tadashi Ohashi
Hank Osuna
Daniel Pelavin
Colleen Quinn
Susie Reed
Alan Sanders
Ward Schumaker
Duqald Stermer
David Stevenson
Bud Thon
Carolyn Vibbert

AGENCY
Pentagram Design, Ltd.

CLIENT
Chronicle Books

*MAGAZINE DESIGN
COVER*

ART DIRECTOR Rip Georges	*ART DIRECTOR* Phil Waters
DESIGN DIRECTOR Rip Georges	*DESIGNER* Phil Waters
DESIGNER Rip Georges	*PHOTOGRAPHER* Dr. Richard Champlin
PHOTOGRAPHER/ ILLUSTRATOR Various	*AGENCY* Times Mirror Square
EDITOR Joie Davidow	
AGENCY LA Style Magazine	
CLIENT LA Style, Inc.	

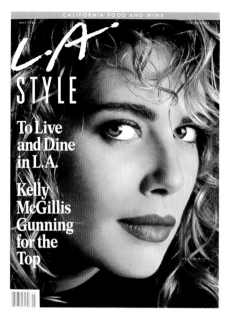

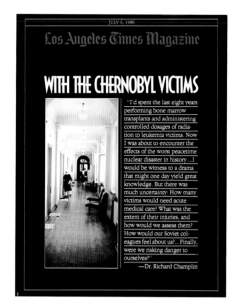

ART DIRECTOR
Jolie Gabrielle Kowalski

DESIGNER
Jolie Gabrielle Kowalski

WRITER
Wayne Dunham

*PHOTOGRAPHER/
ILLUSTRATOR*
Christopher Hawker
Laurie Rubin

AGENCY
Chicago Magazine

CLIENT
Chicago Magazine

MAGAZINE DESIGN
COVER

ART DIRECTOR
Jack Anderson
DESIGN DIRECTOR
Jack Anderson
DESIGNER
Jack Anderson
John Hornall
PHOTOGRAPHER
Mark Burnside
ILLUSTRATOR
Jack Anderson
AGENCY
Hornall Anderson
Design Works
CLIENT
Print Magazine

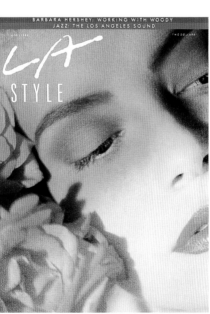

ART DIRECTOR
Chris McAllister
DESIGN DIRECTOR
Chris McAllister
DESIGNER
Chris McAllister
*PHOTOGRAPHER/
ILLUSTRATOR*
Chris McAllister
AGENCY
McAllister Design
CLIENT
Glendale Publishing
Corp.

ART DIRECTOR
Rip Georges
DESIGN DIRECTOR
Rip Georges
DESIGNER
Rip Georges
*PHOTOGRAPHER/
ILLUSTRATOR*
Various
EDITOR
Joie Davidow
AGENCY
LA Style Magazine
CLIENT
LA Style, Inc.

EDITORIAL

MAGAZINE DESIGN

ART DIRECTOR
Robert J. Post
DESIGN DIRECTOR
Robert J. Post
DESIGNER
Robert J. Post
PHOTOGRAPHER/
ILLUSTRATOR
Stephen Shames
AGENCY
Chicago Magazine
CLIENT
Chicago Magazine

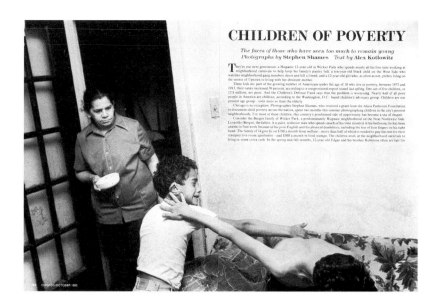

CHILDREN OF POVERTY

The faces of those who have seen too much to remain young
Photographs by Stephen Shames Text by Alex Kotlowitz

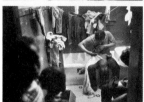

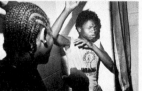

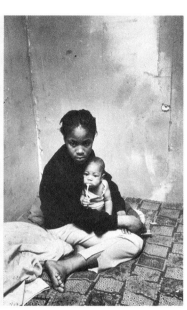

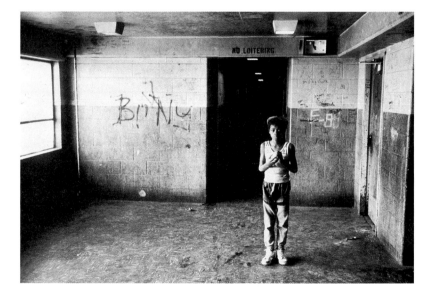

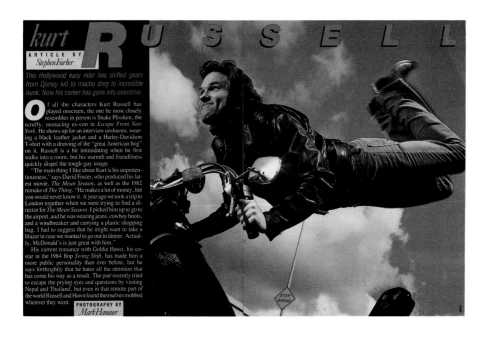

kurt RUSSELL

ARTICLE BY
Stephen Farber

This Hollywood easy rider has shifted gears from Disney kid to macho drag to incredible hunk. Now his career has gone into overdrive.

Of all the characters Kurt Russell has played onscreen, the one he most closely resembles in person is Snake Plissken, the scruffy, menacing ex-con in *Escape From New York*. He shows up for an interview unshaven, wearing a black leather jacket and a Harley-Davidson T-shirt with a drawing of the "great American hog" on it. Russell is a bit intimidating when he first walks into a room, but his warmth and friendliness quickly dispel the tough-guy image.

"The main thing I like about Kurt is his unpretentiousness," says David Foster, who produced his latest movie, *The Mean Season*, as well as the 1982 remake of *The Thing*. "He makes a lot of money, but you would never know it. A year ago we took a trip to London together when we were trying to find a director for *The Mean Season*. I picked him up to go to the airport, and he was wearing jeans, cowboy boots, and a windbreaker and carrying a plastic shopping bag. I had to suggest that he might want to take a blazer in case we wanted to go out to dinner. Actually, McDonald's is just great with him."

His current romance with Goldie Hawn, his co-star in the 1984 flop *Swing Shift*, has made him a more public personality than ever before, but he says forthrightly that he hates all the attention that has come his way as a result. The pair recently tried to escape the prying eyes and questions by visiting Nepal and Thailand, but even in that remote part of the world Russell and Hawn found themselves mobbed wherever they went.

PHOTOGRAPHY BY
Mark Hanauer

DANCE

TRISHA BROWN'S
PERMANENT REVOLUTION

AN AMERICAN
ORIGINAL MARKS
HER COMPANY'S
FIFTEENTH YEAR.
AT CITY CENTER

ALSO COMING UP:

BALANCHINE'S
'BURIED'

LAURA DEAN

MAURICE BÉJART

ALVIN AILEY

THE JOFFREY

Photograph by MARK HANAUER

TOBI TOBIAS

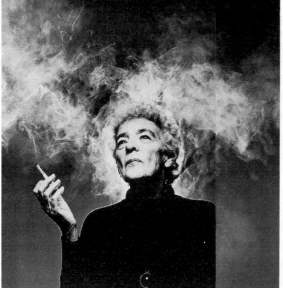

A WOMAN OF FIBER

by Christopher Lyon For more than 50 years Claire Zeisler has been a collector and a maker of art. "It was all natural," she says

Photograph by Victor Skrebneski CHICAGO/NOVEMBER 1985

MAGAZINE DESIGN

ART DIRECTOR
Andrew Epstein

DESIGN DIRECTOR
Andrew Epstein

DESIGNER
Andrew Epstein

WRITER
Stephen Farber

PHOTOGRAPHER/
ILLUSTRATOR
Mark Hanauer

AGENCY
Mark Hanauer
Photography

CLIENT
Moviegoer Magazine

ART DIRECTOR
Jordan Schapps

DESIGNER
Jordan Schapps

WRITER
Tobi Tobias

PHOTOGRAPHER/
ILLUSTRATOR
Mark Hanauer

AGENCY
Mark Hanauer
Photography

CLIENT
New York Magazine

ART DIRECTOR
Robert J. Post

DESIGN DIRECTOR
Robert J. Post

DESIGNER
Robert J. Post

PHOTOGRAPHER/
ILLUSTRATOR
Victor Skrebneski

AGENCY
Chicago Magazine

CLIENT
Chicago Magazine

MAGAZINE DESIGN
ART DIRECTOR
Rip Georges
DESIGN DIRECTOR
Rip Georges
DESIGNER
Rip Georges
*PHOTOGRAPHER/
ILLUSTRATOR*
Various
EDITOR
Joie Davidow
AGENCY
LA Style Magazine
CLIENT
LA Style, Inc.

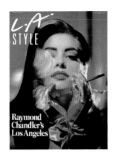

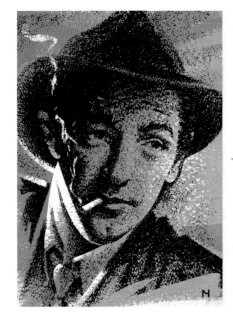

ART DIRECTOR
Marc Balet
DESIGN DIRECTOR
Marc Balet
WRITER
Pat Hackett
*PHOTOGRAPHER/
ILLUSTRATOR*
Herb Ritts
Richard Bernstein
AGENCY
Interview
CLIENT
Interview Magazine

ART DIRECTOR
Kit Hinrichs
DESIGN DIRECTOR
Kit Hinrichs
DESIGNER
Karen Berndt
WRITER
George Cruys
COVER PHOTO
Lee Boltin
PHOTOGRAPHER
Obremski, Bruno
Barbey, Peter Frey,
John Barstow, Randy
O'Rourke, Larry
Gordon, Terry
Heffernar, Charles
Weckler, Ara Guler,
A. Gesar, Richard
Steedman, Peter
Marlow, Henrik Kam,
Geoffrey Hiller,
Marvin Newman,
Harvey Lloyd, Nick
Pavlof, A. Edgewater
ILLUSTRATOR
David Stevenson
AGENCY
Pentagram Design, Ltd.
CLIENT
Royal Viking Line

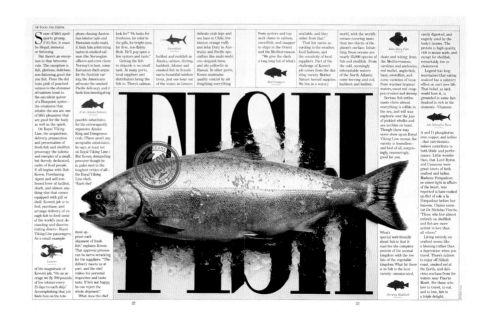

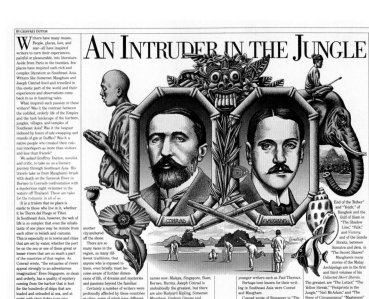

MAGAZINE DESIGN

ART DIRECTOR
Kit Hinrichs

DESIGN DIRECTOR
Kit Hinrichs

DESIGNER
Karen Berndt

WRITER
George Cruys
Peterson & Dodge
Geoffrey Dutton
Tom Keneally

PHOTOGRAPHER
Tom Tracy
Harvey Lloyd
Henrik Kam

ILLUSTRATOR
David Stevenson
Dugald Stermer
Justin Carroll
Ed Lindlof
Rosemary Woodruff Gant

AGENCY
Pentagram Design, Ltd.

CLIENT
Royal Viking Line

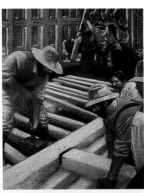

DESIGN DIRECTOR
Ron Coates

DESIGNER
Anita Muncie
Bob Feie

WRITER
Various

PHOTOGRAPHER/
ILLUSTRATOR
Various

AGENCY
Boller/Coates/Spadaro,
Ltd.

CLIENT
Alexander
Communications

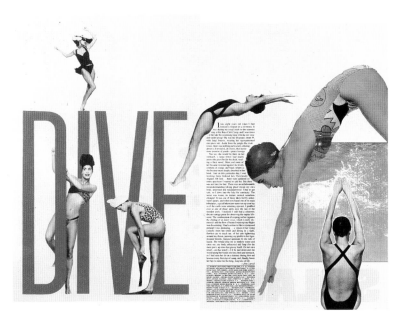

ART DIRECTOR
Marc Balet

WRITER
Jim Carroll

PHOTOGRAPHER/
ILLUSTRATOR
Gordon Munro

AGENCY
Interview

CLIENT
Interview Magazine

ENTERTAINMENT

MOTION PICTURE—PRINT
ART DIRECTOR
Tony Seiniger
DESIGN DIRECTOR
Tony Seiniger
DESIGNER
Tracy Weston
PHOTOGRAPHER/
ILLUSTRATOR
Nancy Ellison
AGENCY
Seiniger Advertising
CLIENT
Warner Bros.

ART DIRECTOR
Vahé Fattal
DESIGN DIRECTOR
Vahé Fattal
VIDEO EFFECT
Ken Rubin
PHOTOGRAPHER
Brigitte Lacombe
AGENCY
Fattal & Collins
CLIENT
ABC Motion Pictures

MOTION PICTURE—PRINT

ART DIRECTOR
Jeffrey Bacon
David Reneric

DESIGN DIRECTOR
David Reneric

DESIGNER
Yuri Hashimoto

*PHOTOGRAPHER/
ILLUSTRATOR*
David Grove

AGENCY
Bacon/Reneric
Design, Inc.

CLIENT
Joel Wayne,
Warner Bros.

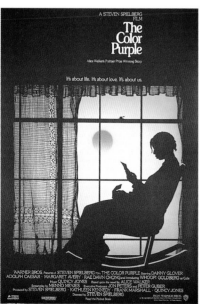

DESIGN DIRECTOR
Anthony Goldschmidt

*PHOTOGRAPHER/
ILLUSTRATOR*
John Alvin

AGENCY
Intralink Film
Graphic Design

CLIENT
Joel Wayne,
Warner Bros.

MOTION PICTURE—PRINT

ART DIRECTOR
Brian D. Fox

DESIGN DIRECTOR
Robert Biro

PHOTOGRAPHER
Ron Derhacopian

AGENCY
B.D. Fox & Friends, Inc.

CLIENT
B.D. Fox & Friends, Inc.

WE'VE MOVED.

B.D. FOX & FRIENDS, INC.
ADVERTISING
1111 BROADWAY
SANTA MONICA, CA 90401
213-394-7150

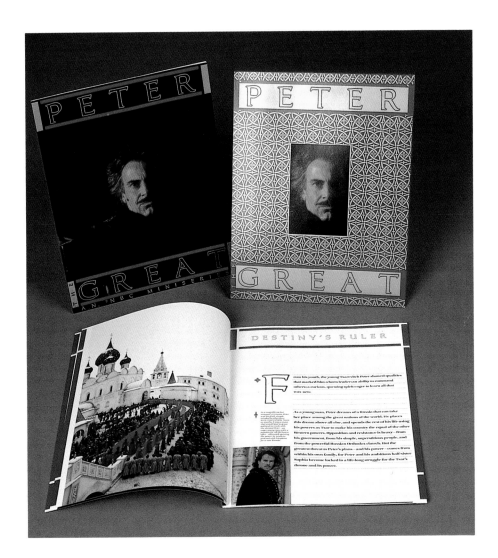

MOTION PICTURE—PRINT

DESIGN DIRECTOR
Charles Blake
Elaine Zeitsoff
DESIGNER
Barbara Shapokas
WRITER
Steve Jaffe
PHOTOGRAPHER/
ILLUSTRATOR
Various
AGENCY
NBC In-House
Design Department
CLIENT
Sales Marketing
(NBC In-House)

This Christmas
EDDIE MURPHY
will search for

THE
GOLDEN
CHILD

DIRECTOR
Anthony Goldschmidt
AGENCY
Intralink Film
Graphic Design
CLIENT
Paramount Pictures

"THE GOLDEN CHILD"

VIDEO: Fade up on a snow filled mountain scene. The wind is blowing, the landscape is desolate, until off in the distance a figure on a yak slowly comes toward us.

Cut to a close up of the yak's hooves as they trudge through the snow. The person pulls up on the reins, as his scarf falls off his face.

It's Eddie Murphy. He complains to us about the trials of making this movie.

As he continues to murmur, the title card "This Christmas Eddie Murphy will search for"

The Golden Child logo fades up.

AUDIO: (An important traditionally epic sounding voiceover with dramatic music under.)

NARRATOR: Every thousand generations a perfect child is born. A child with magical powers. A child sent to bring good into the world. A Golden Child. But now this child has been kidnapped by the forces of evil. As foretold by the Nechung Oracle, only one man can find him. Only one man can rescue him. He is a man from the City of Angels. He is a man who does what is right. A brave man. A true man. It is his destiny to save The Golden Child. He is The Chosen One.

As the scarf comes off his face Eddie Murphy starts yelling:

MURPHY: "If I'm The Chosen One, how come I'm freezing while you're sitting in the warm movie theatre. I'm going back to L.A. and kicking somebody's behind. This isn't supposed to be happening to me. Chosen One my behind. Why couldn't someone choose me to go to the Bahamas? Hawaii's nice. You could have sent me to Vegas. The Chosen One..."

"RUNNING SCARED"

VIDEO: *Fade up on a dark tenement hallway, filled with graffiti and trash. We share the point of view of Billy Crystal and Gregory Hines as they walk down the hall. They exchange small talk.*

We come to an apartment door. They knock and announce they're police ... there's no answer. Suspecting trouble they prepare themselves for busting the door down. They begin shooting at the door, completely demolishing it, pieces of wood and smoke fly everywhere.

We now are inside the apartment as they break down the door...No one's home. It's the wrong apartment. They shrug and leave the scene.

AUDIO: *(Sounds of a tenement: babies crying, people yelling, a couple having a fight)*

CRYSTAL: "That sounds like your first marriage."

HINES: "Give me a break, huh?"

HINES: "Maid service is a little slow today."

CRYSTAL: "Could this carpeting be older? This is like the lining of Liberace's coat here."

They arrive at the door.

HINES: "You got your gun? You ready?"

CRYSTAL: "No, I'm just happy to see you, of course I've got my gun."

They knock on the door.

HINES: "Open up police!"

CRYSTAL: "Boy, remember when that used to work?"

HINES: "Police!"

CRYSTAL: "I'm gonna shoot high, you shoot low. Ready?! OK!"

The door is exploded with gunshots. The door is completely blown apart and falls with little resistance when they kick it in.

HINES: "Police, freeze!"

They see the room is empty, the air is full with dust and debris.

CRYSTAL: "I thought you said they were going to be here?"

HINES: "That's what I was told, this is 301!"

CRYSTAL: "This is 310!"

HINES: "Geez, look what we did to this place."

CRYSTAL: "I know, I love this job!"

They smile and exit the scene.

HINES: "So you want to hit 301?"

CRYSTAL: "That's what I came here for!"

HINES: "Don't get so uptight."

CRYSTAL: "We just blew up someone's house."

HINES: "So, we'll leave them a note."

DIRECTOR
Anthony Goldschmidt
AGENCY
Intralink Film
Graphic Design
CLIENT
Greg Morrison—MGM

MOTION PICTURE—VIDEO

DIRECTOR
Anthony Goldschmidt
AGENCY
Intralink Film
Graphic Design
CLIENT
Greg Morrison—MGM

"POLTERGEIST"

VIDEO: Fade up on an interior shot of a home. Camera pans over the top of a desk with a picture of a little girl on it. The camera snorkels downward to the floor and we see two dolls sitting in the children-size chairs. As we pass one of the dolls, her eyes open, her head follows us as we pass by.

The camera then stops on a child's toy phone. A child's hand reaches into frame and picks up the phone.

The camera pulls back to reveal the back of a little girl.

She turns to us and says, "They're back."

Immediately we hear horrible screaming and screeching sounds. The screen becomes filled with a montage of horrible images, skeletons, ghosts, etc.

The title then zooms in and seats as sound F/X crescendo.

AUDIO: We hear a grandfather's clock ticking as the only sound to this peaceful scene.

As we travel through the room a phone rings. We find the phone as it continues to ring incessantly. A child's hand comes in and answers it. She turns and says to camera, "They're back."

We cut to a montage of horrific scenes and horrible sounds building to a crescendo.

"PSYCHO III TEASER"

OPEN ON MAN ASCENDING A DIMLY LIT STAIRWAY CARRYING A DINNER TRAY.

MUSIC: (BUILDS THROUGHOUT SPOT.)

SFX: (MAN'S FOOTSTEPS. AN OCCASIONAL CREAK.)

CRANE SHOT: (CAMERA FOLLOWS HIM UP THE STAIRS.)

MOTHER: "Who's there? Is that You?"

CU OF MAN AT TOP OF STAIRS AS HE TURNS TO REVEAL—NORMAN BATES.

MOTHER: "Answer me, *Norman!*"

NORMAN SMILES.

NORMAN: "Yes, Mother...It's me."

JAGGED RED EDGES OF TITLE TREATMENT JUMP CUT IN OVER FREEZE FRAME OF SMILING FACE.

REVEAL FULL TITLE SUPER:

ANTHONY PERKINS—PSYCHO III

ART DIRECTOR
Duane Meltzer
Ken Harman
DESIGN DIRECTOR
Anthony Perkins
DESIGNER
Carol McMillan
Duane Meltzer
David Sameth
WRITER
Carol McMillan
AGENCY
Universal Studios
CLIENT
Universal Studios

TELEVISION—PRINT

ART DIRECTOR
Vahé Fattal

DESIGN DIRECTOR
Vahé Fattal

AGENCY
Fattal & Collins

CLIENT
CBS

ART DIRECTOR
Scott A. Mednick

DESIGN DIRECTOR
Scott A. Mednick

DESIGNER
Scott A. Mednick
Daniel J. Simon

PHOTOGRAPHER/
ILLUSTRATOR
Wendy Ahrensdorf

AGENCY
Scott Mednick
& Associates

CLIENT
CBS Television

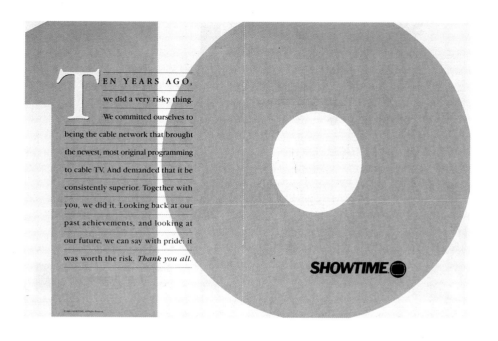

TEN YEARS AGO, we did a very risky thing. We committed ourselves to being the cable network that brought the newest, most original programming to cable TV. And demanded that it be consistently superior. Together with you, we did it. Looking back at our past achievements, and looking at our future, we can say with pride: it was worth the risk. *Thank you all.*

SHOWTIME

TELEVISION—PRINT

ART DIRECTOR
Stuart Kusher
Brian O'Reilly
Don Zubalsky
Tom Brothers

DESIGNER
Fred Fehlau

AGENCY
Metro Advertising Inc.

CLIENT
Showtime

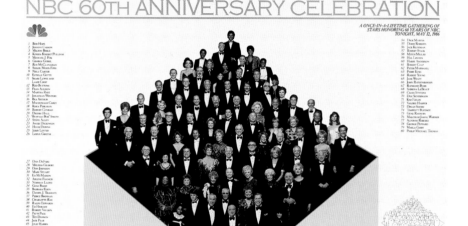

ART DIRECTOR
David Pai Ritchie

DESIGN DIRECTOR
Laura McGannon

DESIGNER
David Pai Ritchie

WRITER
Ernest Cunningham

*PHOTOGRAPHER/
ILLUSTRATOR*
John Lawlor

AGENCY
Lawlor on Location, Inc.

CLIENT
NBC Entertainment

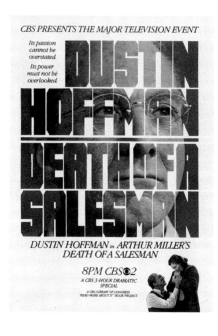

CREATIVE DIRECTOR
Jay Rothman

ART DIRECTOR
Thom Williams

WRITER
Nancy Richardson
Suellen Mayfield

AGENCY
Fattal & Collins

TELEVISION—PRINT

ART DIRECTOR
Scott A. Mednick

DESIGN DIRECTOR
Scott A. Mednick
Cliff Hauser

DESIGNER
Scott A. Mednick
Daniel J. Simon
Allan F. Taylor
Mari Migliore

WRITER
Barbara Witzer

*PHOTOGRAPHER/
ILLUSTRATOR*
David Leach

AGENCY
Scott Mednick
& Associates

CLIENT
Samuel Goldwyn
Television

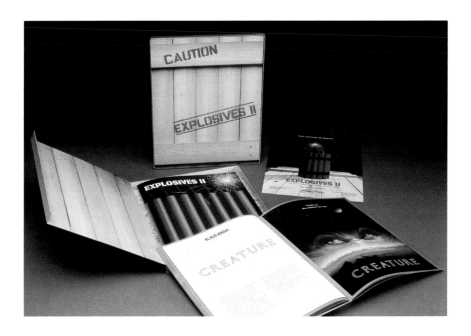

WRITER
Bob Bibb

AGENCY
NBC Advertising
and Promotion

CLIENT
NBC Entertainment

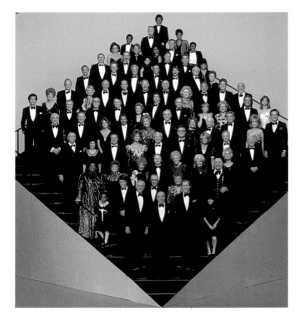

CREATIVE DIRECTOR
John LePrevost, CBS

ASSOCIATE
CREATIVE DIRECTOR
Lewis Hall, CBS

DESIGNER
Mark Hensley

EXECUTIVE
PRODUCER
Morton J. Pollack, CBS

ANIMATOR
Glenn Entis, P.D.I.

AGENCY
Mark Hensley Design

CLIENT
CBS Entertainment

TELEVISION—VIDEO

WRITER
Lewis Goldstein
Bob Bibb

AGENCY
NBC Advertising
and Promotion

CLIENT
NBC Entertainment

RECORDS

ART DIRECTOR
Tibor Kalman

DESIGNER
Alexander Isley

*PHOTOGRAPHER/
ILLUSTRATOR*
Davies and Starr

AGENCY
M & Co.

CLIENT
A & M Records

ART DIRECTOR
Carol Bobolts

DESIGNER
Carol Bobolts

*PHOTOGRAPHER/
ILLUSTRATOR*
David Febland

AGENCY
Atlantic Records

CLIENT
Cotillion Records

RECORDS

ART DIRECTOR
Jeff Ayeroff

DESIGNER
Norman Moore

*PHOTOGRAPHER/
ILLUSTRATOR*
Naoki Fukuda

AGENCY
Design/Art, Inc.

CLIENT
Geffen Records

ART DIRECTOR
Tony Lane
Nancy Donald

DESIGN DIRECTOR
Tony Lane
Nancy Donald

DESIGNER
Tony Lane
Nancy Donald

PHOTOGRAPHER
John Pfahl

AGENCY
CBS Records

CLIENT
CBS

ART DIRECTOR
Bob Defrin

DESIGN DIRECTOR
Bob Defrin

DESIGNER
Bob Defrin

*PHOTOGRAPHER/
ILLUSTRATOR*
Braldt Bralds

AGENCY
Atlantic Records

CLIENT
Atlantic Records

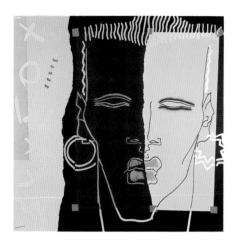

RECORDS

ART DIRECTOR
Roy Kohara
DESIGNER
Koji Takei
ILLUSTRATOR
Tony Viramontes
AGENCY
Capitol Records, Inc.
CLIENT
Capitol Records
▲

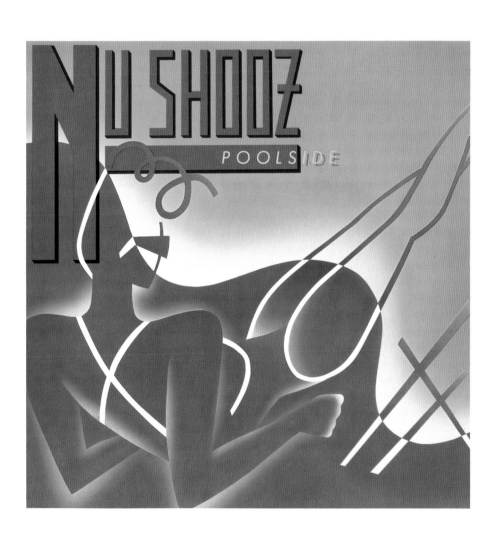

ART DIRECTOR
Bob Defrin
DESIGN DIRECTOR
Bob Defrin
PHOTOGRAPHER /
ILLUSTRATOR
Javier Romero
AGENCY
Atlantic Records
CLIENT
Atlantic Records

RECORDS
ART DIRECTOR
Jeri McManus Heiden
Jeffrey Kent Ayeroff
DESIGNER
Jeri McManus
PHOTOGRAPHER
Herb Ritts
AGENCY
Warner Bros. Records
CLIENT
Madonna

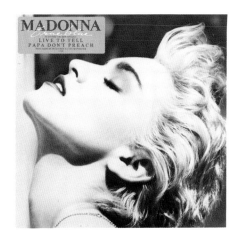

ART DIRECTOR
Jodi Rovin
PHOTOGRAPHER/
ILLUSTRATOR
Javier Romero
AGENCY
Atlantic Records
CLIENT
Atlantic Records

AHMAD JAMAL **D**IGITAL WORKS

RECORDS

ART DIRECTOR
Bob Defrin
DESIGN DIRECTOR
Bob Defrin
DESIGNER
Bob Defrin
PHOTOGRAPHER /
ILLUSTRATOR
Roy Volkmann
AGENCY
Atlantic Records
CLIENT
Atlantic Records

ART DIRECTOR
Norman Moore
DESIGNER
Norman Moore
AGENCY
Design/Art, Inc.
CLIENT
A&M Records, Inc.

ART DIRECTOR
Laura LiPuma
DESIGNER
Laura LiPuma
PHOTOGRAPHER
Willie Osterman
AGENCY
Warner Bros. Records
CLIENT
54.40

HOME VIDEO

ART DIRECTOR
Christopher Garland
DESIGNER
Christopher Garland
AGENCY
Xeno
CLIENT
Sound Video
Unlimited

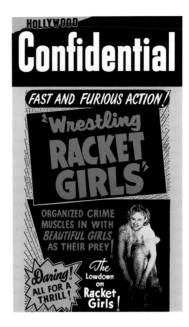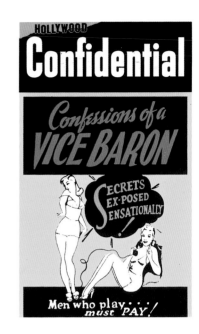

ART DIRECTOR
Michael Brock
DESIGN DIRECTOR
Michael Brock
DESIGNER
Michael Brock
WRITER
Warner Home Video
PHOTOGRAPHER/
ILLUSTRATOR
Tom Keller
AGENCY
Michael Brock Design
CLIENT
Warner Home Video

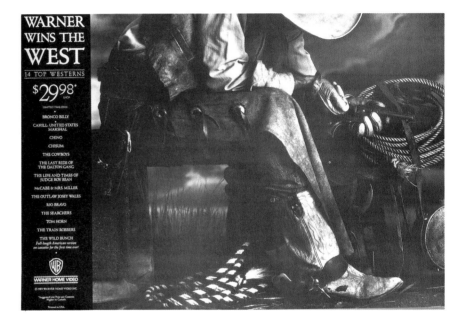

ART DIRECTOR
Ken White
DESIGN DIRECTOR
Lisa Levin Pogue
DESIGNER
Petrula Vrontikis
AGENCY
White + Associates
CLIENT
Media Home
Entertainment

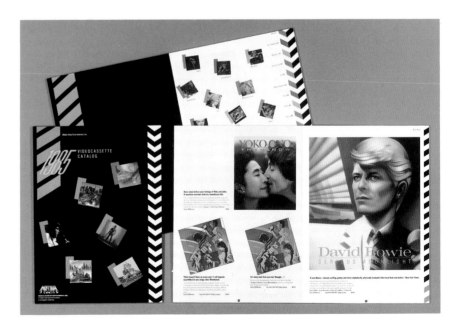

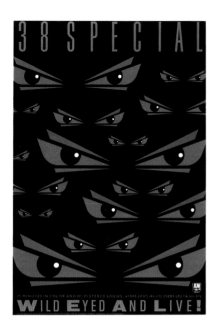

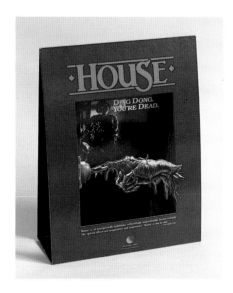

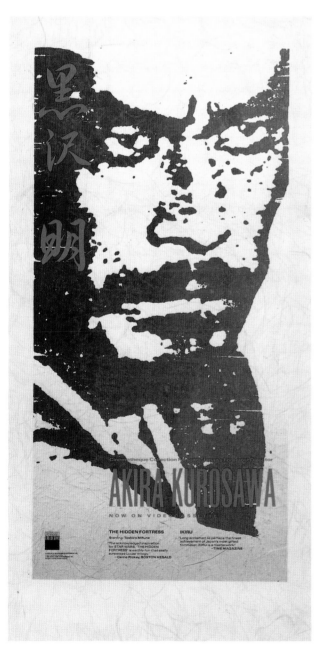

ART DIRECTOR
Norman Moore

DESIGNER
Norman Moore

AGENCY
Design/Art, Inc.

CLIENT
A&M Video

HOME VIDEO

ART DIRECTOR
Jeff Price

DESIGNER
Jeff Price

WRITER
Pick-up

PHOTOGRAPHER/
ILLUSTRATOR
Pick-up

AGENCY
Broyles, Garamella,
Kavanaugh &
Associates

CLIENT
Dena Wholey—
New World Video

ART DIRECTOR
Deborah Norcross

DESIGNER
Deborah Norcross

WRITER
Jeff Lamont

PHOTOGRAPHER/
ILLUSTRATOR
Deborah Norcross

AGENCY
Media Home
Entertainment

CLIENT
Cinematheque
Collection
Division of
Media Home
Entertainment

INDEX

ART DIRECTOR

ADLA:2 ERRATA

CREDITS

PAGE 174

ART DIRECTOR
Willi Kunz

DESIGN DIRECTOR
Willi Kunz

DESIGNER
Willi Kunz

PRODUCTION ARTIST
Alyssa Weinstein

AGENCY
Willi Kunz Associates

CLIENT
Typogram

PAGE 221

ART DIRECTOR
Alan Ferguson

DESIGNER
Stan Kong

PRODUCTION ARTIST
Stan Kong

AGENCY
Xenoworks West

CLIENT
Xenoworks West

INCORRECT FRAMES

PAGE 138
Frames 1, 3, 4 and 6 should be Frames 1, 3, 4 and 6 on page 139.

PAGE 139
Frames 1, 3, 4 and 6 should be Frames 1, 3, 4 and 6 on page 138.

MISSPELLINGS

Steve Berg
Ivan Chermayeff
George Tcherney
Allison Dunn
Jaime Odgers
Jeffrey Spear
Jordon Miller
Walter Herrington
Herrington & Soter Inc.

CORRECT SPELLING

Steve Borg
Ivan Chermayoff
George Tcherny
Allyson Dunn
Jayme Odgers
Jefferey Spear
Jordan Miller
Walter Harrington
Harrington & Soter Inc.

OUR FACES WIN MORE AWARDS.

Saul Bass
*Bass/Yager &
Associates*

Keith Bright
*Bright and
Associates*

Rod Dyer
*Dyer/Kahn,
Inc.*

Deborah Sussman
*Sussman/Prejza,
Inc.*

Rip Georges
*L.A. Style
Magazine*

Vernon Simpson
*Vernon Simpson
Typographers,
Inc.*

Photography Norman Seeff Design Kathleen Boss

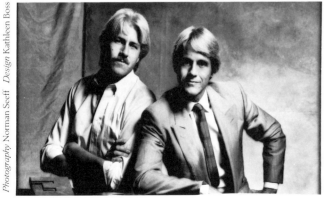

**Bill and Drew
Andresen**
*Andresen
Typographics*

AT ANDRESEN, WE'RE PROUD TO WORK WITH some of the leading faces in both Design and Advertising. We specialize in the type of service and quality of typography that award winners require. If your next project needs to be a winner, or you simply want the best faces available to make it perfect, give Andresen Typographics a call.

Andresen Typographics

L.A. MELROSE	L.A. 6TH STREET	BERTHOLD VENUE	ORANGE COUNTY	SAN FRANCISCO	TUCSON, ARIZONA	PHOENIX, ARIZONA
(213) 464-4106	(213) 384-2525	(213) 384-3881	(714) 250-4450	(415) 421-2900	(602) 623-5435	(602) 254-1710

CONGRATULATIONS TO THE WINNERS

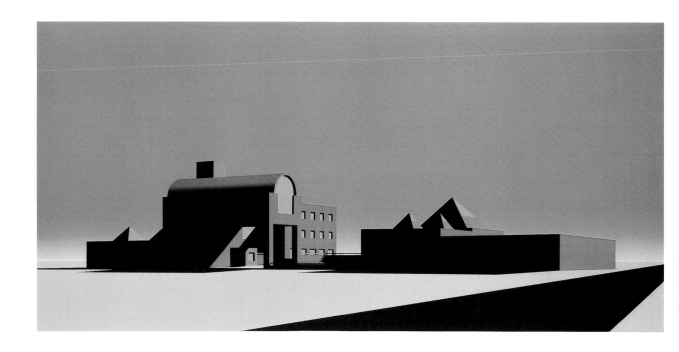

THE MUSEUM OF CONTEMPORARY ART LOS ANGELES

Architect Arata Isozaki

*One of our
winners
PIA 1986
Award*

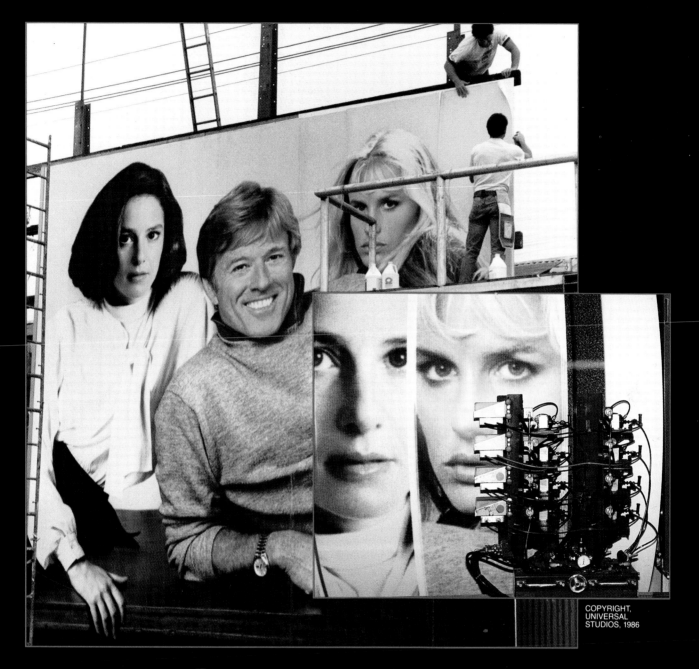

COPYRIGHT,
UNIVERSAL
STUDIOS, 1986

FACE REALITY

When you advertise famous faces in high places, you need a precision printing process you can count on.

Introducing the MegaPrint™: your answer to uncompromising color and accuracy for billboards, murals and signs.

State-of-the-art in computer technology, the MegaPrinter™ reproduces your photographic image in brilliant color—consistently faster, cost effectively. Every color, tone and detail is digitized then translated to a high speed computerized airbrush printer onto paper, vinyl or pressure-sensitive vinyl.

The World's Largest Computerized Printing System

COMPUTER IMAGE SYSTEMS

19220 Normandie Avenue • Torrance, California 90502 • (213) 538-0742

ADLA

ART DIRECTORS CLUB
OF LOS ANGELES

The Art Directors Club of Los Angeles was formed in 1947 to satisfy a need among communication arts specialists...for communication. For sharing experience and information with peers capable of contributing to each other's growth.

ADLA serves your quest for knowledge and experience by sponsoring programs with highly-respected guest speakers from all areas of art direction and graphic arts. Speakers like Saul Bass, Si Lam, April Grieman, Jay Chiat.

The ADLA Annual is a member benefit provided free to those having paid a full year's dues.

Join ADLA today, and you'll become part of a creative network of communication arts specialists. It may be the wisest tax-deductible investment you've ever made.

Annual Dues are $75 and are billed in May of each year. Student dues are $15 and are not pro-rated. Please remember to include the $25 application fee with your dues check.

JUNE	$75.00	SEPTEMBER	$56.25	DECEMBER	$37.50	MARCH	$18.75
JULY	$68.75	OCTOBER	$50.00	JANUARY	$31.25	APRIL	$12.50
AUGUST	$62.50	NOVEMBER	$43.75	FEBRUARY	$25.00	MAY	$ 6.25

Please indicate area of activity below:
- ☐ REGULAR
 - ☐ Art Director
 - ☐ Jr. Art Director
 - ☐ Graphic Designer
- ☐ Illustrator
- ☐ Film Director
- ☐ Animator
- ☐ ASSOCIATE
 - ☐ Photographer
 - ☐ Production
 - ☐ Vendor

☐ STUDENT

☐ Other _____

Name _____

Company _____

Title _____

Address _____

City _____ State _____ Zip_____

Telephone (_____) _____

Home Address _____

City _____ State _____ Zip_____

Telephone (_____) _____

Please send my mail to ☐ Business

☐ Home

Enclosed is my check in the amount of $_____ .

_____ _____
Signature of Applicant Date

Please complete and return this application to the ADLA office along with first year dues and initiation fee.

Mail to:

Art Directors Club of Los Angeles
1258 North Highland Avenue Suite 209
Los Angeles, California 90038